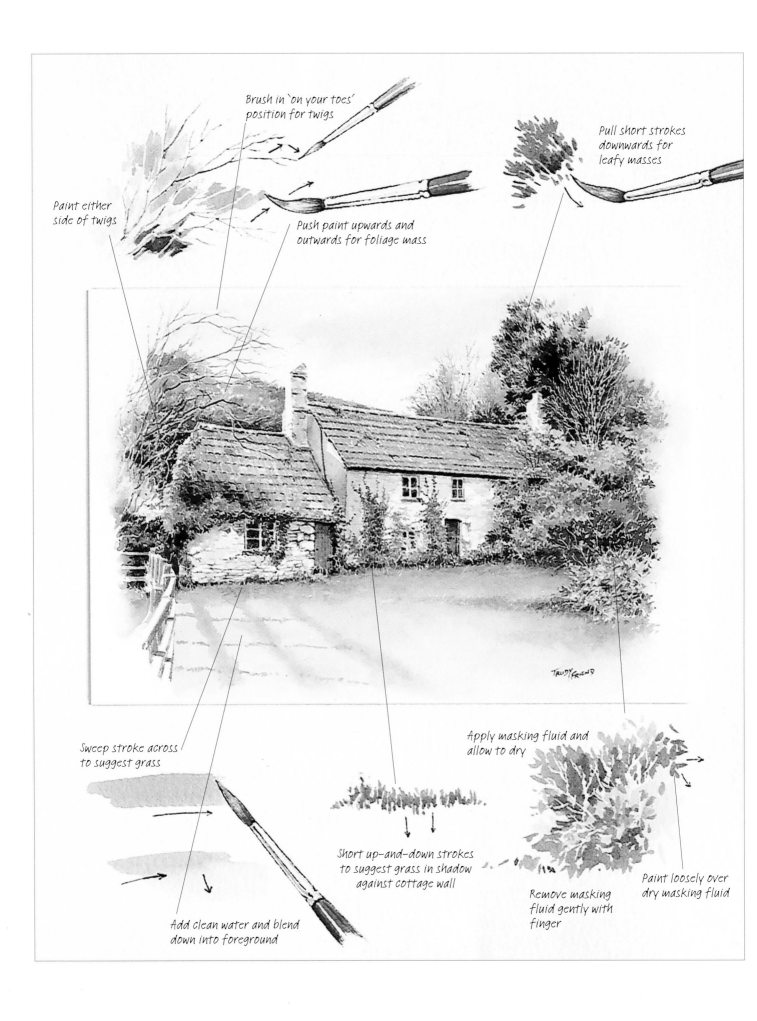

Brush in 'on your toes' position for twigs

Pull short strokes downwards for leafy masses

Paint either side of twigs

Push paint upwards and outwards for foliage mass

Sweep stroke across to suggest grass

Apply masking fluid and allow to dry

Add clean water and blend down into foreground

Short up-and-down strokes to suggest grass in shadow against cottage wall

Remove masking fluid gently with finger

Paint loosely over dry masking fluid

TRUDY FRIEND

A TROUBLE-SHOOTING HANDBOOK

Landscape
Problems and Solutions

Trudy Friend

David & Charles

To my grandmother

A DAVID & CHARLES BOOK

First published in the UK in 2004

Copyright © Trudy Friend 2004

Distributed in North America
by F&W Publications, Inc.
4700 East Galbraith Road
Cincinnati, OH 45236
1-800-289-0963

A catalogue record for this book is available from the
British Library.

ISBN 0 7153 1647 8 hardback
ISBN 0 7153 1650 8 paperback (USA only)

Printed in Singapore by KHL Printing Co Pte Ltd
for David & Charles
Brunel House Newton Abbot Devon

Senior Editor Freya Dangerfield
Desk Editor Lewis Birchon
Art Editor Sue Cleave
Project Editor Ian Kearey
Production Controller Kelly Smith

Visit our website at www.davidandcharles.co.uk

David & Charles books are available from all good
bookshops; alternatively you can contact our Orderline
on (0)1626 334555 or write to us at FREEPOST EX2110,
David & Charles Direct, Newton Abbot, TQ12 4ZZ (no
stamp required UK mainland).

This book is based on Trudy Friend's popular 'Problems
and Solutions' series in *Leisure Painter* magazine. For
subscription details and other information please contact:
The Artists' Publishing Company Ltd, Caxton House,
63–5 High Street, Tenterden, Kent TN30 6BD, Tel: 01580
763315 www.leisurepainter.co.uk

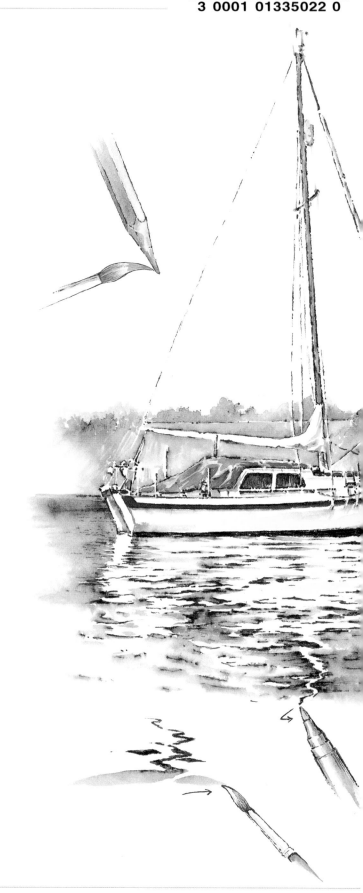

Contents

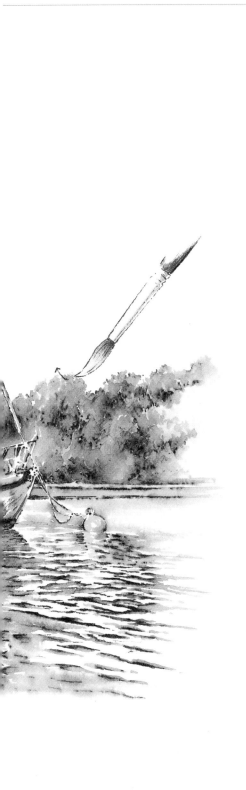

Introduction

With this book I will be helping you…
to love your art,
to live your art
and see the world go by
as colour, texture, line and form
and with an 'artist's eye'.

To love and live your art may be regarded as a total commitment or an invisible thread woven into the fabric of your day-to-day life – or anywhere between the two. It is primarily an awareness of the part you wish your art to play, and where you choose to let it blossom and flourish.

Colour, texture, line and form can work together or individually, depending upon the way you incorporate them into your artwork, but the 'artist's eye' needs to be nurtured and developed as an integral part of the whole. In this book I endeavour to reaffirm what artists throughout the ages have experienced, and to introduce some of the excitement I feel for my subjects.

Colour

When considering colour, whether in its fullest sense or as a limited palette, it is also important to refer to tone. On page 38 you can see how a painting can be built with just two colours with the emphasis on their tones.

Page 41 introduces a limited palette, which is useful for expressing mood and atmosphere.

Texture

Observing and appreciating the variety and interest of surface textures is of great importance when creating convincing interpretations of landscapes – tree bark, stone walls, foliage and water effects, for example, would lose their impact if they were all treated in the same way. Textures can be achieved by using techniques such as blotting off (page 21), drybrush (page 23) and wax resist (page 24); and very often it is the support that is most important when creating textures.

Line

Line drawing is very useful for sketchbook work – using a 'wandering line' to capture impressions of moving objects; and combining line with tone in pencil sketches, ink and wash studies or in watercolour pencil with wash

pictures. This offers the options of drawing first and applying a tonal overlay (page 93), painting in washes first and bringing the picture together with a drawing (page 106), or working the two together (page 107).

Form

Contour lines help find form in order to create a three-dimensional impression on a two-dimensional surface. These lines may be the important underdrawing, lightly applied as a guide and then absorbed within the tonal images of the final interpretation. They can also be attractive in their own right as part of an interesting and personal style.

and application. Look for unexpected opportunities that may lead to new discoveries of techniques and ideas, and you will never tire of the endless possibilities they present, allied with your powers of observation.

The themes

Each theme commences with basic pencil marks that relate to the following pages, and concludes with a demonstration in one or more of a variety of media, giving you an opportunity to study the medium or media in more depth. Within the themes the various media are used in a number of ways and with different styles, techniques and subject matter, so that you can become more aware of some of the vast array of choices at your disposal.

Play and exercise pages

As children we learn from play, and there is no reason not to continue to enjoy playing as part of the learning process with art; so part of the introduction to each theme consists of a few relevant exercises with brush or pencil, which can be regarded as enjoyable warming up prior to the more serious work that follows.

I use the word 'serious' because I regard discipline as an important factor, especially in the early stages when learning the basics. This will ensure that a firm foundation for artwork is established – but there should also be an element of fun and a desire to take advantage of 'happy accidents', as well as flexibility of approach

Discipline leads to freedom

Establish the basic disciplines of drawing, observation and methods of application, and you will enjoy the freedom to create your own style – detailed and controlled, or loose and free – in the sure knowledge that you fully understand what you are trying to achieve, and are developing the confidence that will enable you to achieve it.

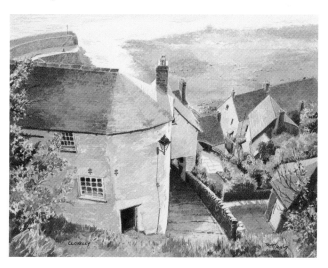

Materials

Pencils

Graphite pencils
The ones suitable for drawing are soft and range from a grade B through to the much softer 9B.

Watersoluble pencils
These are ideal as a sketching medium as well as for detailed drawings; they also combine well with watercolour paint in mixed-media works.

Charcoal pencils
These are made from particles of natural charcoal mixed with finest clays, encased in round cedarwood barrels. The grades – light, medium and dark – offer a useful range of tones, but because the charcoal is powdery, the pencils have to be handled carefully and finished drawings need to be fixed to prevent smudging.

Graphite sticks
Similar in appearance to pencils, these are made from solid graphite, sometimes protected by paper or thin plastic, which can be peeled away as the sticks are used. Chunky graphite blocks are uncased, which means that both the tips and sides can be used.

Compressed charcoal
Smooth natural charcoal, made in the shape of a convenient rounded chunky stick, can be used as an alter-

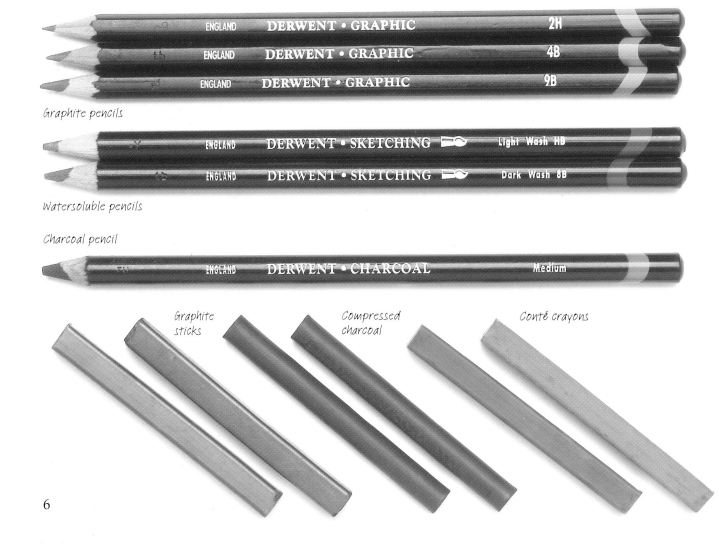

Graphite pencils

Watersoluble pencils

Charcoal pencil

Graphite sticks

Compressed charcoal

Conté crayons

native to more delicate and unevenly shaped natural charcoal sticks.

Pastel pencils
Effective used on their own, particularly upon a tinted or coloured surface, these also work well used alongside soft pastel sticks: the sticks can cover large areas, with the sharpened pencils providing fine detail.

Artists' and studio coloured pencils
The artists' variety are of larger diameter than studio pencils, and the colour strip is slightly waxy, making them useful for blending and superimposing colours. The studio ranges are ideal for fine, detailed work, as they are slimmer, and their hexagonal barrels are helpful when executing delicate work. They are formulated not to crumble during use, which makes them reliable.

Watercolour pencils
When used dry on dry paper, these produce a soft effect; when water is lightly washed over the marks, the images swiftly become a painting. Further drawing can be overlaid when the pigment has thoroughly dried, and this combination of drawing and painting is an appealing one.

Woodless watercolour sticks
Used in a similar way to watercolour pencils, these have the added advantage of having no casing, which means that they can be broken into suitable lengths and be used lengthways to create broad strokes of colour.

Profipens
These are available in a number of nib sizes, to produce everything from very fine to quite broad lines. Depending on the tooth of the paper on which they are used, they can create solid or broken, textured lines. They can be used on their own or in combination with another medium, very often watercolour paint.

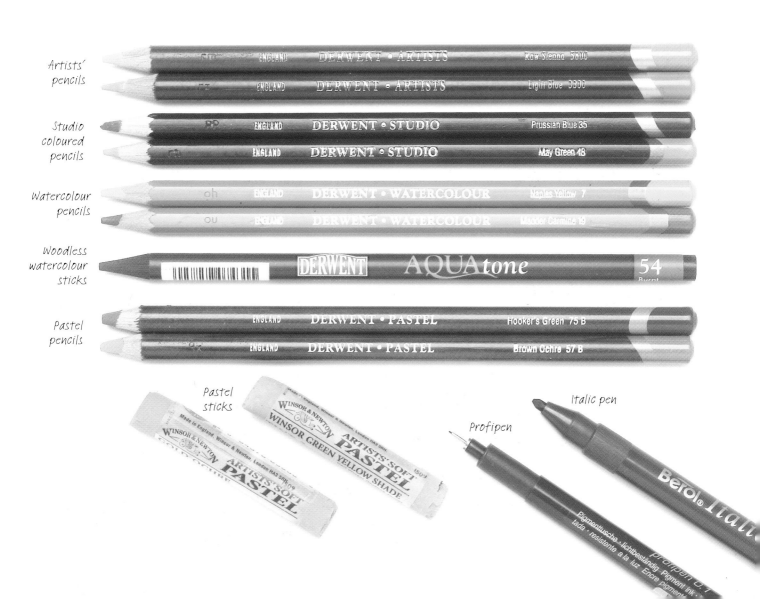

Artists' pencils

Studio coloured pencils

Watercolour pencils

Woodless watercolour sticks

Pastel pencils

Pastel sticks

Profipen

Italic pen

Watercolour

Paints

Watercolour paints are available in tubes and pans – and you can use watercolour pencils in the same way by mixing water with shavings of pigment (see page 98).

Rather than buying a pre-made set of paints, it is a good idea to purchase a box or tin to hold pans or tubes, and to choose individual colours to create your own range of hues. Working in monochrome or with a limited palette is advantageous when starting out, so it is not necessary to fill the box or tin all at once, which means that you can purchase artists' quality paints when you can afford them. Pocket-size watercolour boxes, which sometimes contain an integral brush and water pot, are useful for working on-site.

Brushes

As with paints, it is preferable to have one or two good-quality sable brushes rather than an array of indifferent specimens. I often complete an entire painting using only one brush, as long as it possesses the necessary attributes for my personal style: good water-holding capacity, flexibility (hairs that spring back into place after the application has been made), and a fine point.

A versatile starting set of brushes would be Nos 3, 6 and 8 round; I occasionally use a flat brush as well, for drybrush overlays (see page 23) and wash overlays (see page 83).

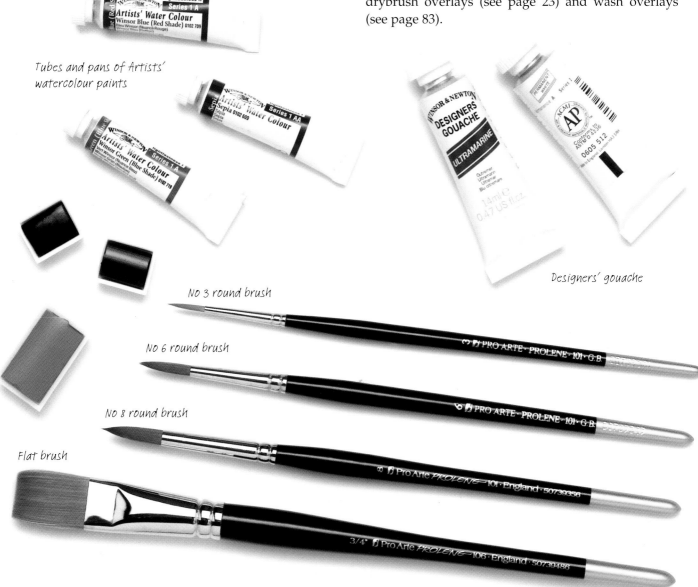

Tubes and pans of Artists' watercolour paints

Designers' gouache

No 3 round brush

No 6 round brush

No 8 round brush

Flat brush

Other Equipment

Water pots

To preserve the shapes of your brushes, use a water pot that allows them to be supported, with the tips facing downwards, around the edge of the pot. The drip tray, which doubles as a lid when not in use, catches the drips, and the brushes retain their points.

Palettes

I always use ceramic palettes, as they are easy to clean and do not stain; this allows each new colour or mix to remain clear and not be influenced by what has been in the palette well beforehand.

Sharpeners

My preference is to use a Stanley knife rather than a craft knife or pencil sharpener; the metal version is better than a plastic one, as the extra weight helps with the execution of movements that take off slivers of wood and graze the lead to produce fine pencil points.

Erasers

A putty eraser can be kneaded into various shapes, which makes it useful for lifting soft pastel and char-coal marks. For erasing pencil marks or cleaning drawing paper surfaces, a variety of other erasers, including plastic ones, is available from art or office suppliers.

I prefer to use erasers as little as possible, and draw very lightly at first, adding intensity of tone by applying more pressure, only correcting as the images develop. I feel that many of the most interesting drawings result from seeing how the artist developed the work, by observing the underlayers.

WORKING ON-SITE

Try to be as comfortable as possible, and have all your materials to hand. A lightweight 'sketching' easel, on which a plastic water jar may be hung, is a help if you find working on a watercolour block (or pad) on your lap too awkward. A lightweight folding seat with a back rest may be preferable to a stool and a field or pocket box of paints (brush included) with tissues or kitchen roll will complete a watercolour kit.

When painting out of doors the weather conditions may influence your work to such an extent that you will need to consider how you intend to deal with them. Warm clothes are needed if it is chilly, and a sun hat should be used for protection should the opposite apply.

Because you will need to consider changes in cast shadows as the hours pass, photographic reference (using a digital or instant camera) or sketchbook drawings depicting the position of shadows where they enhance the composition, are of great help.

Brush pot

Putty eraser

Ceramic palette

Paper

Drawing paper

Standard office copier paper is ideal for sketching and preliminary layouts; you can also practise drawing techniques on this inexpensive support – but remember to use the thin sheets in the form of a pad, as it is otherwise easy to pick up texture inadvertently from the board or table on which the paper is placed.

For more permanent drawings there is a wide range of quality cartridge paper of differing weights available, and it is a good idea to experiment with various combinations of paper and drawing media to find out which best suits your individual style and requirements.

Watercolour paper

HP (Hot-Pressed) watercolour paper is suitable for drawings, and allows you to happily combine pencil drawing with watercolour painting, without the cockling effect that sometimes occurs with lighter-weight cartridge papers.

With its forgiving painting surface, Bockingford is an economical watercolour paper that is ideal for practise exercises as well as completed paintings. Also available in a variety of tinted surfaces – blue, eggshell, cream and oatmeal – and in an extra-rough version, the Bockingford range may be all you need to get started.

I have used Saunders Waterford NOT (Cold-Pressed) watercolour paper for a number of the illustrations in this book, and it is one of my favourite surfaces on which to work. Where a rough surface is required, Saunders Waterford Rough is ideal.

Other papers and sketchbooks

The papers described above can be used with a variety of media, including watercolour, pen and ink, pencil, gouache, acrylic, charcoal and pastels. When using the latter, a heavyweight Rough paper with a watercolour wash underpainting makes a very good surface. Pastels also respond well to the Somerset Velvet range (see page 14), and can be used on pastel board and sandpaper.

On page 95 you can see how a tinted surface (also available in the Somerset Velvet range) offers an ideal support for the drier methods of paint application, such as gouache and acrylic.

A variety of papers are offered for sale in sketchbooks, and I find that the spiral-bound versions are particularly useful for working on location. The sizes and formats vary, so shop around to see what suits you best.

see page 14; On page 95

STRETCHING PAPER

When working on lightweight watercolour papers, it is advisable to stretch the sheet on a board to avoid cockling when areas of wash are applied. Make sure that the paper size is less than that of the board, allowing sufficient margin for the gummed strip to adhere evenly around the edges

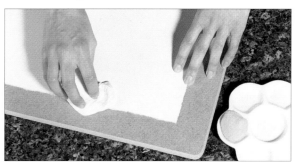

1 Cut four strips of gummed paper to length, approximately 50mm (2in) longer than the paper edges. Immerse the paper in a tray (or bath) containing enough water to cover the sheet, and leave for a few moments before lifting it out and allowing the water to run and drip off. Lay the sheet gently on the board, making sure that the edges run parallel to the board and the margins are even. Use a sponge to gently smooth the paper to eliminate any air bubbles and blot off excess moisture.

2 Dampen the gummed strips and secure all the edges of the paper to the board; overlap the paper edges by about 12mm (½in), and allow about 25mm (1in) to spare at the corners.

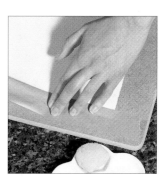

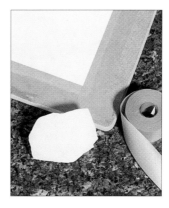

3 Use crumpled kitchen paper to gently smooth along the edges until they are flat and the moisture is even across the whole sheet. Dry flat at room temperature – angling the board can cause moisture to accumulate at the base and the gummed paper to lose its adhesion.

Drawing Techniques

Mark-making

There is such an exciting choice of pencils available to the artist that it would be impossible to include everything here. Instead, I have demonstrated a few from this vast selection in order to show some of the marks they make and how you can try out materials that may be new to you.

Rather than making just abstract marks, I like to start immediately to imagine in what context they may be used. The marks on these pages were made on a smooth, white paper. The same movements and pressures will almost certainly appear different on other surfaces, so experiment and see what happens.

Graphite pencils

The hard 2H is ideal for drawing with a wandering line

A 2B pencil, for general-purpose drawing, allows you to enrich your tones

The soft 9B lends itself to a more painterly approach

Coloured pencils

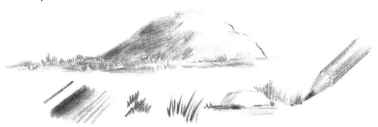

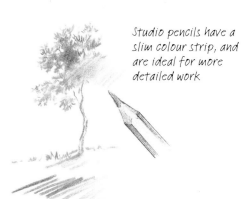

Studio pencils have a slim colour strip, and are ideal for more detailed work

Artists' pencils have a thick strip of colour, encouraging a looser interpretation

Graphite sticks

Soft sticks create rich, dark tones. They are easily smudged, so an early application of fixative is required

The darks from medium sticks are not as deep, but are compensated for by being easier to work with

With a twisting/turning application of a hard stick, a crisp effect, useful for depicting distant reeds or grasses, can be achieved

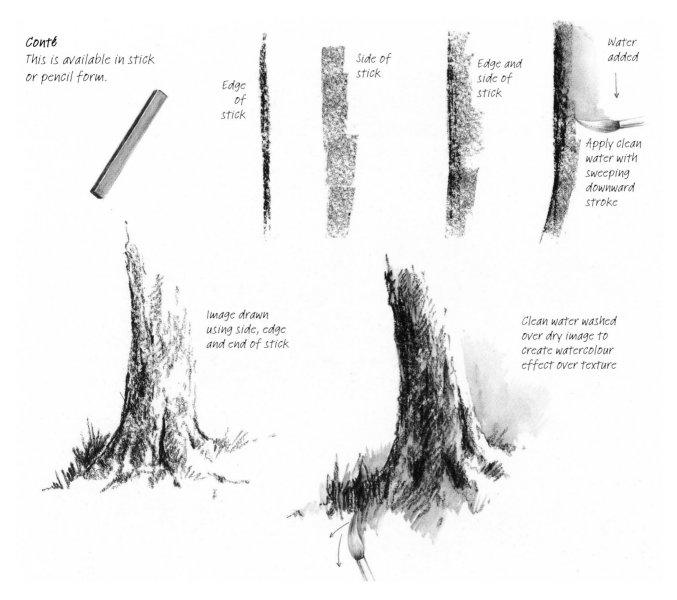

Conté
This is available in stick or pencil form.

Edge of stick

Side of stick

Edge and side of stick

Water added

Apply clean water with sweeping downward stroke

Image drawn using side, edge and end of stick

Clean water washed over dry image to create watercolour effect over texture

Soft charcoal pencil
This medium is very responsive to the application of water. Experiment by drawing on to a wet surface for richer darks.

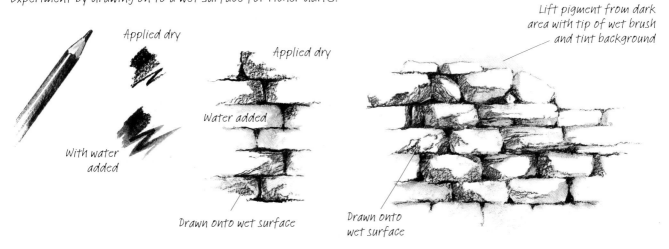

Applied dry

With water added

Applied dry

Water added

Drawn onto wet surface

Lift pigment from dark area with tip of wet brush and tint background

Drawn onto wet surface

Pastels

There is a wide selection of pastel-based products available; for this page, I have concentrated on soft pastel sticks and pastel pencils.

Supports for pastels

All pastels require a surface that has some texture, and are most effective when used on a coloured or tinted ground. Pastel paper, where one side is smoother than the other, is available in assorted colours. Pastel board possesses more texture; as always, try out a variety of supports to find one that suits you.

Pastel sticks

Pastel sticks can be used on their sides for broad strokes, and the edges of the blunt ends provide a crisp line for more detailed areas.

Pastel pencils

Pastel pencils can be used as an individual medium or combined with pastel sticks. Pastel pencils are also very useful for monochrome work, and, being water soluble, can be used alone in this context as well as part of mixed-media techniques.

Contrasts with pastel sticks

Using a black surface allows you to see strong contrasts of pale hues and exciting textures where the ground is visible through lightly applied pastel strokes.

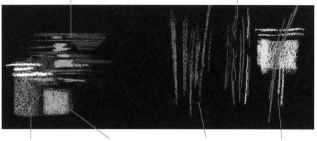

Side dragged horizontally produces wide lines

Edge of blunt end produces finer lines

Side used in a downward movement for area of texture

Reinforcing stroke creates thicker pigment

Side used in up-and-down movement

Combination of strokes

Pastel pencil

Applying a range of greens using short, curved strokes allows the black ground to enhance the image

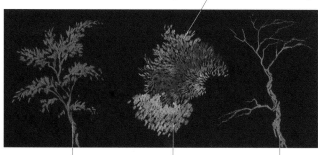

Use one colour to create pale silhouette, concentrating on directional stroke application

Place a light background using a different application of directional strokes

Twisting the pencil produces interesting structures

Bricks with sticks

Using the side of a pastel stick to create a shape such as a brick gives you a base upon which to build other colours and marks.

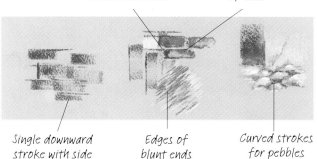

Horizontal movement/ stroke with side

Limited range of hues

Single downward stroke with side

Edges of blunt ends

Curved strokes for pebbles or cobbles

Pencil colouring

Pastel pencils allow you to create both lines and blocks of colour easily by turning them as you work.

Erratic application of pencil creates textured bark effect

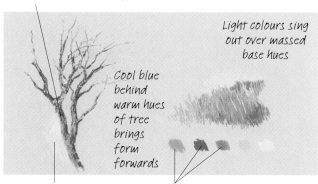

Light colours sing out over massed base hues

Cool blue behind warm hues of tree brings form forwards

Ground colour is integral part of overall impression

Three base colours create a mass upon which other hues can be applied

Pen and Ink

From the very fine nib of a mapping pen to wide italic nibs, there has always been a variety of pen choice. Experiment with as many different pens as possible, using both permanent and water-soluble inks, and vary the surfaces upon which you draw; this will encourage diversity of application and techniques.

Movements and marks

Just as the use of varied pressure of a pencil or brush on paper creates variation and interest of line and tone, so can you do this with a pen. Again, in the same way as pencil and paint react in different ways to different surfaces, so do pens.

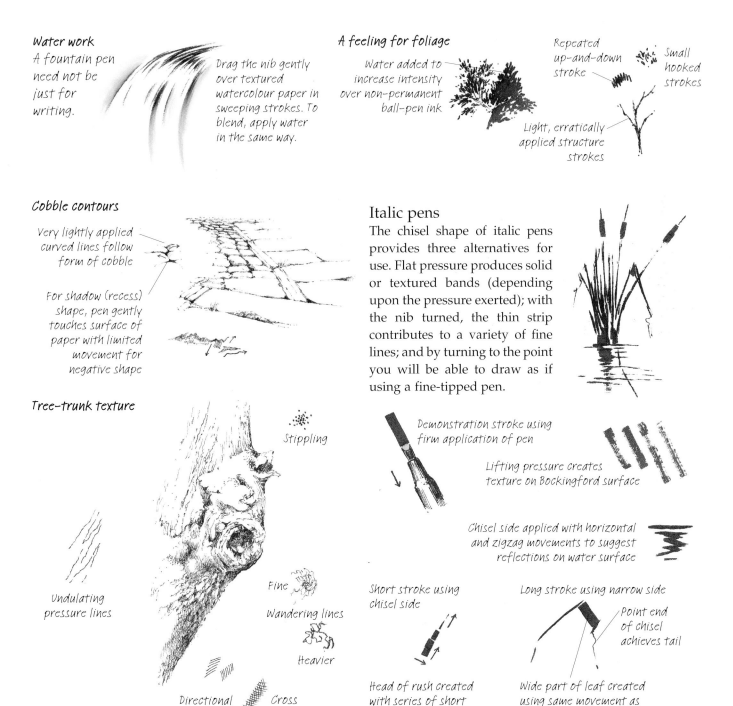

Water work
A fountain pen need not be just for writing.

Drag the nib gently over textured watercolour paper in sweeping strokes. To blend, apply water in the same way.

A feeling for foliage

Water added to increase intensity over non-permanent ball-pen ink

Repeated up-and-down stroke

Small hooked strokes

Light, erratically applied structure strokes

Cobble contours

Very lightly applied curved lines follow form of cobble

For shadow (recess) shape, pen gently touches surface of paper with limited movement for negative shape

Tree-trunk texture

Stippling

Undulating pressure lines

Fine

Wandering lines

Heavier

Directional lines

Cross hatch

Italic pens
The chisel shape of italic pens provides three alternatives for use. Flat pressure produces solid or textured bands (depending upon the pressure exerted); with the nib turned, the thin strip contributes to a variety of fine lines; and by turning to the point you will be able to draw as if using a fine-tipped pen.

Demonstration stroke using firm application of pen

Lifting pressure creates texture on Bockingford surface

Chisel side applied with horizontal and zigzag movements to suggest reflections on water surface

Short stroke using chisel side

Long stroke using narrow side

Point end of chisel achieves tail

Head of rush created with series of short overlapping block strokes

Wide part of leaf created using same movement as demonstration stroke

Exercise in Accuracy

This demonstration is an exercise, a set of mark placings designed to improve your observation skills and drawing ability – where to start and in what sequence to move from one area to another as you piece together the image(s) you have chosen to depict. This way of working may be applied to any subject, and it may be helpful to approach the drawing through a series of check points – they refer to this particular picture, but you can adapt the sequence to your own picture.

- Start with the strongest vertical; a vertical line drawn down the side of a dominant form, or a guideline, can be established vertically as a basis from which to work. In the views here, the strongest vertical is down the shadow side of the distant tower.
- Once the line is drawn, think of it as a drop line and extend it below the base of the tower, down into the water. You can then use it to help position other parts of the picture.
- The next guideline is to be drawn along an important horizontal, in this case the obvious waterline.
- To start relating the shapes below the horizontal line, extend two guidelines from either side of the tower downwards, crossing the horizontal line, and start looking for negative shapes and shapes between.
- Negative shapes are the ones we see between objects. I have indicated (right) a negative shape (yellow area) between two vertical poles and a piece of canvas on a gondola. Between the two poles you can see the water beyond.
- A shape between is the shape drawn on the paper that is between some parts of objects and a guideline. Shown here in green, it helps place objects in relation to each other.

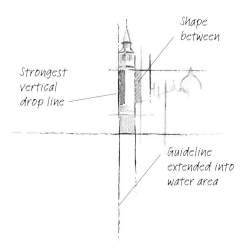

Shape between

Strongest vertical drop line

Guideline extended into water area

Scaffolds

With this method of observation drawing you are erecting a scaffold of structure lines upon which your images may be built. To avoid getting lost among the scaffolding, it is a good idea to tone some areas as solid shapes – in this scene the poles are an obvious choice for this treatment – as well as a few tonal blocks for distant buildings. This will give you points of reference.

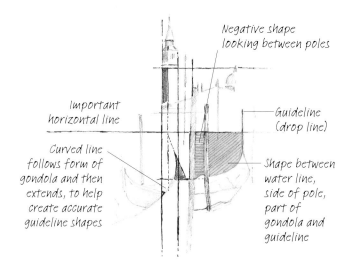

Negative shape looking between poles

Important horizontal line

Curved line follows form of gondola and then extends, to help create accurate guideline shapes

Guideline (drop line)

Shape between water line, side of pole, part of gondola and guideline

Merit points

To encourage enjoyment you can give yourself merit points along the way. On the illustration opposite above I have indicated 'mini merits' and 'mini shapes'. A mini merit is where you recognise a tiny shape between and note it with a view to establishing relationships within your scaffold lines. A merit shape is a larger, more obvious (three-sided) shape, usually with two sides from an object and the third in the form of a guideline.

Contact points

Contact points can be visual – where two objects cross behind or in front of each other visually, although in fact they are some distance apart – or physical, where they do actually touch. I have placed large dots on the illustration opposite above to show some instances.

Look along the relevant guideline between these contact points plus other lines that occur in between, to see how the objects relate using the vertical and horizontal scaffold. You now need to train your eye and practise drawing shapes accurately – squares and rectangles mainly, with curved lines crossing them at certain points – and in this way, you can create your own grid to construct a pictorial composition.

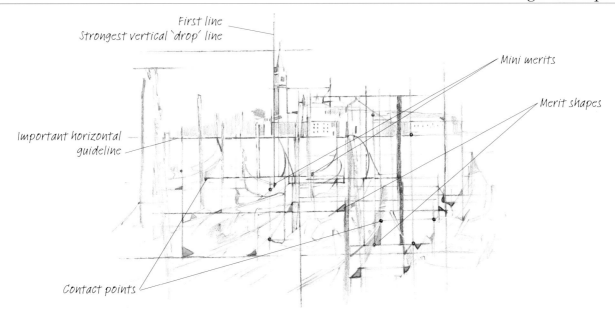

First line
Strongest vertical 'drop' line

Mini merits

Merit shapes

Important horizontal guideline

Contact points

Solving perspective problems

Using guidelines correctly should remove problems with perspective. If every shape and line drawn is in the correct relationship with the others within the basic scaffold, you need only remove the structure lines of the scaffold to have a drawing that works.

Removing the scaffold

Whether placed as part of an accuracy exercise or swiftly positioned to help establish main areas in relation to each other as part of a looser interpretation, guidelines need only be obvious for the initial part of the drawing, where you rely on them for accurately placing the components. If guidelines are drawn lightly, overworking with bolder lines and tones as the drawing progresses

will cause them to become absorbed and finally lost by the time the work is complete.

Alternatively, guidelines can be established boldly on layout or copier paper and corrected or altered repeatedly until you are pleased with their placing. Then it is only a matter of tacking your drawing to a window, placing a clean sheet of paper over the top, and taking off (tracing) the main, important areas onto the new sheet of clean paper, omitting the guidelines. The final stage is to develop your drawing in line and tone, using the lightly traced image on a new sheet of paper.

When you have trained your eye and learnt how to depict shapes between accurately, the perspective within your composition will also be accurate.

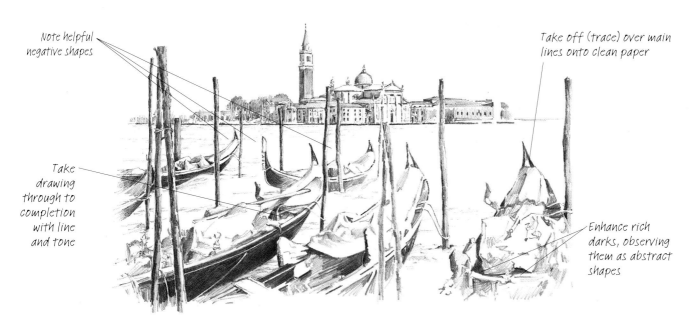

Note helpful negative shapes

Take off (trace) over main lines onto clean paper

Take drawing through to completion with line and tone

Enhance rich darks, observing them as abstract shapes

Watercolour Techniques
Making Marks – Brushstrokes

When practising brushstrokes in watercolour, because the marks are important in these exercises, it is helpful to work either with neutral hues or in monochrome. The marks here demonstrate how to mix useful neutrals.

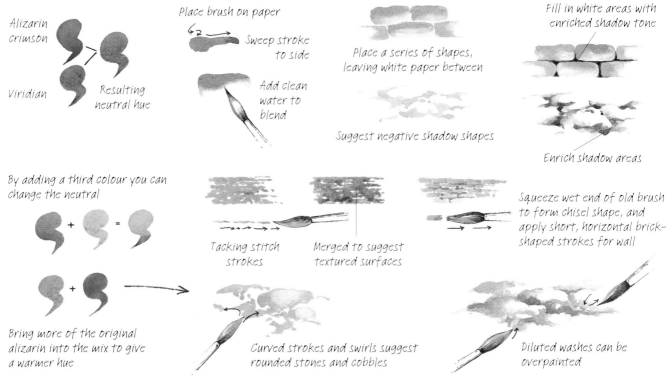

Alizarin crimson

Viridian

Resulting neutral hue

By adding a third colour you can change the neutral

+ =

Bring more of the original alizarin into the mix to give a warmer hue

+ →

Place brush on paper

Sweep stroke to side

Add clean water to blend

Tacking stitch strokes

Merged to suggest textured surfaces

Curved strokes and swirls suggest rounded stones and cobbles

Place a series of shapes, leaving white paper between

Suggest negative shadow shapes

Squeeze wet end of old brush to form chisel shape, and apply short, horizontal brick-shaped strokes for wall

Diluted washes can be overpainted

Fill in white areas with enriched shadow tone

Enrich shadow areas

Foliage impressions

In depicting everything from areas of countryside, through town and village gardens, to city parks and tree-lined avenues, you need to consider how to give the impression of foliage mass or individual leaves.

Demonstrated here is a series of foliage brushstroke movements, shown in relation to the structure of trunks and branches. By working solely in monochrome you will be able to concentrate upon the direction of stroke application and the variations in tone.

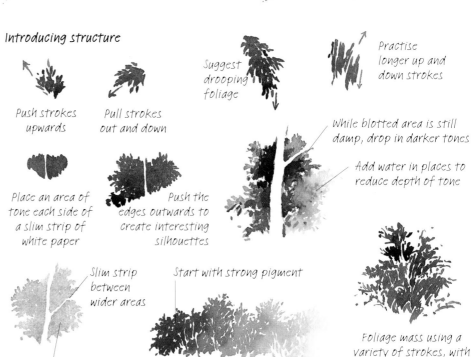

Introducing structure

Push strokes upwards

Pull strokes out and down

Place an area of tone each side of a slim strip of white paper

Push the edges outwards to create interesting silhouettes

Slim strip between wider areas

Blot gently to produce paler tone

Start with strong pigment

Add a little more water to each new area

Suggest drooping foliage

Practise longer up and down strokes

While blotted area is still damp, drop in darker tones

Add water in places to reduce depth of tone

Foliage mass using a variety of strokes, with longer up-and-down movements introducing structure effects

Exercises

The best way to develop drawing and painting skills is to make learning fun, and to create little exercises that you really enjoy.

Sometimes if a painting goes wrong, once you have accepted what has happened you can then play about with it, knowing you cannot spoil what has already gone wrong. This attitude can lead to a new freedom of expression.

It is also possible to play with marks on a clean sheet of paper. This 'play time' is an opportunity to develop knowledge, understanding and, as a result of these, confidence in your art.

Go for a globule

Place a globule of strong pigment mixed with plenty of water

Push the globule upwards and outwards using the tip of your brush

Create interesting and uneven edges to establish a foliage mass silhouette

Gather the globule and pull downwards from the main mass with individual strokes

Mixture should accumulate at base to form reservoir

Increase side of area covered by impression of foliage mass

Add strokes to indicate branches and twigs

Continue downwards with globule

Before the image has dried, blot gently using a scrunched sheet of kitchen roll, pressing lightly and unevenly when you blot. Some areas will blot dry (pale) and others will retain moisture and a darker tone

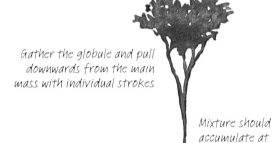

On Rough-surface watercolour paper you can retain control of your globule and need only guide it gently

Retain a strong gradient for the angle of the board

Push globule using tip of brush

Globule viewed from side – note prominence

19

Washes

The examples of washes shown here rely upon the paper being supported at a sufficient angle to allow liquid to form a reservoir at the lower edge of each horizontal stroke in order that it may be taken into the next stroke across. The brush needs to be re-loaded before the reservoir has diminished, to ensure even application and the achievement of a totally flat wash.

Note that it is essential to mix enough water with your pigment to retain fluidity throughout.

Laying a wash

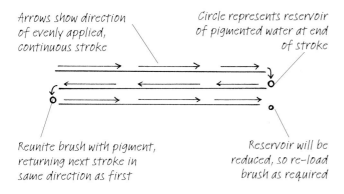

Arrows show direction of evenly applied, continuous stroke

Circle represents reservoir of pigmented water at end of stroke

Reunite brush with pigment, returning next stroke in same direction as first

Reservoir will be reduced, so re-load brush as required

Flat wash

When practising a flat wash, remember to mix sufficient pigment with your water to produce the density of colour required, as colours will appear lighter when dry than when applied. It is also advisable to mix more in your palate than you think you will require, to avoid running out while the wash is being applied.

Laying a wash is a continuous process from which you cannot break off or go back over any area during its application. To do so would prevent it from being a truly flat wash.

When the final horizontal stroke has been placed, lift the remainder of the reservoir by squeezing out your brush and placing it gently along the base of the stroke to absorb excess moisture.

Flat wash

Gradated wash

A gradated wash is achieved by the addition of clean water to each brushstroke of your palette of colour as you progress down the paper.

Gradated wash

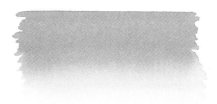

Variegated wash

A variegated wash is achieved by using a number of colours. Where the colours blend into each other, ensure your palette wells contain enough of each different colour before you start, and that the pigment-to-water ratio is correct for your needs.

Variegated wash

Work in the same way as for the gradated wash, but instead of clean water add the next colour

Wash exercise

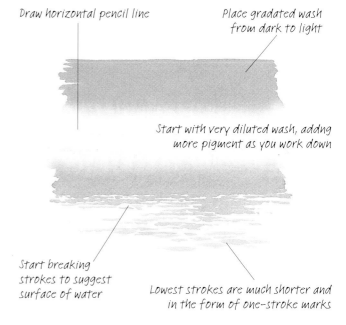

Draw horizontal pencil line

Place gradated wash from dark to light

Start with very diluted wash, adding more pigment as you work down

Start breaking strokes to suggest surface of water

Lowest strokes are much shorter and in the form of one-stroke marks

Blotting Off

Blotting off can be used to achieve and enhance texture, as shown in the foliage exercises, or to remove pigment completely, for example in creating cloud formations.

Surfaces for blotting off

It is important to understand that different effects can be achieved upon different surfaces of watercolour paper, and you should experiment with various papers to note the reactions of the method on a number of surfaces. Some papers are more absorbent than others and may produce problems if blotting off only removes extra moisture, leaving a flat area of tone.

Spontaneity of approach

This method of producing texture requires a swiftness of execution that allows the image to retain enough moisture to ensure that blotting with crumpled kitchen paper produces some areas that are not completely covered. The effect relies upon the darker pigment that is dropped in working its way and bleeding into and along some still-damp areas.

Experiment with mark-making in the form of a foliage mass on a barely absorbent surface

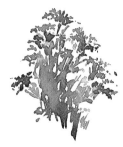

Working quickly and freely, create interesting arrangement of marks to suggest foliage

Immediately drop in some dark pigment to spread into still-damp areas

Gently blot whole area while still quite wet

As the image dries, enhance the darks while retaining the lighter areas that have already dried

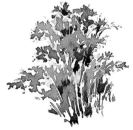

Blotting for clouds

To achieve untextured images, the illustration demonstrates how to create cloud formations within a flat wash.

While a flat wash was still wet, a dampened, screwed-up tissue was firmly pressed onto the surface to absorb as much pigment as possible

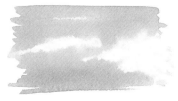

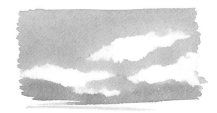

For crisper, clearer images, a dry tissue was pressed very firmly on to the wet paper

Lifting off for highlights

To achieve the effect of highlights by lifting off, you need plenty of pigment in your mixture, as the method relies upon pigment being absorbed into the hairs of a damp brush placed upon a wet surface. If the pigment does dry, apply a damp brush to the paint and agitate the hairs to disturb the pigment, prior to either blotting or re-applying more clean water.

Highlighting a dry image

Agitate the surface with a brush that has been dipped in clean water to lift off some of the pigment and create a highlighted area

Creating highlights on a damp surface

When stonework is completely dry, fill in between stones with dark colour to suggest shadow recess lines and shadow shapes

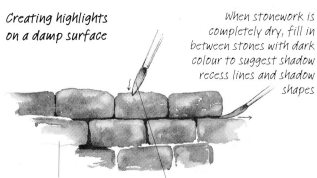

Loosely paint series of brick-shaped stones using plenty of pigmented water

With brush dipped into clean water and squeezed dry, place hairs against wet paint to lift off moisture and absorb pigment

21

Wet into Wet

Two ways in which the wet-into-wet method may be approached are demonstrated here – by working on a wet or dampened surface; and by dropping in additional tone or colour on a wet or damp painted surface, such as within an image or background area.

Working on a damp surface

A simple example of this method is to paint a sky by dampening the paper surface with clean water before painting blue areas, retaining white paper shapes that indicate cloud formations.

A more complex example of this method is shown in the tree trunk against foliage. Although this painting is in monochrome (a mix of blue and brown to create a neutral hue), there has been some colour separation, which enhances the effect.

Simple sky

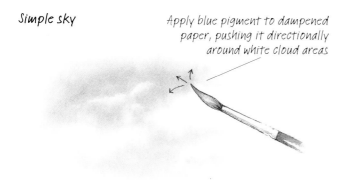

Apply blue pigment to dampened paper, pushing it directionally around white cloud areas

Tree trunk against foliage

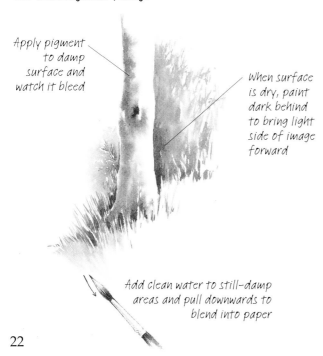

Apply pigment to damp surface and watch it bleed

When surface is dry, paint dark behind to bring light side of image forward

Add clean water to still-damp areas and pull downwards to blend into paper

Dropping in

A quick and freely applied image can be enhanced by dropping in additional colours/tones while still wet to enhance the dark, shadow areas. This is useful to achieve richness in shadow recesses at the base of a form.

Direction of movement

Work with your board angled to encourage pigment to flow downwards at all times

Create impressions of mass and structure as you work downwards

Mix plenty of water with pigment to create reservoir of liquid

Darkest tones will accumulate at base

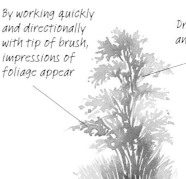

By working quickly and directionally with tip of brush, impressions of foliage appear

Drop in darker tones and hues while image is still damp

Note separation of colour

Richest darks provide strong contrasts against untouched white paper as they flow down

Exercise

The image at left was made by drawing a quick impression with a brush using clean water only. To indicate where the water has been applied, angle the paper away from you from time to time so you can see the sheen upon the paper's surface. Gently drop in pigment against the wet areas only, from where it swiftly spreads outwards into other wet areas so that pigmented shapes appear.

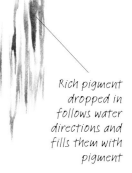

Clean water applied to paper with swift up and down movements

Rich pigment dropped in follows water directions and fills them with pigment

Drybrush and Wet on Dry

Drybrush

When the pigment on a brush has almost dried before it is applied to the paper's surface, it produces a textured effect. Dragging a brush prepared in this way across a flat surface can create interesting treatments for impressions of sparkling water and texture on wood and stone.

Laying a flat texture

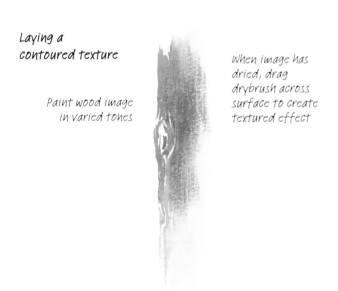

Place small amount of pigment and water in palette

Press brush into pigment, encouraging hairs to flatten

Drag pigmented, flattened hairs swiftly across textured surface of the watercolour paper

Laying a contoured texture

Paint wood image in varied tones

When image has dried, drag drybrush across surface to create textured effect

Wet on dry

A good way to practise this approach is using monochrome. By working onto a background area that has been painted and allowed to dry, using wet pigment as an overlay of shapes, you can suggest depth with a variety of tones.

Texture on stone

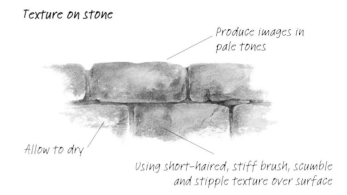

Produce images in pale tones

Allow to dry

Using short-haired, stiff brush, scumble and stipple texture over surface

Combined methods

This illustration demonstrates both methods combined. A stone statue with a textured surface was depicted using the drybrush treatment, and was placed in front of a foliage background depicted in monochrome using the wet-on-dry method.

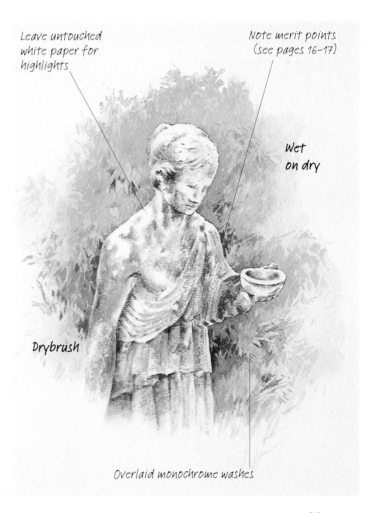

Leave untouched white paper for highlights

Note merit points (see pages 16–17)

Wet on dry

Drybrush

Overlaid monochrome washes

Resists

A resist method is when part of the paper's surface is coated with a substance that prevents any overlaid washes of pigment reaching the paper underneath. But, the resist methods shown here can sometimes create problems as well as solving them.

Candle wax

Applying candle wax to the paper causes the surface to resist application of pigment to the extent that a textured effect is achieved. It is ideal for use in the depiction of sparkling water and many other effects, and the method is shown here as an aid to achieving the impression of a light snow covering on an otherwise bare mountain.

With a bulky mark-making object such as a candle you may experience difficulty at times when trying to depict delicate shapes, and a solution using a sharp craft knife is included in the illustration.

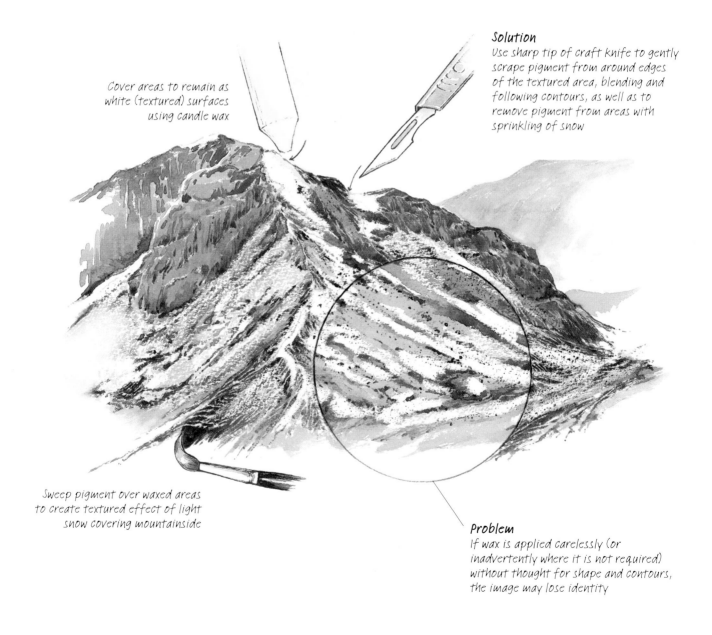

Cover areas to remain as white (textured) surfaces using candle wax

Solution
Use sharp tip of craft knife to gently scrape pigment from around edges of the textured area, blending and following contours, as well as to remove pigment from areas with sprinkling of snow

Sweep pigment over waxed areas to create textured effect of light snow covering mountainside

Problem
If wax is applied carelessly (or inadvertently where it is not required) without thought for shape and contours, the image may lose identity

Masking fluid

This liquid, which is rubbery when dry, is applied to the paper using an old brush, a pen nib or the special applicator attached to a plastic bottle containing the fluid. When the paint has thoroughly dried, you can remove the rubbery substance gently by passing a finger across the surface or, in some instances, actually pulling it away. It is not always easy to achieve fine lines with masking fluid, and the illustration demonstrates the kind of problem that can occur, and how to solve it.

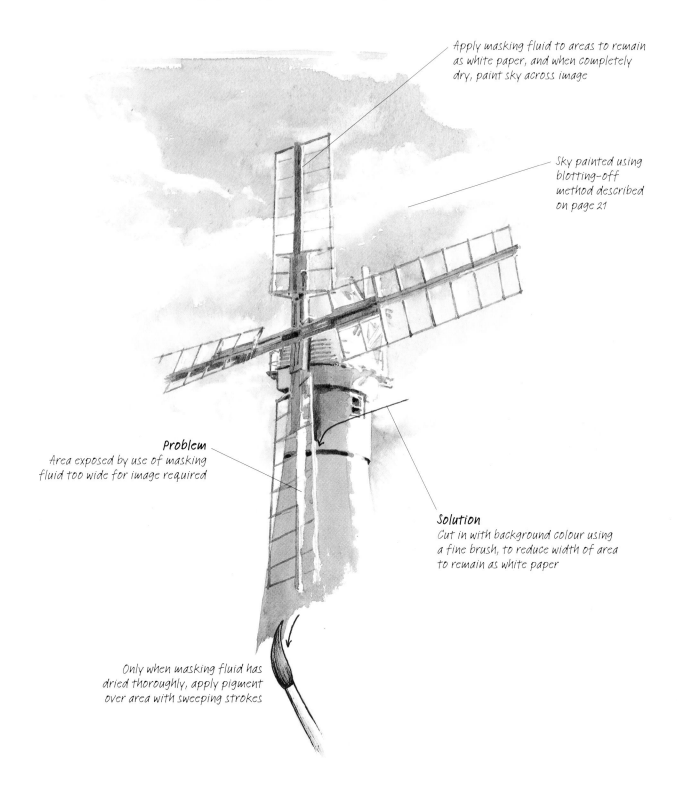

Apply masking fluid to areas to remain as white paper, and when completely dry, paint sky across image

Sky painted using blotting-off method described on page 21

Problem
Area exposed by use of masking fluid too wide for image required

Solution
Cut in with background colour using a fine brush, to reduce width of area to remain as white paper

Only when masking fluid has dried thoroughly, apply pigment over area with sweeping strokes

Watercolour Pencils

Watercolour pencils are a very versatile medium: there are numerous ways in which they can be used upon tinted or white paper surfaces – either on their own or combined with other mediums.

Working on a tinted ground

A straightforward application of watercolour pencils is to draw the image onto watercolour paper and then gently disturb and blend the pigment with a little clean water on the tip of a brush. This effect is enhanced by working on a tinted surface, and can look very effective executed in monochrome. Bockingford tinted papers are ideal for this method, and were used for the exercises on this page.

Choose a coloured pencil that complements the tint of the paper and subject, and if fine detail is important for the overall effect, make sure you retain a sharp point on the pencil throughout the drawing.

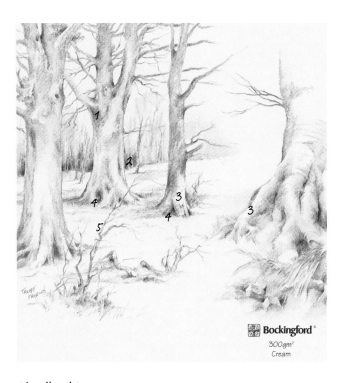

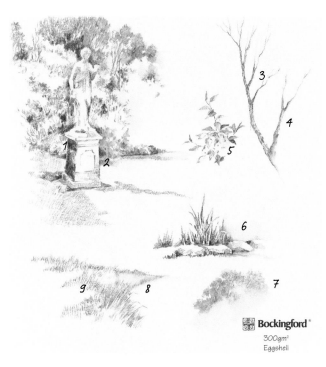

Woodland trees

The images on the left show the spacing of the dominant trees in the foreground, with other trees gathered close together in the background. On the right is a detailed close-up study showing tree roots, rocks and grasses.

1 Dark shadow area in front of light background

2 Darks behind light form

3 Leave some areas of untouched paper

4 Create rich dark areas of contrast

5 Superimpose delicate drawing in foreground to help create feeling of distance

Garden setting

The solid stone statue contrasts with a more delicate depiction of background foliage. The other little detail studies give an opportunity for close observation and experimentation with texture and water application.

1 Dark in front of lighter background

2 Dark background behind light form

3 Dry on dry

4 Blended with water

5 Detailed interpretation of individually drawn/toned leaves

6 Study depicting contrasts of tone, shape and texture

7 Adding water to foliage mass

8 Water gently brushed over surface

9 Dry on dry

Exercises

An exciting way to depict interesting textures on some rough surfaces, and to conserve your pencils, is to sharpen the pencils onto dampened paper.

Wet an area with a brush of sufficient size to hold enough water for quick coverage. Sharpen your pencil – being careful not to encroach upon the wood – onto the wet surface. Watch the pigment spread, then with either the tip of your pencil (where lines drawn upon contact will bleed) or a fine-tipped brush, guide the resulting marks/textures into the desired shapes. 'Happy accidents' can easily occur with this method, and it is also possible to blend pale washes of colour over the textured areas after the area has dried.

To create pale washes in your palette, sharpen the chosen coloured pencil into the well, add water, and mix to achieve your wash.

Playing with texture

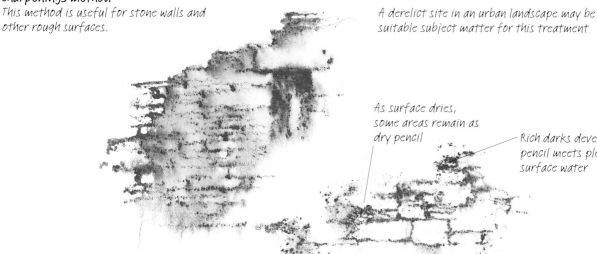

Suitable effect for tree foliage

Wet paper, place tip of pencil upon wet surface and lift – repeat over area to be covered

Blending occurs where the pencil meets the very wet surface

Sharpenings method

This method is useful for stone walls and other rough surfaces.

A derelict site in an urban landscape may be suitable subject matter for this treatment

As surface dries, some areas remain as dry pencil

Rich darks develop where pencil meets plenty of surface water

Pencil sharpenings on wet surface

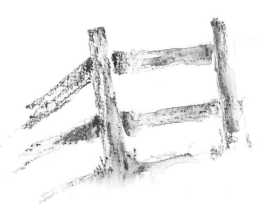

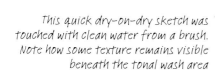

This quick dry-on-dry sketch was touched with clean water from a brush. Note how some texture remains visible beneath the tonal wash area

Mixed-media Techniques

Introducing Gouache

In addition to being enjoyable as a medium in its own right, gouache, or body colour, can also be used effectively with other mediums.

Unlike pencil and watercolour techniques – where the white paper often plays an important part in the depiction of highlights and white areas – gouache benefits from being used on a tinted or coloured ground, which means that white and light pigments create exciting contrasts when applied on the darker hues.

Extending the drybrush technique (see page 23) into gouache on a dark support produces interesting textures when combined with normal paint coverage. When used to depict a variety of textured surfaces, this combination of techniques, incorporating the hue of the support as part of the method, can be used with or without the addition of other mediums.

Gouache on a coloured support

Here, an old boat, which could be part of an inland scene as well as by the coast, is used to demonstrate the use of gouache on a coloured support. This is an opportunity to add gouache to other water-based mediums.

Working on 600gsm (300lb) Saunders Waterford Rough paper, I applied a wash of dark olive watercolour and allowed it to dry before drawing the boat using zinc white gouache with a fine pointed brush. For the white planks I used a small flat brush.

For the build-up of colour a limited palette, of Winsor blue, Winsor green, French ultramarine, yellow ochre and burnt sienna, was mixed together as washes or with white, to cover the coloured ground. This support colour plays an important part in unifying (harmonising) the hues.

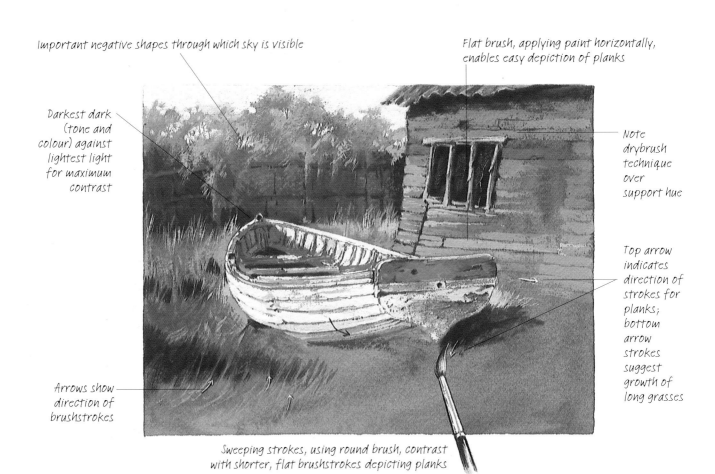

Important negative shapes through which sky is visible

Flat brush, applying paint horizontally, enables easy depiction of planks

Darkest dark (tone and colour) against lightest light for maximum contrast

Note drybrush technique over support hue

Top arrow indicates direction of strokes for planks; bottom arrow strokes suggest growth of long grasses

Arrows show direction of brushstrokes

Sweeping strokes, using round brush, contrast with shorter, flat brushstrokes depicting planks

Gouache with charcoal pencil

There are many coloured supports available that are suitable for use with gouache – here, I used a grey-tinted Bockingford 300gsm (140lb) paper.

Trees provide interesting subject matter for a delicate approach using gouache, where texture and linear work combine with looser brushwork that requires the addition of more water than the gouache method shown opposite. Where the texture on the boat was achieved by the build-up of dryer paint over the coloured ground, here it is the charcoal drawing, beneath a watery application of paint, that produces the effects.

The use of a soft charcoal pencil necessitated the application of a layer of fixative prior to painting, as well as during the painting process, when more drawing was used to enhance certain areas. The subtle tint of the ground was used to enhance the effect by being retained within the painting. The drawing was made using minimum pressure and with frequent sharpening of the pencil.

Lighter hues in gouache applied over drawn and painted branches to bring images forward

Initial drawing sketched freely to establish positions and then sprayed with fixative

Grey-tinted paper helps to achieve textured effect

Blue sky painted in gouache between drawn branches

Images of distant trees viewed through negative shapes

Colour applied loosely over fixed charcoal drawing – fixing allows charcoal to remain visible through some coats of paint

Areas of textured underdrawing show through thin layer of paint

Bluebell leaves at base of tree sketched freely using soft charcoal pencil

Introducing Ink

Ink is another medium that is very effective when used alone on various paper surfaces, and the variety of techniques that can be employed with it make it a firm favourite – whether using a tight, controlled approach, a looser style or applying it very freely.

Ink and paint

Combining ink with other mediums adds to the delights of penwork, and two options are shown here within one image, to offer an interesting comparison. Gouache is used on the left, so you can compare the lighter approach of a watercolour tint on the right.

Derelict barns that lean and crumble give the artist an opportunity to explore textured surfaces, which can be effectively achieved with ink on watercolour paper and when ink is used over paint.

The whole image was drawn using a fine 0.1 drawing pen on Saunders Waterford 180gsm (90lb) Rough paper.

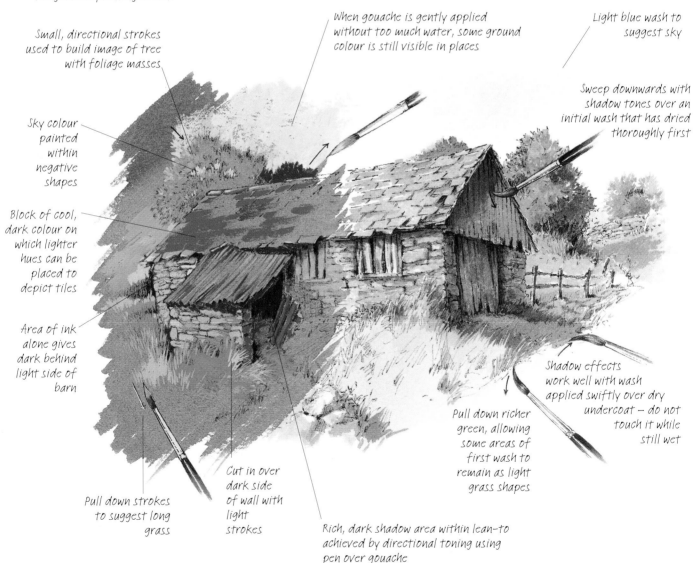

A wash of medium- to dark-toned neutral watercolour was placed over the drawn image. The inkwork is clearly visible through the paint, which is the tinted ground upon which the gouache painting is built

Small, directional strokes used to build image of tree with foliage masses

When gouache is gently applied without too much water, some ground colour is still visible in places

Light blue wash to suggest sky

Sky colour painted within negative shapes

Sweep downwards with shadow tones over an initial wash that has dried thoroughly first

Block of cool, dark colour on which lighter hues can be placed to depict tiles

Area of ink alone gives dark behind light side of barn

Shadow effects work well with wash applied swiftly over dry undercoat – do not touch it while still wet

Pull down richer green, allowing some areas of first wash to remain as light grass shapes

Pull down strokes to suggest long grass

Cut in over dark side of wall with light strokes

Rich, dark shadow area within lean-to achieved by directional toning using pen over gouache

Choices for Mixed Media

Apart from the combinations shown on the previous pages, there are numerous others you could try, including watercolour pencils with ink, watercolour pencils on a watercolour-tinted support, pastel pencils and water-colour, graphite pencils with watercolour, ink and char-coal, and many more. When used in the same way as watercolour washes, acrylic paint combines well with ink, charcoal, and so on.

For these learning exercises, you can also experiment with unusual supports: here, I used ordinary brown wrapping paper, matt side up, where the vertical lines of the paper can help with depicting certain subjects.

Architectural features

A fluted pillar is made easier to represent if you use the vertical lines in the paper as a guide. For this example I mixed three different media: a 0.1 fine drawing pen, using burnt sienna ink for the initial drawing, gouache – as a wash to indicate a pale blue sky as background, and the drybrush method, respectively – and pastel pencils for blocking in some colour.

Pastel pencils work well on the surface of wrapping paper, as does ink, and the strong contrasts of the highlighted and light-coloured areas can produce some interesting effects.

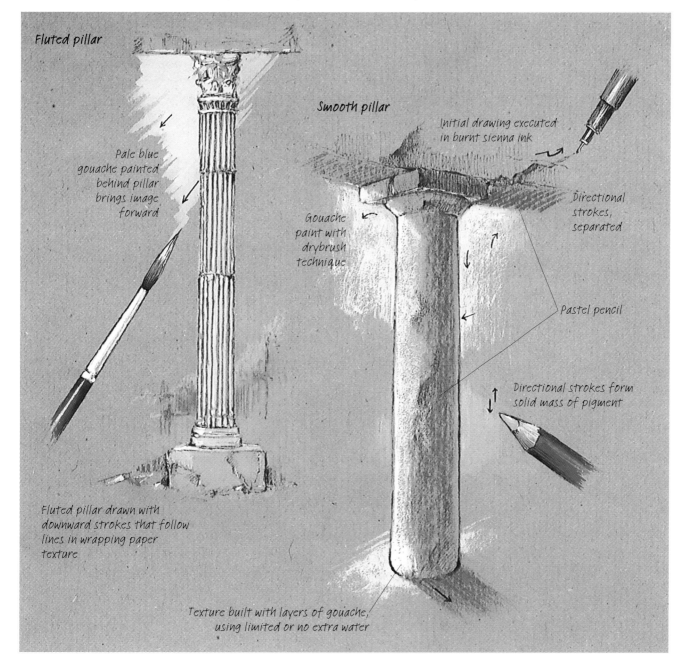

Fluted pillar

Pale blue gouache painted behind pillar brings image forward

Fluted pillar drawn with downward strokes that follow lines in wrapping paper texture

Smooth pillar

Initial drawing executed in burnt sienna ink

Directional strokes, separated

Gouache paint with drybrush technique

Pastel pencil

Directional strokes form solid mass of pigment

Texture built with layers of gouache, using limited or no extra water

Correcting and Repairing Mistakes

Correcting pencil and charcoal

Apart from using a rubber to erase errors, there are other ways of correcting mistakes.

When working on a drawing that requires the surface to remain pristine for final presentation, it is advisable to avoid mistakes by careful pre-planning and tentative application of the drawing material in the first stages. You can then build up the images slowly and with great care, gently erasing errors as they occur and reinforcing the drawing in controlled layers.

For bold, spontaneous work and freely applied sketched images, there are other options where even the methods by which drawings or sketches are altered and corrected become part of the work itself and enhance its development. For any delicate and detailed work, the importance of preliminary, pre-planning stages cannot be over-stressed. The exercise in accuracy (see pages 16–17) should help with this approach.

Freely applied pencil and charcoal

When mistakes occur in pencil and charcoal work, as well as in mixed-media techniques, the two methods of correction shown here are blocking out the area to be corrected using white paint, and cutting or tearing a new piece of paper to be taped in place over the error, or from the back of the paper if the area of error has itself been cut or torn out. It's best to try these methods out on scrap paper first.

Blocking with white paint

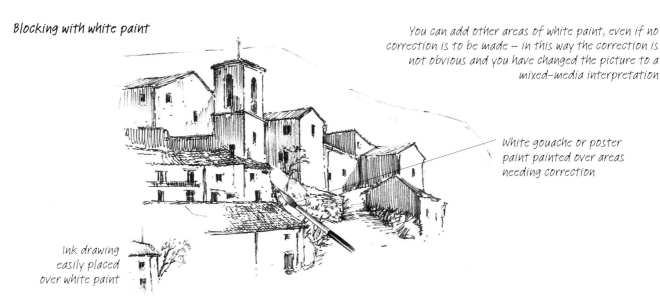

You can add other areas of white paint, even if no correction is to be made – in this way the correction is not obvious and you have changed the picture to a mixed-media interpretation

White gouache or poster paint painted over areas needing correction

Ink drawing easily placed over white paint

Cutting or tearing paper

Sometimes the shape of the new piece of paper can be cut to fit between areas of drawing where lines around forms coincide with the edges of the paper shape. The correction paper will then not appear too obvious

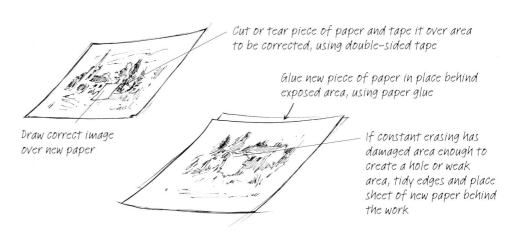

Cut or tear piece of paper and tape it over area to be corrected, using double-sided tape

Glue new piece of paper in place behind exposed area, using paper glue

Draw correct image over new paper

If constant erasing has damaged area enough to create a hole or weak area, tidy edges and place sheet of new paper behind the work

Repairing mistakes in watercolour

When using heavyweight watercolour paper, some mistakes are easy to repair using the following methods.

Sponging off

Gently applying a sponge soaked in clean water to the paper to remove most of the offending pigment (unless it is a strong staining colour) allows you to re-paint when the area has dried. Sometimes gently agitating the pigment using a brush containing clean water can also achieve this effect.

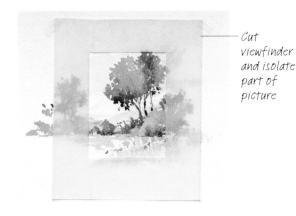

Cut viewfinder and isolate part of picture

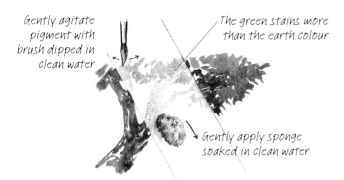

Gently agitate pigment with brush dipped in clean water

The green stains more than the earth colour

Gently apply sponge soaked in clean water

Scraping off

Heavier papers permit you to gently lift the unwanted pigment from the surface by scraping or scratching with a sharp craft knife. However, once the paper has been affected by this method it might not always be possible to add more pigment over the area successfully. Practise the method as an exercise to understand its limitations.

Developing details

When drawing a sketch from life and limitations of time, weather or comfort inhibit your interpretation, it is worthwhile sketching a few details of some of the confused areas, using the space around the main image.

Sketchbook work is a valuable learning experience and teaches you to be observant as well as encouraging the development of drawing skills. We do not always produce sketches with a view to turning them into paintings at a later date, but when areas of a sketch become confused, it is a good idea to re-draw around the main image in the form of details.

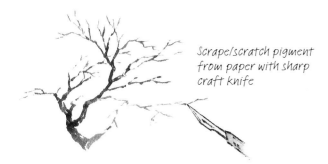

Scrape/scratch pigment from paper with sharp craft knife

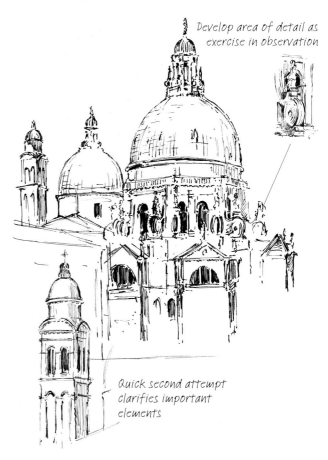

Develop area of detail as exercise in observation

Quick second attempt clarifies important elements

Rescue methods

If the composition of your drawing or painting is not developing to your satisfaction, cut a viewfinder to suitable proportions and isolate a part of the picture with which you are pleased. This area can then be cut out and mounted, and the unwanted pieces can be discarded.

Whether it is a drawing or a painting that is not progressing in the way you anticipate, it is worth considering the option of turning it into a mixed-media work in order to preserve and develop it.

Perspective in Composition

Composing a picture involves numerous considerations, among them placing a focal point, guiding the observer's eye through the picture to maintain interest, juxtaposing shapes, using contrasts (of shape as well as tone), what to include and what to leave out (see pages 36–37) and creating a feeling of movement. This last does not refer to just obvious movement – for example, a waterfall – but to movement of the observer's eye through and within the picture, rather than using perspective lines that cut through the composition from one side to the other.

The way a picture is divided into areas of sky and foreground (a third of one against two-thirds of the other works well), and placing the components are two other important factors; but we shall deal with perspective first.

Perspective in buildings

This diagram covers some of the straightforward aspects of perspective lines used on a building where parts of two sides are visible. Taking a strong horizontal line through at eye level, you can see how the lines converge at two separate vanishing points.

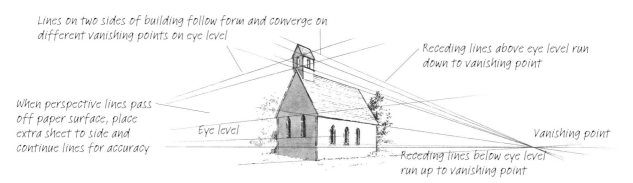

Lines on two sides of building follow form and converge on different vanishing points on eye level

When perspective lines pass off paper surface, place extra sheet to side and continue lines for accuracy

Eye level

Receding lines above eye level run down to vanishing point

Vanishing point

Receding lines below eye level run up to vanishing point

Perspective relationships

This illustration works towards considerations of pictorial composition involving elements at the outer edges of the picture. The relationship of a strong vertical tree formation against the horizontal rectangle of a boat seen as a perspective angle, and a semicircular form of a little bridge in the distance, provides interesting contrasts of shape that are the essence of successful composition.

You do, however, need to consider the format carefully, whether it is to be viewed within a landscape or portrait presentation. The subject of this sketch is suitable for either format.

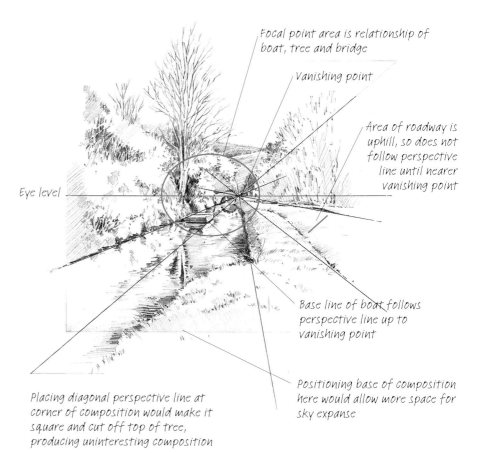

Focal point area is relationship of boat, tree and bridge

Vanishing point

Area of roadway is uphill, so does not follow perspective line until nearer vanishing point

Eye level

Base line of boat follows perspective line up to vanishing point

Positioning base of composition here would allow more space for sky expanse

Placing diagonal perspective line at corner of composition would make it square and cut off top of tree, producing uninteresting composition

Thumbnail sketches

Drawing thumbnail sketches is one of the best ways to plan your compositions. They are quick to produce due to their size – the originals are actually about 63 x 88mm (2½ x 3½in) – which will enable you to work out areas of contrast, tone, form and movement.

Many beginners do not feel the necessity to avail themselves of this introduction to their final composition. For this reason, the series of sketches here should encourage experimentation with this useful and essential stage.

Combining observation methods

After creating a series of thumbnail sketches, you may find on drawing an enlarged image on another sheet of paper, that you are experiencing doubts concerning the accuracy of the perspective. In this case it is a good idea to place a sheet of tracing paper over your drawing and add perspective lines in pencil to establish your accuracy.

You can enlarge your sketch (making a few alterations as necessary) by copying it to fit a larger sheet of paper, or, if more accuracy is required, squaring up. You can even enlarge from your small sketch using a photocopier for convenience and then using tracing paper or the window method (see page 17).

Using the guidelines method illustrated on pages 16–17 also reduces the possibility of perspective problems.

Image placing
This sketch shows how easy it is to fall into the trap of placing the focal point centrally.

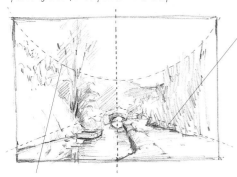

Observer's eye taken into and straight through picture, rather than being encouraged to wander through composition

Note semicircular feel to placing of tree formations

Adjusting image placing

Void is unsatisfactory central area

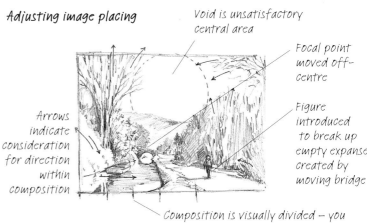

Focal point moved off-centre

Arrows indicate consideration for direction within composition

Figure introduced to break up empty expanse created by moving bridge

Composition is visually divided – you need to decide if you are happy with this type of development when it occurs

Looking for shapes

More interesting area of sky

Circle and diamond relationship

Suggestion of another path leading into picture

Reflections, shadows and open areas determine visual shapes created

Viewfinder image diagram

Note some of the abstract shapes created within the composition

Alternative view
Using a viewfinder concentrates your attention on a particular area, rather than taking in too much of the view at one time

Small area of sky left as simple, light area, contrasting with busy foliage areas

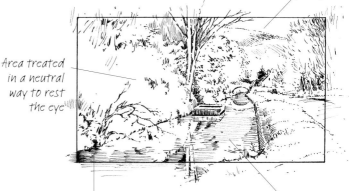

Area treated in a neutral way to rest the eye

Interesting tonal contrasts placed effectively within mount

Small reflection of sky in contrast to darker areas of water surface

Editing In and Out

Artist's licence

Creating a pictorial composition is more involved than simply choosing a viewpoint and, using a viewfinder, selecting an area on which to concentrate.

The term 'artist's licence', used literally, means that you can choose to disregard conventions for effect – to the extent that you are free to do as you wish with the content of your pictorial compositions. Alternatively, you can interpret it in another way by adding content or taking objects or areas out of the view, in order to compose a better picture. These pages show examples of editing in and editing out.

Editing in

This tranquil scene provides a pleasing composition, with an interesting building, the pattern of a rotting wooden construction in the foreground and a variety of textures in the relationships of building, foliage areas, sloping ground and water. The two boats add interest in the middle ground, but the foreground is empty.

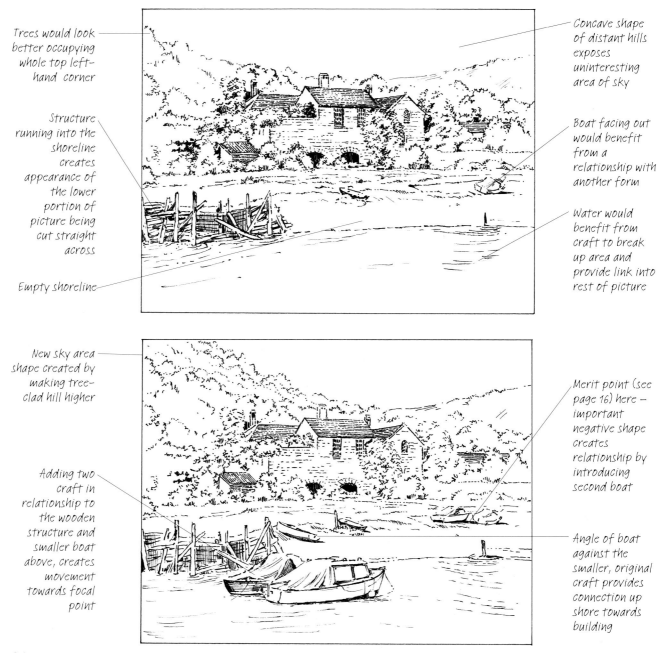

Trees would look better occupying whole top left-hand corner

Structure running into the shoreline creates appearance of the lower portion of picture being cut straight across

Empty shoreline

Concave shape of distant hills exposes uninteresting area of sky

Boat facing out would benefit from a relationship with another form

Water would benefit from craft to break up area and provide link into rest of picture

New sky area shape created by making tree-clad hill higher

Adding two craft in relationship to the wooden structure and smaller boat above, creates movement towards focal point

Merit point (see page 16) here – important negative shape creates relationship by introducing second boat

Angle of boat against the smaller, original craft provides connection up shore towards building

Editing out

This more complex angle, looking down upon a row of cottages and featuring a tree-clad hillside with more buildings above, requires a different set of considerations.

Using a viewfinder, as with the scene on page 35, to isolate two or three cottages, may be the answer to this overcrowded landscape. You can, therefore, edit out certain aspects to simplify the view.

This quick pen and ink layout shows positions of all buildings seen in the view

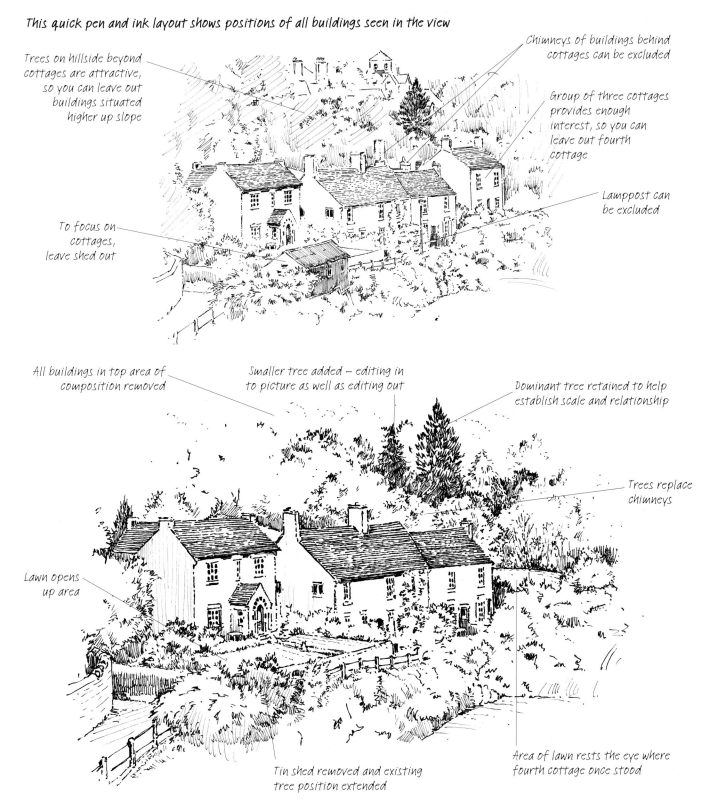

Trees on hillside beyond cottages are attractive, so you can leave out buildings situated higher up slope

Chimneys of buildings behind cottages can be excluded

Group of three cottages provides enough interest, so you can leave out fourth cottage

Lamppost can be excluded

To focus on cottages, leave shed out

All buildings in top area of composition removed

Smaller tree added – editing in to picture as well as editing out

Dominant tree retained to help establish scale and relationship

Trees replace chimneys

Lawn opens up area

Area of lawn rests the eye where fourth cottage once stood

Tin shed removed and existing tree position extended

37

Tone

In a graphite pencil drawing, tone is seen as shades of grey between black and white; in coloured media, tone also refers to the lightness or darkness of colours.

The exercise on this page uses two colours to depict a foliage-clad structure that demonstrates the tonal range for each colour. Sepia and raw umber were mixed in a palette to produce the hue for stonework, while olive green for the foliage was taken straight from the pan.

On the opposite page are examples of working in monochrome. For the exercise on this page I used both the sepia mix and the olive green for monochrome studies that work together to produce a two-coloured image. Blue sky was added so that the paler tones at the top of the tower were clearly visible. The sepia mix and the green are kept separate, showing a complete range of tones for each, yet never mixing the two.

Before you start the exercise, make a tonal scale for each colour and experiment with the range of tones in a stonework area and foliage mass, respectively, to practise achieving a comprehensive range of tones.

Making a tonal scale

Draw two parallel lines with a pencil for each colour. Mix the darkest hue first and paint a block of colour between the lines. Allow to dry before placing the next block. You will need to dilute the mix with a little clean water before each application until you blend the palest tone into the white paper for the last (eighth) block.

Practising tone

Using line, tone and texture, create a small area that resembles the palest expanse of stonework or foliage. When this has dried, add the next range of tones, making sure to include some areas that are as dark as the darkest tone on your scale.

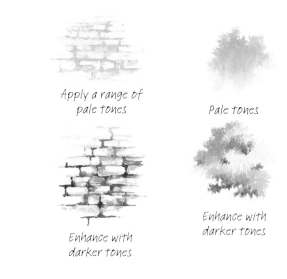

Apply a range of pale tones

Pale tones

Enhance with darker tones

Enhance with darker tones

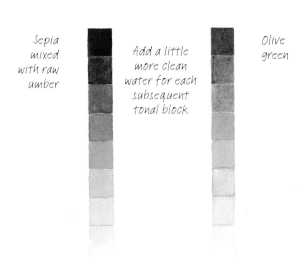

Sepia mixed with raw umber

Add a little more clean water for each subsequent tonal block

Olive green

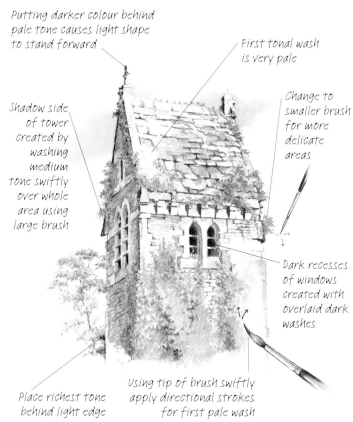

Putting darker colour behind pale tone causes light shape to stand forward

First tonal wash is very pale

Change to smaller brush for more delicate areas

Shadow side of tower created by washing medium tone swiftly over whole area using large brush

Dark recesses of windows created with overlaid dark washes

Place richest tone behind light edge

Using tip of brush swiftly apply directional strokes for first pale wash

Working in Monochrome

Dry on dry

Monochrome, the use of one colour only, can be enhanced by working on a tinted ground. Even a simple coloured crayon can produce some exciting results when used on a tinted paper of similar hue.

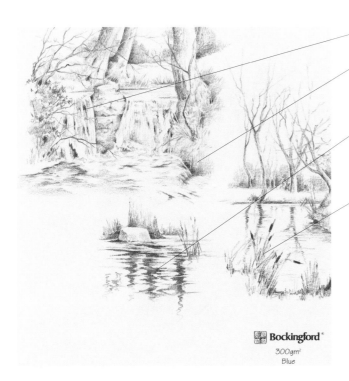

Bockingford®
300gm²
Blue

Water movement in monochrome

These three separate coloured pencil studies show how falling water, disturbed surface and reflections, all produce a range of tones and textures that are enhanced by being depicted in one colour only.

Note rich dark areas between curtains of falling water

Pleasing textures created by using pencil on tinted watercolour paper

Strong contrasts seen in reflections on disturbed surface

Variety of texture and tone

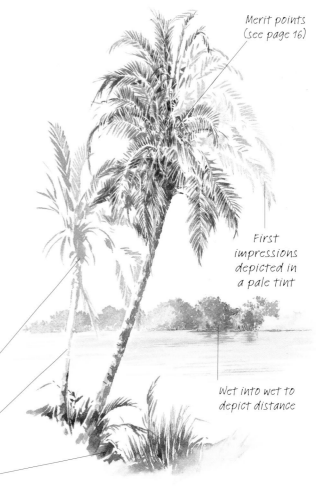

Merit points (see page 16)

First impressions depicted in a pale tint

Wet into wet to depict distance

Wet on dry and wet into wet

Wet into wet (see page 22) is ideal for depicting distance, and works well with wet on dry, which gives crisp foreground shapes. Both methods are combined in this study of palm trees. I used the same mix as for the stonework on the opposite page – sepia and raw umber – but with a different ration: raw umber is the predominant colour in this mix, producing a pleasant monochrome colour that matches the tranquillity of the waterside scene.

Look for tonal shapes upon which to build

Leave light areas as white paper

Wet on dry in foreground to produce crisp contrasts

Colour

Colour in your paintings will help you express mood and atmosphere, and the mixing of colours should be a considered activity, rather than a random one.

Your choice of colours, and how many you consider necessary for use in a particular painting, will benefit from acquired knowledge and understanding of colour. The best way to gain both of these is through exercises and experimentation, and, like any learning experience, this can be enhanced if there is an element of fun.

Colour wheels

The basic colour wheel contains the three primary colours – red, blue and yellow – with their secondaries of purple, green and orange. The tonal colour wheel above far right demonstrates a gradation towards the central area to show the relationship of the paler hues.

Balloon into colour!

Because there are no reds, blues or yellows that are actually primary – instead, there are warm and cool reds, blues and yellows – I have created a colour balloon to help you understand the differences.

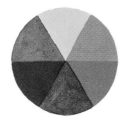

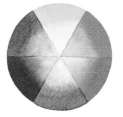

Basic colour wheel *Tonal colour wheel*

The top area of the balloon contains the cool primaries and their secondaries, while the lower part consists of the warmer hues. Imagine that there is cool air above the balloon (cool colours) and a warm rush of air from the flames beneath (warm colours).

The area in between shows some useful neutral hues, obtained by mixing the primaries together in different proportions. The neutrals are applied in a way that introduces an impression of subtle texture, and the highlights and shadows add interest.

Groups of warm and cool primary colours, in the form of balloons on either side of the main image, relate the hues to those in the main balloon.

Primary cool colours

Primary and secondary cool colours

Primary warm colours

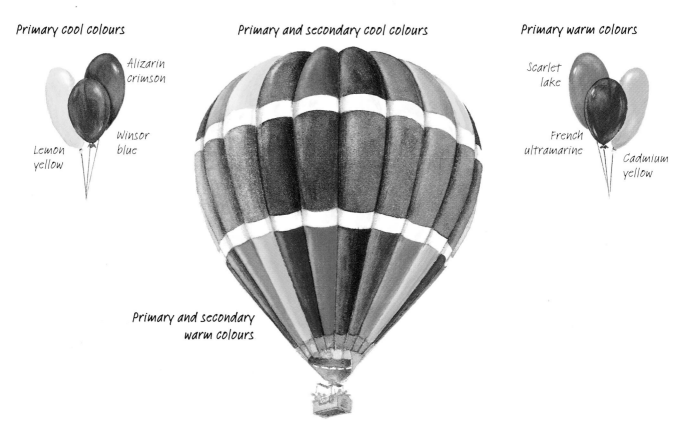

Alizarin crimson

Winsor blue

Lemon yellow

Scarlet lake

French ultramarine

Cadmium yellow

Primary and secondary warm colours

Choosing a Palette of Colours

You may feel the process of choosing a suitable palette from the vast range of colours available to be rather daunting. If so, start by working with a limited palette, which will encourage you to be more resourceful.

Limited palette

The challenge of working with a limited palette gives you an opportunity to discover colour permutations that might otherwise remain unknown to you. Restricting your palette to three, or even two, colours can encourage you to produce some exciting results.

Below, a monochrome interpretation of a window in an old building shows how a mix of raw sienna and French ultramarine produces a useful hue that is ideal for depicting this type of subject matter.

By introducing a third colour, you will discover a very pleasing range with which to work. I use these three colours initially in the form of a controlled exercise and then demonstrate how they work within a little study of a church. The white paper also plays an important part for much of the main image, with the neutral hue enhancing the shadow areas.

Simple colour-mixing exercise

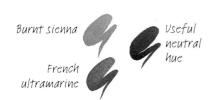

Burnt sienna

French ultramarine

Useful neutral hue

Without drawing image first, lay supporting lines directly onto paper with brush

Add further structure lines

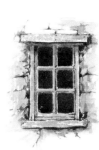

Build around structure in layered washes, and add rich tones within shadow areas using full range of tones

Controlled colour-mixing exercise

Burnt sienna

Useful neutral hue

French ultramarine

Controlled shapes showing colour permutations

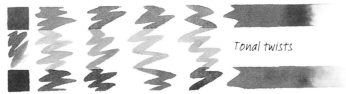

Tonal twists

Finish the strips after changing the position of the two colours

Colour ribbon

A palette of only two colours can produce a range of hues. Add a third, and you will discover endless opportunities to create exciting hues. Try blending the colours in a controlled way to experiment with abstract shapes, as well as the more straightforward approach to colour mixing on page 42.

The colours used here are those in the colour ribbon, showing that a painting of rich colours can be developed from a very few hues.

Three-colour painting

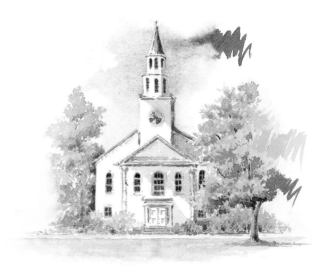

Colour Mixing

There are numerous ways in which colour mixing may be practised, and you can easily make reference charts. Sometimes, however, it is fun to work with a more flexible approach, which is demonstrated here with a set of two-colour mixes.

Primary mixes

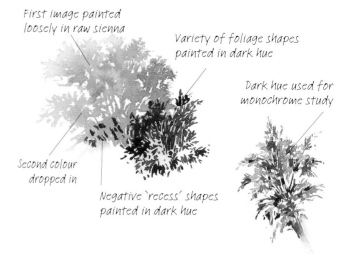

Cool yellow

Warm blue

Cool yellow

Cool red

Warm yellow

Cool blue

Note the effect as the blue bleeds into the still-damp yellow; the resulting green hue is shown separately

When the yellow is quite wet, the red quickly spreads into a larger area. This mix can produce a deep orange

Note the difference between this green and the one on the left

Going for greens

Beginners often experience problems when mixing greens, but you can have fun creating a range, as shown here.

Mix a little raw sienna with a cool blue and paint a swirl of the resulting green upon your paper. Then add a little more raw sienna to the palette and place another swirl. Then a little more, and so on, until you finally reach a swirl of pure raw sienna again. Do the same with the blue, and note how many different greens you have been able to create with just two colours.

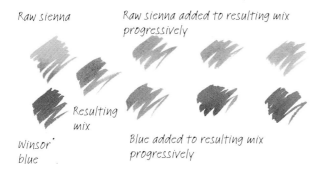

Raw sienna

Raw sienna added to resulting mix progressively

Resulting mix

Winsor blue

Blue added to resulting mix progressively

Mixing colours on paper

Colours also mix well on paper (see page 22), so try this little exercise with the raw sienna and cool blue hues. Create a foliage mass image on the paper using pure raw sienna. Drop in one of the greens you have already mixed, and watch it spread. When this has dried, mix a dark hue by increasing the proportion of blue in your palette, and paint within the negative recess shapes as well as a freely interpreted foliage mass at the side. Note the exciting contrasts. This dark hue is also very effective used as a monochrome study.

First image painted loosely in raw sienna

Variety of foliage shapes painted in dark hue

Dark hue used for monochrome study

Second colour dropped in

Negative 'recess' shapes painted in dark hue

Warm and cool colours

You have seen how warm and cool colours may be mixed with each other. These two examples show some of the different greens that can be achieved by mixing only warm colours with warm, and cool colours with cool. Remember to keep your colours pure, and for these exercises, use no more than three colours in any mix.

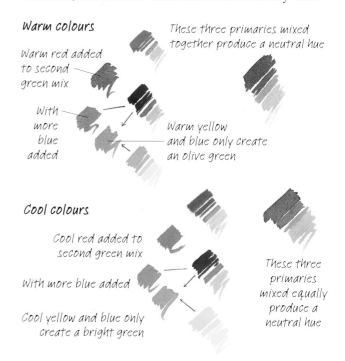

Warm colours

These three primaries mixed together produce a neutral hue

Warm red added to second green mix

With more blue added

Warm yellow and blue only create an olive green

Cool colours

Cool red added to second green mix

With more blue added

Cool yellow and blue only create a bright green

These three primaries mixed equally produce a neutral hue

Blending Dry Media

Whether blending dry pigment smoothly into the paper's surface or into another previously applied colour, you will need to decide upon the direction of your strokes.

This can be easily achieved by paying regard to the subject matter. Alternatively, you may decide to use diagonal or vertically applied strokes throughout the application, or other permutations of strokes.

Smooth blending

Here, coloured pencils are used to demonstrate smooth blending on a smooth paper surface to depict the bark of a tree. Practise in monochrome first, and experiment with pencil pressure to achieve rich darks, contrasting these with light areas to create a three-dimensional effect. Subsequent diagonal or curved directional strokes can be superimposed over the evenly blended areas if desired.

Smooth blending on a textured surface

Artists' pencils can be successfully worked on textured paper. The texture of the paper can be retained if the pencil pressure is light – more heavily applied, the pigment will produce a smooth sheen on the surface, enabling a sharpened pencil to create dark areas of hue and tone. Cut in crisply at edges to achieve contrasts.

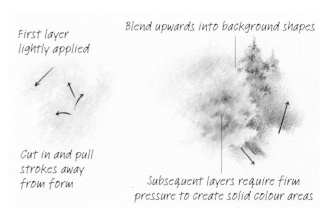

First layer lightly applied

Blend upwards into background shapes

Cut in and pull strokes away from form

Subsequent layers require firm pressure to create solid colour areas

Blending dry mediums

If you enjoy working with rich hues on a heavily textured surface, apply a coloured watercolour ground to a rough paper such as Saunders Waterford 600gsm (300lb), and allow it to dry: it can then be used as a support for soft pastels.

Experiment with the two methods shown here, layering the pastels over each other and using a torchon, a stick of tightly rolled paper in the shape of a pencil.

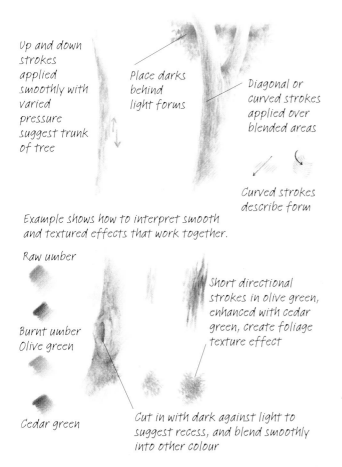

Up and down strokes applied smoothly with varied pressure suggest trunk of tree

Place darks behind light forms

Diagonal or curved strokes applied over blended areas

Curved strokes describe form

Example shows how to interpret smooth and textured effects that work together.

Raw umber

Burnt umber
Olive green

Cedar green

Short directional strokes in olive green, enhanced with cedar green, create foliage texture effect

Cut in with dark against light to suggest recess, and blend smoothly into other colour

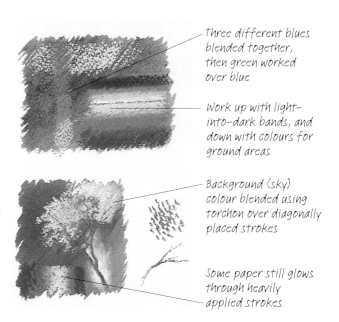

Three different blues blended together, then green worked over blue

Work up with light-into-dark bands, and down with colours for ground areas

Background (sky) colour blended using torchon over diagonally placed strokes

Some paper still glows through heavily applied strokes

Aerial Perspective

One of the problems often experienced by beginners in landscape paintings is that of avoiding the depiction of aerial perspective in situations where it is not intended. Knowing that a pond is round when viewed from above, they endeavour to show this as much as possible, even when, from the angle they view it when standing on the ground, the shape they actually see is totally different, and features nothing that suggests roundness.

Seen from above

For this reason two different interpretations of aerial perspective are shown here, to illustrate how much (and how little) we are able to see certain objects and features when viewed from above.

Seen from a plane, as below, the countryside shows buildings at a perspective angle that is very similar to those that are observed when standing on a cliff top and looking down at the roof tops of seaside houses built against the cliff.

Viewing a wide river and skyscrapers from above will give you an idea of extreme distance, with the landscape stretching as far as the eye can see.

Rural patterns

Fields and pastures resemble the appearance of a patchwork quilt, with each area offering different colours, textures and tonal variations, the latter quite often affected by cloud formations. Well-grazed fields often have a mottled appearance, whereas ploughed fields contain linear patterns. Lush green pastures appear as a more uniform rich green. Each area, surrounded by borders of hedge or fence and interspersed with occasional groups of houses, gives the appearance of ordered tranquillity.

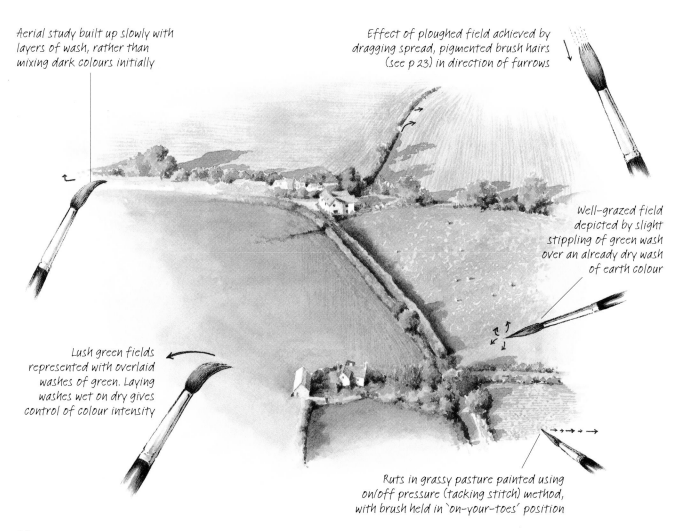

Aerial study built up slowly with layers of wash, rather than mixing dark colours initially

Effect of ploughed field achieved by dragging spread, pigmented brush hairs (see p 23) in direction of furrows

Well-grazed field depicted by slight stippling of green wash over an already dry wash of earth colour

Lush green fields represented with overlaid washes of green. Laying washes wet on dry gives control of colour intensity

Ruts in grassy pasture painted using on/off pressure (tacking stitch) method, with brush held in 'on-your-toes' position

Urban patterns

City and town patterns consist mainly of horizontal and vertical forms arranged in close proximity. Although these may be broken in places by areas of parkland and massed tree formations, the effect often relies upon a wide river to provide an area within the composition that rests the eye. The placing of bridges will help retain unity within the picture, and cloud formations in the sky can be used to soften what may otherwise appear a very angular scene.

For distant areas pencil pressure needs to be as gentle as possible for first strokes to maintain control of intensity

Tower block focal point provides strongest vertical guideline (see page 16), from where horizontal and vertical reference lines relate to rest of composition

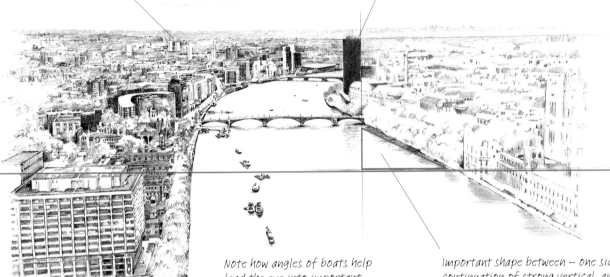

Note how angles of boats help lead the eye into important crossover (unifying) movement, to connect both sides of river up to focal point

Important shape between – one side a continuation of strong vertical, and second giving the riverbank angle – on third side leads the eye to important relationship with prominent building

Close observation, patience and practice help control marks in complex areas

Pencil exercises

To achieve an accurate, controlled line

Place short stroke first, going back over it, working over it again and continuing beyond

Create horizontal line in same way

Series of parallel lines

Place short, continuous application line then others parallel to it and contoured edges

Sharp pencil moved up and down before the main downward line creates darker tone

Leaving gaps

This series of curved edge lines started as continuously placed parallels. A gap was left and the lines were applied with shorter strokes to increase the gap size.

Complex patterns

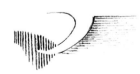

More complex shapes suggest walls, windows, bridges and so on

Working Outdoors

Using photographs

The best way to use photographs successfully is alongside, and as a back-up for, sketchbook work. There is a spontaneity in drawing from life that is lost in a direct copy from a photograph, yet photographic reference can be a great support for your artwork. It captures the mood of the moment, immobilises movement (especially helpful with water) to allow you to analyse shapes and forms, and gives you the opportunity to capture a scene quickly if your time is short or the weather conditions doubtful. It also enables you to compose the scene through the lens and swiftly record it from a variety of viewpoints. Written notes alongside your drawings can then be made in haste or at leisure, and colour notes all form a reference library that is unique to you.

Sketchbook work

Draw with sincerity – with a deep desire to put on to paper not just what you think you see, but what you feel about what you see. It is not as difficult as it sounds.

When you start the first marks, do not be concerned about how they will look on paper. Start by observing the subject – really look at it. Absorb it, both the subject(s) and the surroundings. Note relationships, perspective, scale, textures and so on. This is your 'thinking time', and is an invaluable part of any work of art.

Ask yourself why you have chosen this subject in the first place – you will be spending your valuable time working to portray it on paper, so what attracts you to it? This will help you understand where to put emphasis in your portrayal of the view, object(s) or whatever, and by doing this you will be starting to make it unique to you.

Using photographs and sketchbooks

A photograph, being a record of what is in front of you at the time you take the picture, is just that – a record. A sketch, or more detailed drawing, however, may contain areas where you have decided to look and record far more closely – or areas that you have chosen to simplify or even leave entirely untouched. Wherever possible, if you intend to work from your sketches at a later date, do take a series of photographs to enhance your memory, but try not to rely solely upon these.

Fill your sketchbook in every conceivable way, with small studies, larger impressions, experimental marks, detailed observations, quick movements using a variety of tools – anything. It will become the way you see and feel about your surroundings and will influence your finished artwork in an exciting and unique way.

Learn your lines

In a 'working' sketch – one from which you will later work – a pencil can be used freely, with wandering lines travelling loosely over the paper with light pressure, heavier pressure for shadow lines, diagonally applied lines to suggest tonal blocks, and so on.

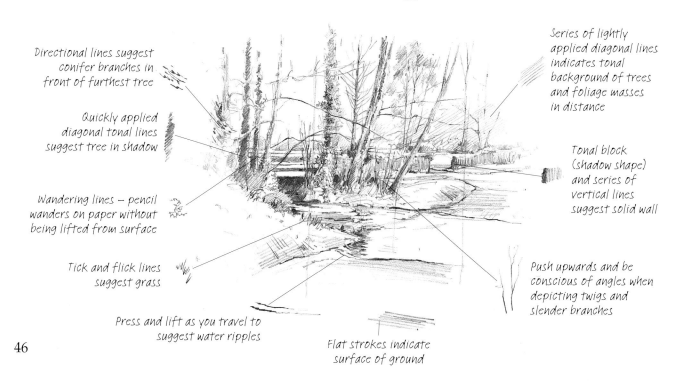

Directional lines suggest conifer branches in front of furthest tree

Quickly applied diagonal tonal lines suggest tree in shadow

Wandering lines – pencil wanders on paper without being lifted from surface

Tick and flick lines suggest grass

Press and lift as you travel to suggest water ripples

Flat strokes indicate surface of ground

Series of lightly applied diagonal lines indicates tonal background of trees and foliage masses in distance

Tonal block (shadow shape) and series of vertical lines suggest solid wall

Push upwards and be conscious of angles when depicting twigs and slender branches

Using the photograph

This more detailed sketch demonstrates how the back-up photograph – taken at the same time as the working sketch opposite was made – is referred to at the same time as the initial sketch to develop a pictorial composition from the scene. The artist composes a picture, which is a very different process from copying a photograph (see page 34–35).

The watercolour interpretation of this second sketch demonstrates how the first tonal washes were applied and, in the same areas, progresses to adding richer hues and tones.

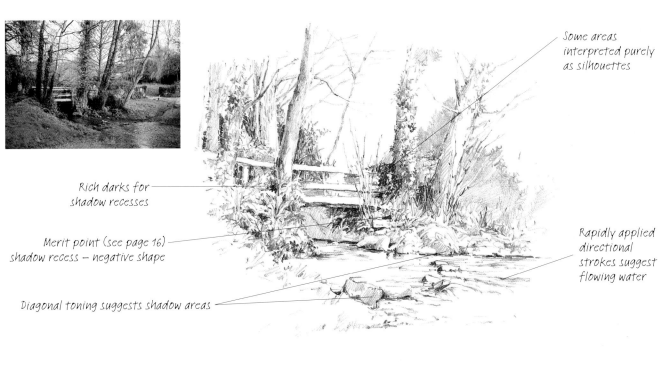

Some areas interpreted purely as silhouettes

Rich darks for shadow recesses

Merit point (see page 16) shadow recess – negative shape

Diagonal toning suggests shadow areas

Rapidly applied directional strokes suggest flowing water

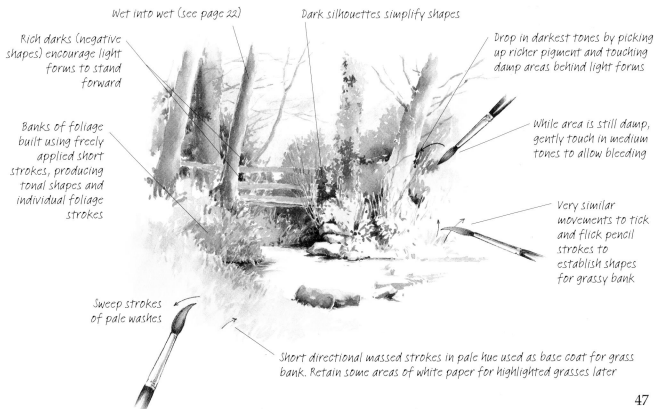

Wet into wet (see page 22)

Dark silhouettes simplify shapes

Rich darks (negative shapes) encourage light forms to stand forward

Banks of foliage built using freely applied short strokes, producing tonal shapes and individual foliage strokes

Drop in darkest tones by picking up richer pigment and touching damp areas behind light forms

While area is still damp, gently touch in medium tones to allow bleeding

Very similar movements to tick and flick pencil strokes to establish shapes for grassy bank

Sweep strokes of pale washes

Short directional massed strokes in pale hue used as base coat for grass bank. Retain some areas of white paper for highlighted grasses later

Skies and Clouds

Drawing Exercises

The direction in which you apply any pencil stroke requires careful consideration. Successful images often require a certain amount of hand, arm and body movement – especially when directing contours and angles.

The exercises on these pages are designed to encourage the flexibility of your wrist, and it is helpful to practise them using as many directions as possible in order to loosen yourself up.

4B pencil

Contoured tonal blocks	*Create a curve using individual strokes*	*Mass strokes gently to form a contoured shape*	*Practise movement of hand and arm and analyse directions with firm strokes*	*Open strokes and give thought to their application*	*Close strokes and practise contoured shapes in other directions*

CHOOSING CONTOUR MARKS

Contour lines, whether broken or continuous, need consistency if they are to achieve accurate representation. The marks you make may be gently toned or firmly placed, but you do need to be in control of them and be aware beforehand of your intended impression.

Practice exercises, approaching the depiction of contour marks from different directions, are essential for developing personal skills.

Long and short contour strokes with even pressure

Contour stroke lines achieved with a series of dashes and on/off pressure

Toned contour shape and light tone overlay using firm pressure with light pressure for overlay

 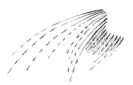

Work outwards from dark-toned central block

Introduce tone within contour shape

Leave light edges to pale-toned contour shapes

Pen and ink

Stippling, although time-consuming, can be very rewarding when a stippled image is complete and viewed as a whole. With the pen held vertically against the paper, place each pressure dot individually and clearly. Do not be tempted to rush, or you will spoil the effect. If you tire during the process, just place your work to one side and return to it later.

Stippling

Place a series of dots holding pen vertical to paper

Mass dots in areas where more tone is required

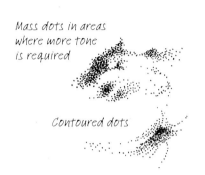

Contoured dots

Dots into dashes

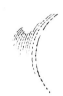

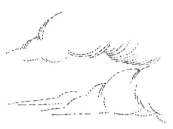

Place a series of dot/dash contour lines

Curve contour 'lines' into recognizable shapes

Watercolour pencils

Monochrome images, which rely on tonal application and variation, are very effective for depicting skies, and are easily achieved by the use of varied pressure.

The important thing to remember is that you need to gain an understanding of the subject in order to know where to place pencil pressure and where to leave white paper.

Working from the negative shape or sky seen between cloud formations

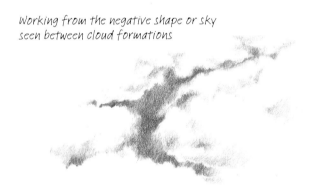

Gentle toning defines edge of cloud

Arrows indicate direction of strokes to work out into contoured edges of clouds

Medium charcoal pencil

A medium charcoal pencil is useful for quick studies of clouds, giving more depth of tone than a light pencil and being better for delicate areas than a dark pencil.

Retain areas of white paper

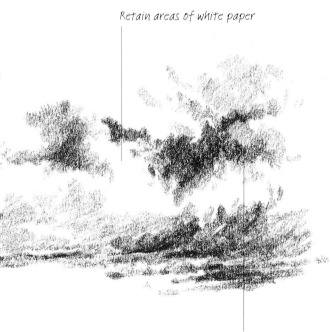

Diagonally applied strokes for sky

Single stroke with on/off pressure – strokes horizontally applied to create effect of receding clouds

Curved strokes on shadow sides of clouds

Watercolour exercises

In the same way that you need to consider contours in ink and pencils, it is by depicting contours with the sweep of a brushstroke that cloud images appear. This is an occasion when the concept, 'It is not just what you paint in that is important, but also the areas you choose to leave *out!*' should be your guiding principle.

These exercises are intended to help you understand how to observe and depict cloud formations before treating them in a style that is personal to you.

Three-colour mix

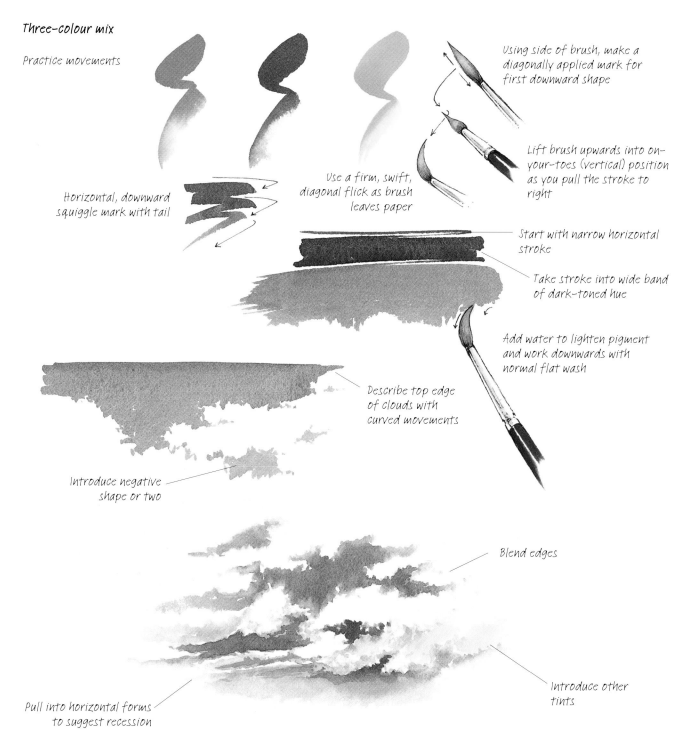

Practice movements

Using side of brush, make a diagonally applied mark for first downward shape

Lift brush upwards into on-your-toes (vertical) position as you pull the stroke to right

Horizontal, downward squiggle mark with tail

Use a firm, swift, diagonal flick as brush leaves paper

Start with narrow horizontal stroke

Take stroke into wide band of dark-toned hue

Add water to lighten pigment and work downwards with normal flat wash

Describe top edge of clouds with curved movements

Introduce negative shape or two

Blend edges

Introduce other tints

Pull into horizontal forms to suggest recession

50

Three different approaches

On this page are three methods for you to experiment with as you familiarize yourself with this fascinating subject. Using the same colour mix as on the opposite page, paint in monochrome for these exercises.

Wet into wet

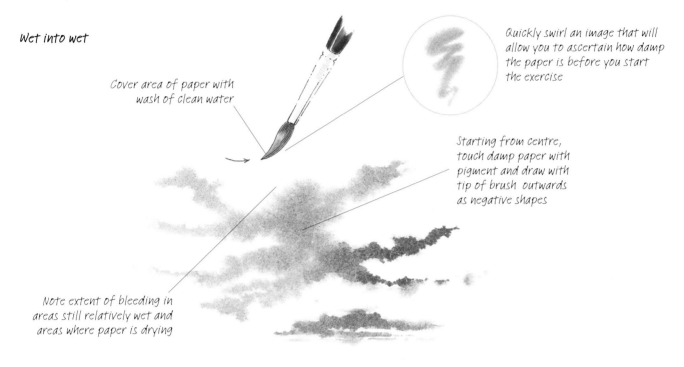

Cover area of paper with wash of clean water

Quickly swirl an image that will allow you to ascertain how damp the paper is before you start the exercise

Starting from centre, touch damp paper with pigment and draw with tip of brush outwards as negative shapes

Note extent of bleeding in areas still relatively wet and areas where paper is drying

Wet on dry

Note change of tone here

All edges are crisp

Press heel of brush firmly to absorb excess moisture

Final area of stroke appears paler and may even take on drybrush effect from brush pressure

Fast and free

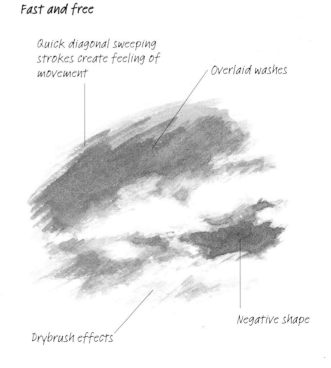

Quick diagonal sweeping strokes create feeling of movement

Overlaid washes

Negative shape

Drybrush effects

Cloud Formations: **Typical Problems**

Cloud formations are so diverse, and the colours found within skies are so varied that your choice of representation is limitless. Skies portray moods and atmospheres with an exciting range of tonal variations. They can be tranquil or full of movement, and it can help to consider their depiction through directional strokes – whether in pencil or brush – with cloud contours against a flat area of blue.

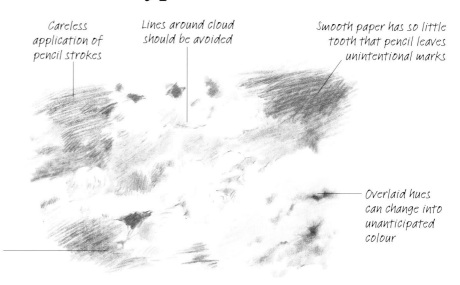

Careless application of pencil strokes

Lines around cloud should be avoided

Smooth paper has so little tooth that pencil leaves unintentional marks

Overlaid hues can change into unanticipated colour

Application of different areas of colour suggests lack of understanding of cloud formations

Tonal drawing

Start with a straightforward tonal drawing, choosing a sky that gives the opportunity to shade from the darkest to the lightest tones (white paper) with the use of subtle blending of one tone into, and against, the other.

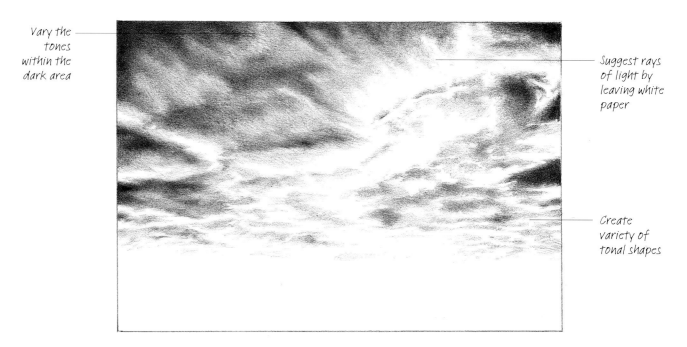

Vary the tones within the dark area

Suggest rays of light by leaving white paper

Create variety of tonal shapes

TRYING YOUR TONES

Starting with diagonal strokes, practise gentle blending, then use crosshatching and strokes that follow the contours of clouds.

2B pencil

Start with simple diagonal stroke tonal block

Eraser taken through pencilwork to remove mistakes easily

Crosshatching

Contour strokes

Solutions

Remember that clouds float in front of the blue beyond. On this illustration, made with Derwent Studio pencils, I placed the blue negative shapes in position first, before contouring the clouds with shadow areas and leaving the lightest areas in front of everything else.

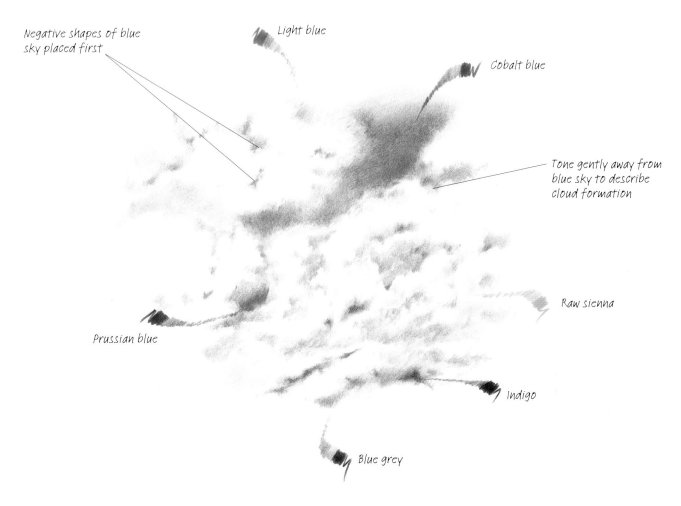

Negative shapes of blue sky placed first

Light blue

Cobalt blue

Tone gently away from blue sky to describe cloud formation

Raw sienna

Prussian blue

Indigo

Blue grey

Colours

Select your colours and use each in turn as a practice exercise in order to familiarize yourself with the pencil and the response of the paper to its application, as you vary your pressure upon the coloured strip. This is an excellent opportunity for you to loosen up and create tonal contours and masses with a variety of strokes.

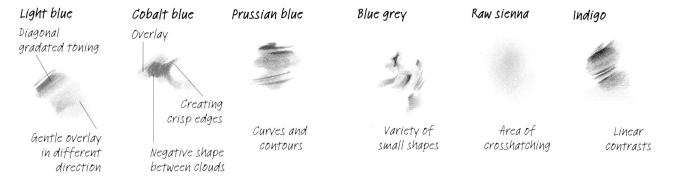

Light blue
Diagonal gradated toning
Gentle overlay in different direction

Cobalt blue
Overlay
Creating crisp edges
Negative shape between clouds

Prussian blue
Curves and contours

Blue grey
Variety of small shapes

Raw sienna
Area of crosshatching

Indigo
Linear contrasts

Mood and Atmosphere: **Typical Problems**

Skies have many changes of mood; I have illustrated two contrasting atmospheres on this spread to help you understand different treatments of the subject. They both rely on the effect of light. On this page you can see how a tranquil sky, viewed at the end of the day, shows strong light behind the horizon, adding a warm glow. On the opposite page the cold light of a stormy sky gives the impression of movement and turbulence.

Clouds outlined

Not enough thought and control given to wet-into-wet method

Unconsidered approach

Thoughts on paper

One of the problems faced by beginners is how to avoid giving a completely flat impression of a sky when cloud formations should be suggesting a third dimension. This division of foreground, middle ground and distance shows the effect created when the largest clouds appear directly above in the foreground, and similar formations appear to recede as they pass into the distance.

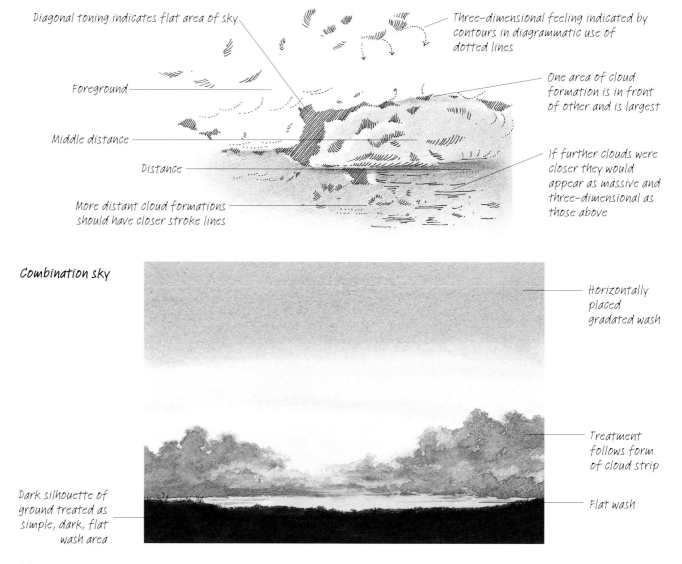

Diagonal toning indicates flat area of sky

Foreground

Middle distance

Distance

More distant cloud formations should have closer stroke lines

Three-dimensional feeling indicated by contours in diagrammatic use of dotted lines

One area of cloud formation is in front of other and is largest

If further clouds were closer they would appear as massive and three-dimensional as those above

Combination sky

Horizontally placed gradated wash

Treatment follows form of cloud strip

Flat wash

Dark silhouette of ground treated as simple, dark, flat wash area

Solutions

In order to create a strong sense of atmosphere, you need to introduce stronger contrasts, both of texture and of tone/colour. The smooth washes in the negative shapes of a darkened sky make a striking contrast with the bright, light edges of fluffy clouds as they move swiftly across the dramatic sky.

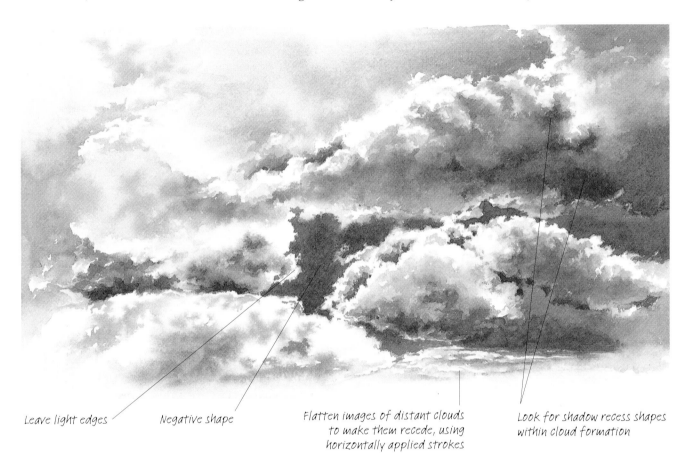

Leave light edges

Negative shape

Flatten images of distant clouds
to make them recede, using
horizontally applied strokes

Look for shadow recess shapes
within cloud formation

Gradation

Practise gradated washes, both for colour and tonal variation. The effect of clean water added at the base can create impressions of filtered light in the sky.

Gradated
wash

Impression
of light rays
created
through
addition of
clean water

Add clean water to wash
to dilute pigment as you
work down

Practice exercises

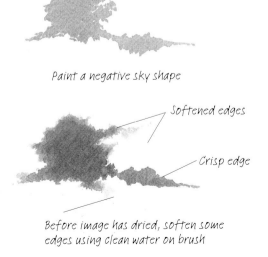

Paint a negative sky shape

Softened edges

Crisp edge

Before image has dried, soften some
edges using clean water on brush

Tighter Approach: **Typical Problems**

Cloud formations lend themselves to depiction in paint, pastel, charcoal, pencil and a loose application in pen and ink, but when considering a tighter, more detailed approach using the latter, problems can occur.

Working with pen and ink, various methods can be practised as warm-up exercises, where it is not only the type of pen and the way it is used that is important, but also the paper upon which we choose to work. Some methods, where the ink is lightly grazed across the surface in order to achieve certain effects, may require a slightly textured surface – a paper that has tooth. This method requires practice to be successful, however.

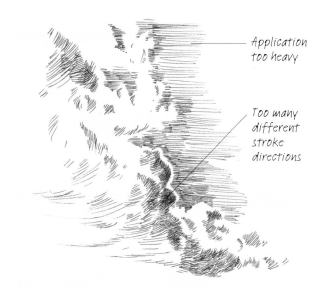

Application too heavy

Too many different stroke directions

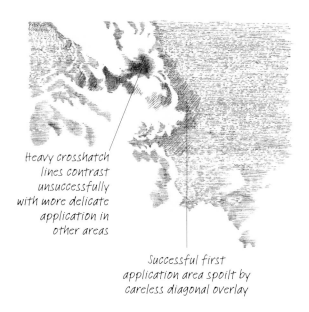

Heavy crosshatch lines contrast unsuccessfully with more delicate application in other areas

Successful first application area spoilt by careless diagonal overlay

Let your strokes follow the form you see – whether it be horizontal application to suggest flat sky areas or curved strokes following the forms of clouds. Practise contoured lines and on/off pressure parallel lines, as well as crosshatching, on different paper surfaces to find out what works best for you.

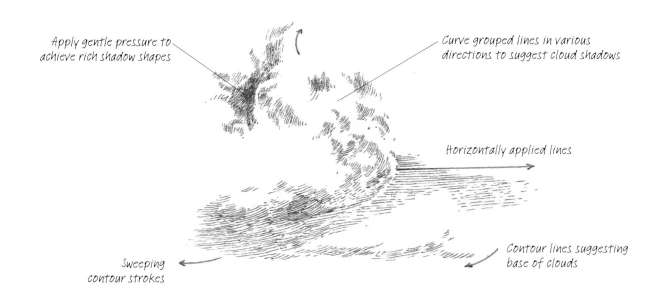

Apply gentle pressure to achieve rich shadow shapes

Curve grouped lines in various directions to suggest cloud shadows

Horizontally applied lines

Contour lines suggesting base of clouds

Sweeping contour strokes

Solutions

Artist's pen

Contoured
crosshatch

Crosshatch

Solid
pigment

Contour

Basic
vertical
dot/dash
line

Lift pen from paper while
continuing movement and
before reapplying to
complete stroke

Graze surface for effect

Stippled negative and
shadow shapes

Massed dots for
darkest tonal areas

Spaced dots for
initial stage

Directional stippled
diagonal images

Negative shapes

Formations in the sky
Five applications

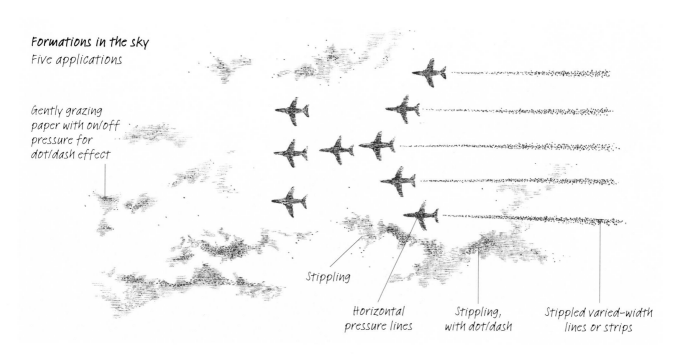

Gently grazing
paper with on/off
pressure for
dot/dash effect

Stippling

Horizontal
pressure lines

Stippling,
with dot/dash

Stippled varied-width
lines or strips

Demonstration: Mixed Sky

A mixed sky of cumulus and cirrus clouds is more interesting to paint when viewed at the end of the day, when there may be brilliant colours and strong tonal contrasts. The foreground silhouettes of trees upon a dark base frame the activity above, and pastels are an ideal medium for this subject.

Planning the composition

If you look through a viewfinder you can position the focal point or point of interest in such a way as to lead the eye into your picture. In the two preliminary sketches, the annotations explain why the sketch below right was chosen as a base from which to work.

Uninteresting large tree silhouette takes up too much foreground

Focal point, main cloud formation, is too central

Large tree gives strength of tone to frame part of foreground

Focal point, main cloud formation, relates to trees in foreground

Shadow clouds help guide eye into picture

PRACTISING STROKES

I keep a supply of old watercolour paper offcuts to use for testing colours or techniques. One of these offcuts was used for practising suitable strokes for the demonstration on these pages. It is a good idea to think your way into your proposed work in monochrome, and this exercise in charcoal can be regarded as a warm-up. I used a cotton-wool bud to blend the charcoal in a similar way to that used in the pastel painting opposite.

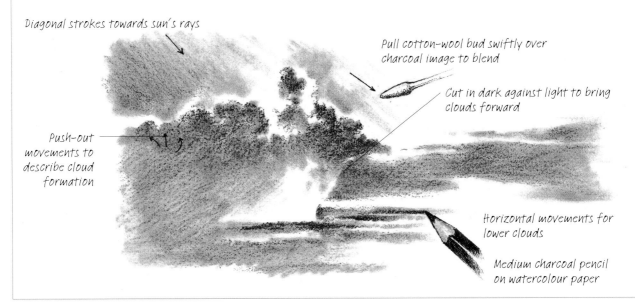

Diagonal strokes towards sun's rays

Pull cotton-wool bud swiftly over charcoal image to blend

Cut in dark against light to bring clouds forward

Push-out movements to describe cloud formation

Horizontal movements for lower clouds

Medium charcoal pencil on watercolour paper

Pastel study

After consideration, I decided to change the shape slightly from my original sketch by elongating the landscape format. As you can see this has the effect of enhancing the horizontal clouds, enabling them to contrast strongly with the main cloud formation. The pale tint of the pastel board could also be incorporated within the painting if necessary.

Diagonal application of blue and white pastel sticks into yellow

Curved, push-out movements to describe clouds

White pastel pencil detail

Detail drawing in pastel pencil defines narrow clouds over horizontal strokes of pastel sticks

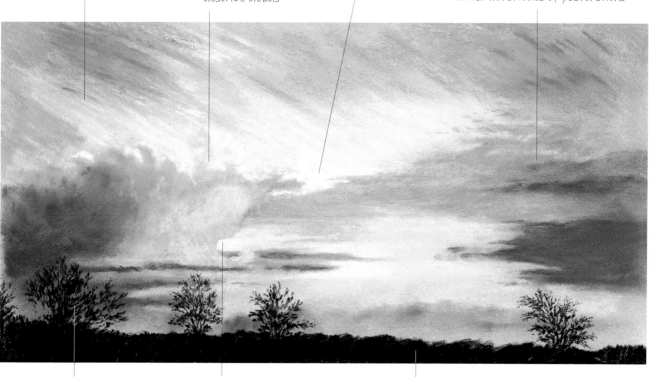

Sharp black pastel pencil depicts delicate tracery of foreground tree silhouettes

Cut in white sky against yellow cloud

Solid block of Indigo pastel stick

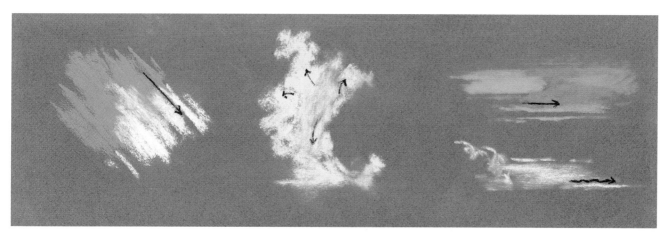

Diagonally applied pastel sticks, moving strokes towards the sun's rays

Strong pressure on pastel stick follows the form of the cloud formation

Horizontal pastel pencil strokes using delicate lines

Water

Drawing exercises

These pencil exercise strokes are applied in different ways, using various angles of the pencil. Those on this page are basic marks, made with a soft, 6B pencil, while those opposite develop the basics and use a variety of mediums to produce different effects.

Side-to-side varied-pressure strokes

Wide edge of pencil Narrow edge of pencil

Tonal block **Slurp stroke**

Angled on/off-pressure zigzag strokes

Drop and splash

Downward zigzag

Upward and outward movement

Combination of strokes

Combination of strokes and pressures

Combinations

Varied pressure shapes (strokes) – dots and dashes

For this line, some strokes passed back over themselves before continuing, to increase tone

Squiggles

Swiftly applied in a downward movement

CHOOSING PAPER

The drawing paper used for the majority of the pencil strokes has a surface that, while allowing some rich dark tones to be created, also produces a strong, textured effect when flat areas of tone are applied. You can reduce this by using a smoother surface, for example Bristol board. It is a good idea to experiment with different surfaces in order to discover which surfaces best suit your own particular style and the effects you want to achieve.

Using paper textures

Swift, continuous, side-and-back shaded area enhances texture of paper

Dot-and-dash lines

Single dot-and-dash line

For less texture on same paper surface, gently draw a series of lines

Play with permutations

Using Bristol board

For less texture you can also use a smoother-surface paper, which also gives the chance to create different effects.

Artists' pencils

This is an ideal medium for creating contours and curves in your drawing, suitable for moving water.

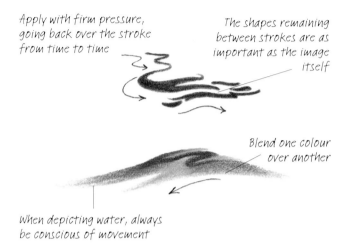

Apply with firm pressure, going back over the stroke from time to time

The shapes remaining between strokes are as important as the image itself

Blend one colour over another

When depicting water, always be conscious of movement

Watersoluble ball pen

Used dry and then wetted with clean water and a brush, this is an ideal medium for creating rich contrasts.

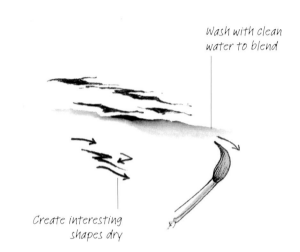

Wash with clean water to blend

Create interesting shapes dry

Watercolour pencils

In this exercise, be conscious of the difference between rich, dark reflections on the water's surface and the paler shadows created by undulating ripples.

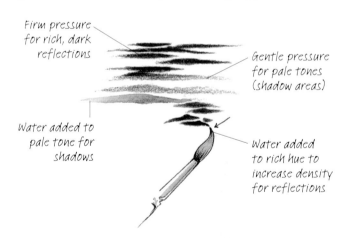

Firm pressure for rich, dark reflections

Gentle pressure for pale tones (shadow areas)

Water added to pale tone for shadows

Water added to rich hue to increase density for reflections

Used dry and then wet as with watersoluble ball pen (see above right), watercolour (or watersoluble) coloured pencils can be used for distant reflections.

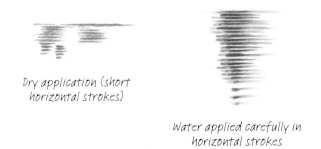

Dry application (short horizontal strokes)

Water applied carefully in horizontal strokes

Watersoluble graphite pencil

After making the basic drawing, use a brush and clean water for a monochrome effect that is particularly useful for falling water.

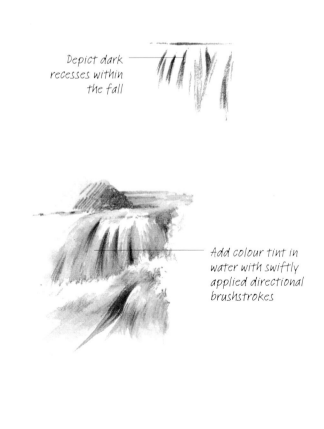

Depict dark recesses within the fall

Add colour tint in water with swiftly applied directional brushstrokes

Watercolour exercises

Like the pencil exercises on the previous page, these watercolour exercise strokes are applied in different ways and with different angles of the brush.

Not only do you need to experiment with different pressures and angles of approach as you master these basic strokes, but it is also an idea to vary the surfaces upon which you work. Three different papers were used to demonstrate these brushstroke exercises – Rough, Cold-Pressed (NOT) and Bockingford.

Slurp stroke
This stroke is applied with a loose wrist movement in the direction of the arrows, holding the tool in a normal writing position.

For the side-to-side strokes of varied pressure, concentrate on keeping your brush/pencil stroke direction horizontal as you touch the paper, press as you travel to expand the stroke, and gently lift off, all in a continuous, smooth movement.

Arrows show direction of brush movement

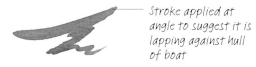

Stroke applied at angle to suggest it is lapping against hull of boat

Each stroke may vary in thickness at different points

Side-to-side strokes of varied pressure

Wide and narrow in one stroke

Drop and splash
The quickly applied downward zigzag of the drop and splash stroke is erratic in movement, using uneven pressure on the strokes. You may also travel back over an existing mark/shape to make the image stronger.

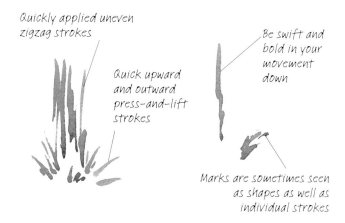

Quickly applied uneven zigzag strokes

Quick upward and outward press-and-lift strokes

Be swift and bold in your movement down

Marks are sometimes seen as shapes as well as individual strokes

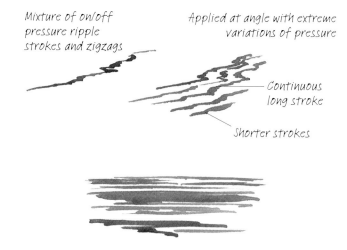

Mixture of on/off pressure ripple strokes and zigzags

Applied at angle with extreme variations of pressure

Continuous long stroke

Shorter strokes

Rapid sideways strokes, some single, others turning back on themselves

Apply in medium-to-light tones and with care and consideration for the areas of white paper that remain

Before paint has dried, drop in darker pigment where reflections from images will appear

Ocean waves

Similar to the slurp stroke, this one is longer and it produces a more solid effect.

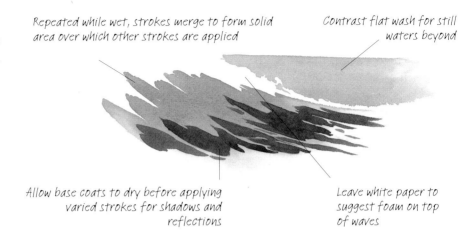

Repeated while wet, strokes merge to form solid area over which other strokes are applied

Contrast flat wash for still waters beyond

Allow base coats to dry before applying varied strokes for shadows and reflections

Leave white paper to suggest foam on top of waves

Flat wash

A flat wash will give you the impression of a glass-like surface on a still lake.

Sparkling water surface

To achieve the effect of light dancing on water, leave some areas of untouched paper among the continuous on/off dot-and-dash lines.

Allow pigment to merge in places

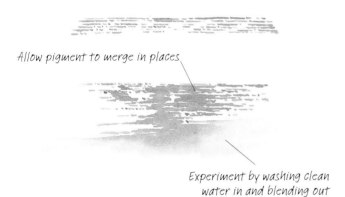

Experiment by washing clean water in and blending out

Watercolour ripples

Basic ripple (one-stroke) shapes

Practise making uneven small and large contoured shapes, leaving slim areas of white paper exposed

Combination exercise

These exercises show how you can build up these techniques and use them in combination with each other to create different effects.

Varied pressure/stroke line

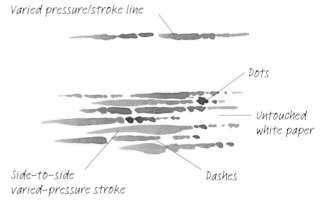

Dots

Untouched white paper

Side-to-side varied-pressure stroke

Dashes

Squiggles

You can use squiggles to depict reflections in still or moving water, varying the pressure on the brush to give the effect of perspective and distance.

Rapid, downward squiggle stroke

Short, brush-shaped horizontal strokes

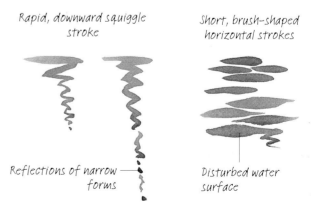

Reflections of narrow forms

Disturbed water surface

Canal Scene: **Typical Problems**

Creating contours using a dry medium such as coloured pencils – where varied pressure enhances tonal contrasts – will give you the opportunity to compare the treatment of quite different surfaces.

The solid structures of buildings are so completely different from the elements of water (a colourless, clear liquid), yet in juxtaposition each affects the other. It is possible to see light that has been shed upon water mirrored in the walls adjacent to buildings, and even more obvious are the reflections from buildings upon the surface of the water.

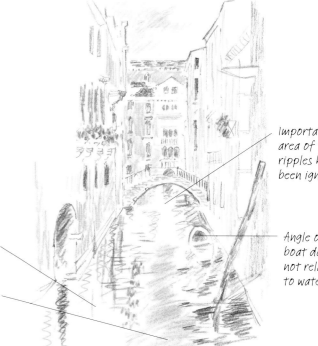

Important area of tiny ripples has been ignored

Angle of boat does not relate to water

Too much white paper in densest area of reflection

Intensity of sky reflection does not relate in treatment to other areas

Monochrome pencil study

Compare tonal values by using a monochrome medium, for example a soft drawing pencil, where you may almost 'paint' with the tool by exerting a variety of pressures as it is applied.

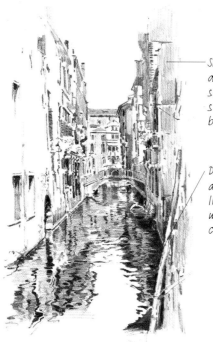

Swift up-and-down strokes suggest sheer sides of buildings

Darkest darks against lightest lights to achieve maximum contrast

Colour notes

Making small (thumbnail) colour sketches of different angles and scenes will help you decide upon a pleasing composition. Practise with a limited palette of colours to prepare for the final interpretation.

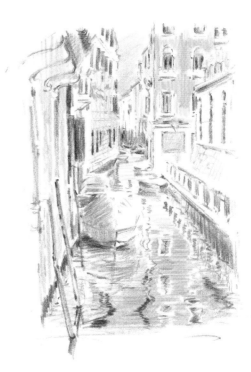

Solutions

The reflections of sturdy structures above disturbed water will appear as an assortment of contours and curves. For the early stages of learning, this static, 'caught-in-time' appearance can best be studied by using photographic references to help gain the understanding that will develop your confidence in drawing.

Main tonal blocks indicated lightly in pencil

Guidelines establish relationship of buildings

Overlay colours to achieve rich shadow areas

Basic reflection shapes established with side-to-side swirls and tonal blocks of burnt umber

Unified with overlay of green earth hue

Colour palette

Burnt umber

Darkest tone

Basic ripple shape

Spruce green

Spruce green over burnt umber

Narrow reflection

Green earth

Green earth over spruce green

Wide reflection

May green

Ash blue over green earth

Sunset gold

Rust

Juniper green

Geranium lake

Harbour: **Typical Problems**

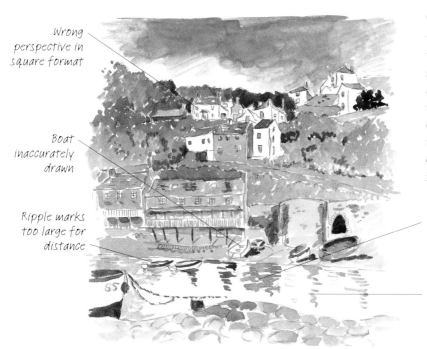

Wrong perspective in square format

Boat inaccurately drawn

Ripple marks too large for distance

Should have been left as white area

Ripple marks and reflections don't match

The effect of ripples upon the surface of water in a sheltered harbour can appear very similar to that of ripples upon the surface of an inland river. Both are affected by buildings and boats on or near the surface, and it is important to be aware of the positions of light areas (for example the hulls of white or light-coloured craft/buildings) as well as the necessity for rich dark shapes.

Monochrome study

Working in monochrome is very helpful in order to analyse tonal variations, but the addition of limited colour provides more overall interest.

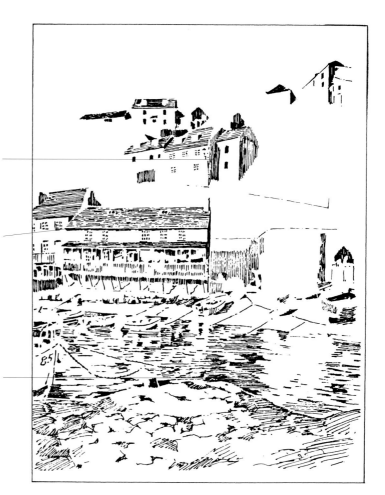

Downward movement of brush for vertical sides

Side-to-side movement for roof

Side-to-side movement for ripples on water

66

Solutions

This painting demonstrates how the effect of colour can be reduced by using more neutral hues. For the reflections in the surface of the water, the majority of ripple marks were depicted with a neutral hue, made by mixing burnt umber and French ultramarine; different strengths of the mix produced variations.

L-shaped mount indicates effect of crisp edges

As scale of boats is small, white paper has been retained for lightest areas. White paper also used to indicate highlights on water surface

Light edge to post ensures shape of shadow side is not lost against dark reflection in water

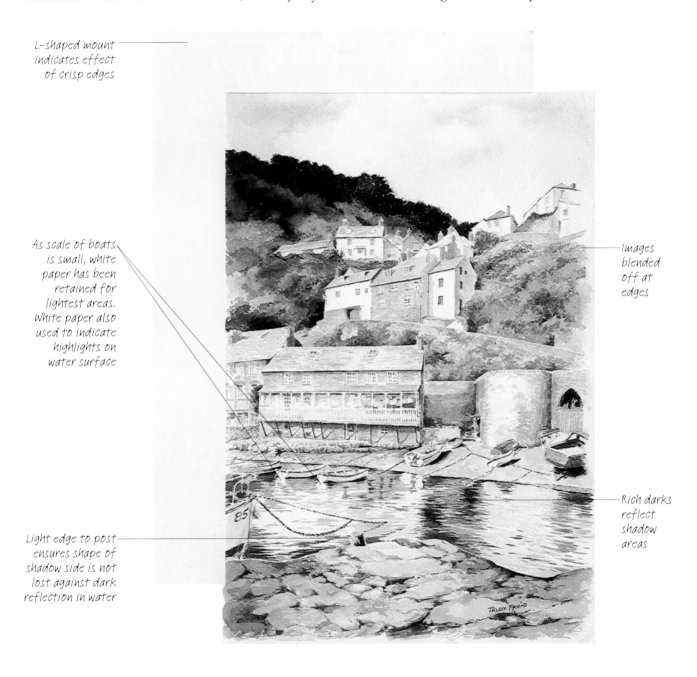

Images blended off at edges

Rich darks reflect shadow areas

Burnt umber + French ultramarine = Neutral hue

Touch Press as you travel

Keep stroke horizontal

Gently lift off for point

Narrow horizontal strokes

Mixed width and pressure strokes

Boat on the River: **Typical Problems**

Whether you depict a large boat travelling sedately along a stretch of river or a small yacht ploughing through choppy water, it is the effect of the ripples that tells the story. Ripples in the wake of any boat are influenced by the weight of the craft, its speed of propulsion and the width of the river, as well as the weather conditions. When depicting these effects, be aware of the importance of horizontal lines as well as the direction of movement within the turbulent areas.

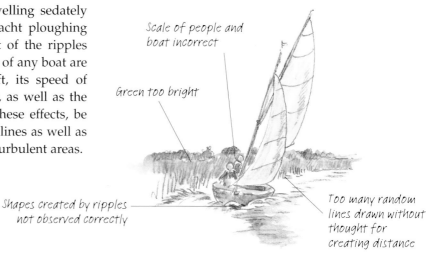

Scale of people and boat incorrect

Green too bright

Shapes created by ripples not observed correctly

Too many random lines drawn without thought for creating distance

Pencil study

This quick sketch uses guidelines to determine the angle of the yacht to the water, and to set the dimensions and proportions accurately.

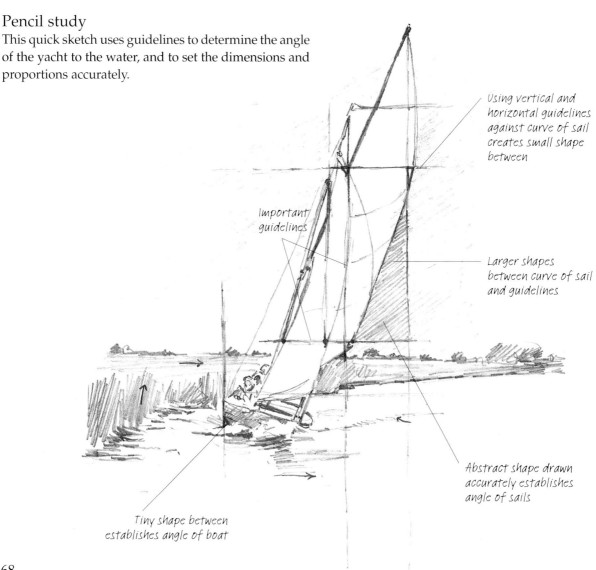

Using vertical and horizontal guidelines against curve of sail creates small shape between

Important guidelines

Larger shapes between curve of sail and guidelines

Abstract shape drawn accurately establishes angle of sails

Tiny shape between establishes angle of boat

Solutions

I depicted the erratic movement of a small yacht on a narrow waterway using watersoluble graphite and watercolour pencils. Loose-tinted drawing achieves the sense of movement of a small craft on water.

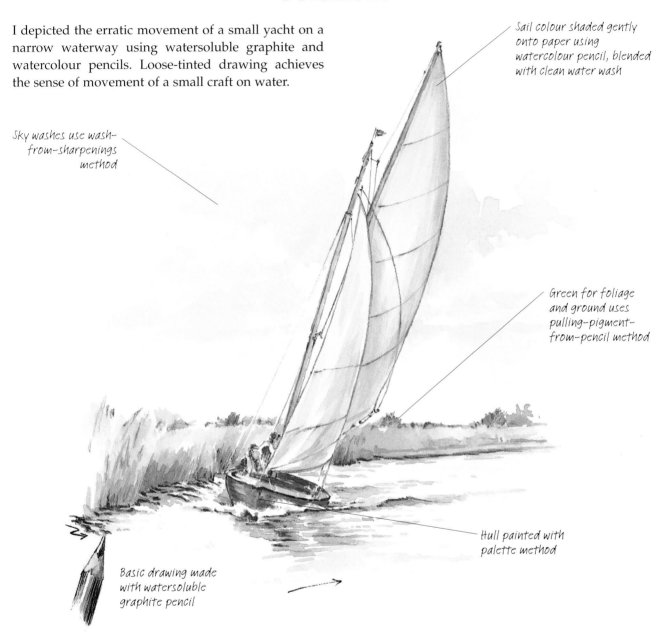

Sail colour shaded gently onto paper using watercolour pencil, blended with clean water wash

Sky washes use wash-from-sharpenings method

Green for foliage and ground uses pulling-pigment-from-pencil method

Hull painted with palette method

Basic drawing made with watersoluble graphite pencil

Methods for yacht

Watersoluble graphite pencil

Erratically drawn directional lines

Pulling pigment from pencil

Flick pigment from pencil down into reservoir to create pigmented water

Use wet brush

Start with reservoir of clean water

Wash from sharpenings

Sharpen pencil into dry, clean palette

Add clean water to create pigmented liquid

Palette method

Create pat of hue by shading area with watercolour pencil

Touch wet brush onto pigment and use as watercolour paint in pan

Demonstration: Waterfall

Whether portraying a large, spectacular waterfall cascading over a cliff, or the smaller variety tumbling over and through rocks and boulders, an artist is faced with the challenge of expressing directional movement when tackling this subject.

This is best analysed and understood by observing less hectic falls, and in this demonstration I have isolated various aspects for the artist's consideration. The drawing opposite was made using watersoluble graphite pencil and watercolour.

Sketching from life *(below)*

When sketching from life prior to developing a watercolour painting, using watersoluble graphite is helpful as the same medium can also be used with watercolour in the final work.

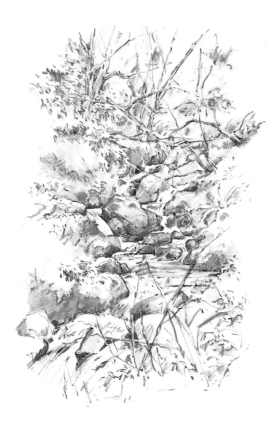

Planning the composition *(right)*

Consider the format for your composition, whether portrait – where water tumbles vertically – or landscape, where you may also introduce horizontal pooling and placement of rocks and boulders.

DIAGRAMMATIC SKETCH

After the spontaneity of initial sketches, closer observation, with more controlled drawing, reveals the structure and direction of movement within the composition.

In this diagrammatic representation a little extra width has been added to some areas of water. The superimposed arrows show my thoughts on paper with regard to the directional brushstrokes I will use to depict the rush of water.

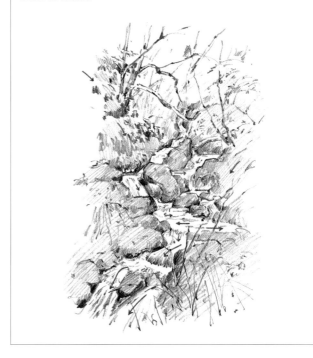

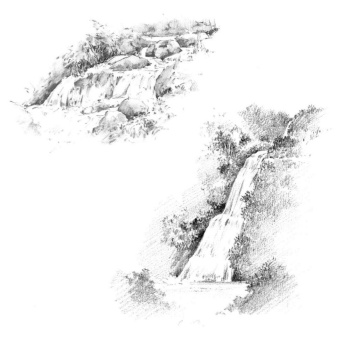

First stage *(right)*

I used smooth drawing paper for the sketches and studies shown opposite, but switched to Saunders Waterford Cold-Pressed (NOT) 300gsm (140lb) paper for the painting, as it suited both the pencil and watercolour.

Developing the painting *(below)*

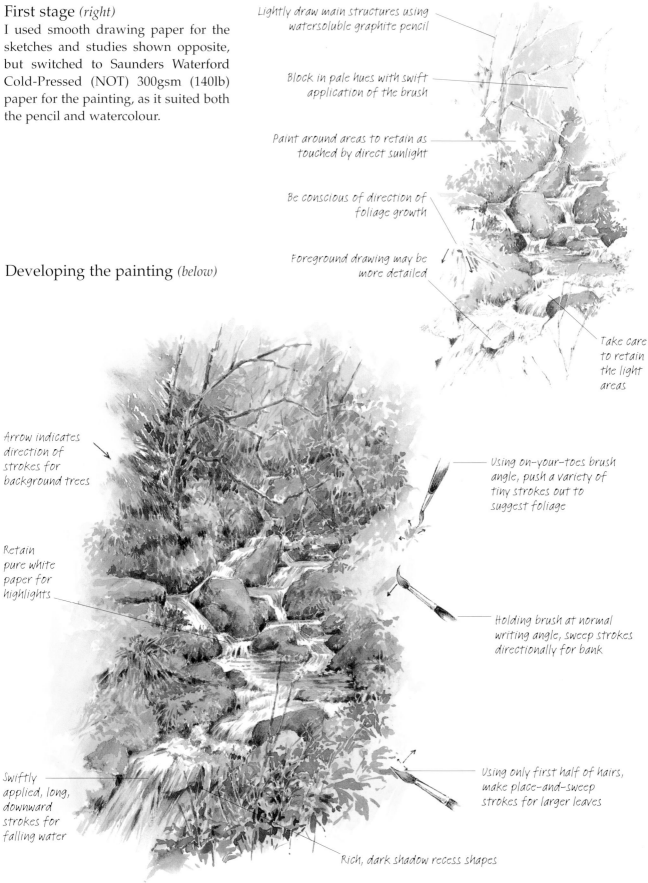

Lightly draw main structures using watersoluble graphite pencil

Block in pale hues with swift application of the brush

Paint around areas to retain as touched by direct sunlight

Be conscious of direction of foliage growth

Foreground drawing may be more detailed

Take care to retain the light areas

Arrow indicates direction of strokes for background trees

Retain pure white paper for highlights

Using on-your-toes brush angle, push a variety of tiny strokes out to suggest foliage

Holding brush at normal writing angle, sweep strokes directionally for bank

Swiftly applied, long, downward strokes for falling water

Using only first half of hairs, make place-and-sweep strokes for larger leaves

Rich, dark shadow recess shapes

Mountains and Hills

Drawing exercises

These strokes demonstrate how to achieve contrasts of rough, jagged movements and smooth, gradated tone. For an aggressive use of tone to suggest hard, uncompromising shapes, lines of a similar nature can be introduced. Smoothly applied, gentle gradated toning requires more care and a sympathetic approach.

Tonal block 4B pencil

Diagonally applied jagged lines using varied pressure

Twist the pencil at the end of the firm strokes for slender tails

Contrasting fine `edge´ lines

Strong, forceful diagonal toning using chisel side of pencil

Carefully applied, gentle diagonal strokes suggest undulations

CHOOSING PRESSURES

The amount of pressure placed upon your pencil when making a variety of strokes needs careful consideration. To avoid areas of pale toning appearing too dark (e.g. when depicting distance) and areas with strong contrasts of dark against light (white) appearing too grey (foreground images in strong light), practise the different pressures in advance. Increase the pressure upon your pencil to the maximum without breaking the lead, and then decrease it to the minimum, to just graze the paper's surface and encourage the pale tone and white paper to blend imperceptibly.

4B pencil Dark tone

Firm up and down (diagonal) movement, maximum pressure

Medium tone

Gentle pressure

Lines showing firm and light pressure strokes

Smooth tonal shape using firm pressure

Light pressure tonal shape

Continuous varied-pressure tonal strip overlaid with varied-pressure lines

Pen and ink

The clarity of marks made with pen and ink offers opportunities for varied strokes to work effectively together – for example, combining straight and curved parallel lines with dots, dashes and solid tonal (block) shapes.

From line into tonal shape

From line into dots

Varied pressure and width lines

Lines depicting grass and rocks

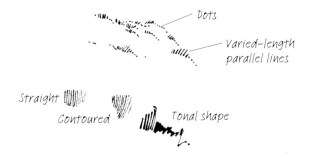

Dots

Varied-length parallel lines

Straight

Contoured

Tonal shape

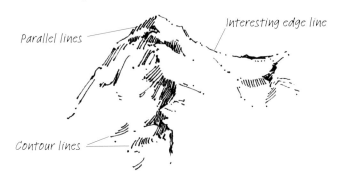

Parallel lines

Interesting edge line

Contour lines

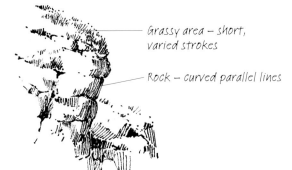

Grassy area – short, varied strokes

Rock – curved parallel lines

Watercolour pencils

Watercolour pencils are very effective when used dry on different paper surfaces. Here, they have been used on a heavy cartridge paper, where they produce a soft effect.

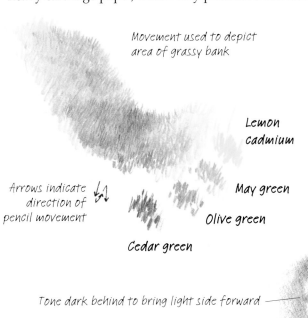

Movement used to depict area of grassy bank

Lemon cadmium

Arrows indicate direction of pencil movement

May green

Olive green

Cedar green

Tone dark behind to bring light side forward

To depict certain bush or tree shapes, the same method can be used as for grass

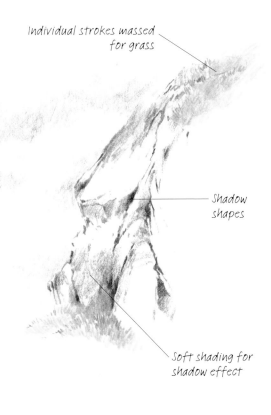

Individual strokes massed for grass

Shadow shapes

Soft shading for shadow effect

73

Watercolour pencils

In the same way that the pencil exercises on the previous pages rely to a great extent upon varied pressure strokes, those shown here also depend upon pencil pressure to achieve their effects.

Leaf mass impressions comprise abstract shapes, as only a few leaves appear in their entirety when viewed en masse. It is more usual to see the overlapping leaves as an overall abstract image.

Abstract shapes

Arrows indicate directions in which pencil is firmly pushed in different directions to establish shapes

Recognizable representation

Established leaf and leaf mass shapes joined by structure lines of twigs

Zigzags

Simple zigzag application in movement of fan shape starts process of depicting distant trees on hillsides

Arrows indicate direction of pencil movements

Dry on dry

Leave some white paper to depict light areas

Introduction of clean water to blend

Wet tip of pencil and transfer swiftly to paper to achieve rich darks

For a more diverse image, wet the paper first and press the tip of the pencil firmly onto the damp surface

Sweeping strokes

Large expanses of fields and hillsides require sweeping strokes. Watercolour pencils can be used in much the same way as watercolour washes. Three different methods of use are illustrated here – practise them all to see how each one works.

Palette method

Place wetted brush onto pigment and transfer to artwork with sweeping strokes

Press dry colour firmly onto paper, making dense tonal block

Dry pencil method

Shade pencil dry on dry over area to be coloured

Wash clean water over pigment to blend

Touch-tip-of-pencil method

Touch tip of pencil with brush dipped in clean water

Transfer to artwork for smooth washes

The longer the brush moves on the pigment, the darker the tone

Dry, wet and dry approach

Images can be blocked in position dry, and a clean water wash can then be placed over them. This achieves an area of solid colour/tint with a smooth appearance. When this is dry, fine detailed drawing can be overlaid to follow form and create texture.

Controlled textures

Place image shape dry on dry

Wash clean water over to blend and allow to dry

Draw directionally dry on dry to follow form and suggest contoured texture

Watersoluble graphite

Watersoluble graphite is useful for sketchbook work. Images may be swiftly sketched on site and elaborated upon at home, using watercolour pencils. The subjects can be interpreted in detail or in the form of tonal blocks and shapes.

Do not assume that the whole image is safely fixed in position once it has been washed with water. There may be small areas that you have unintentionally missed, and these will blend into each new application of a clean colour – however, you may wish for this random effect to happen.

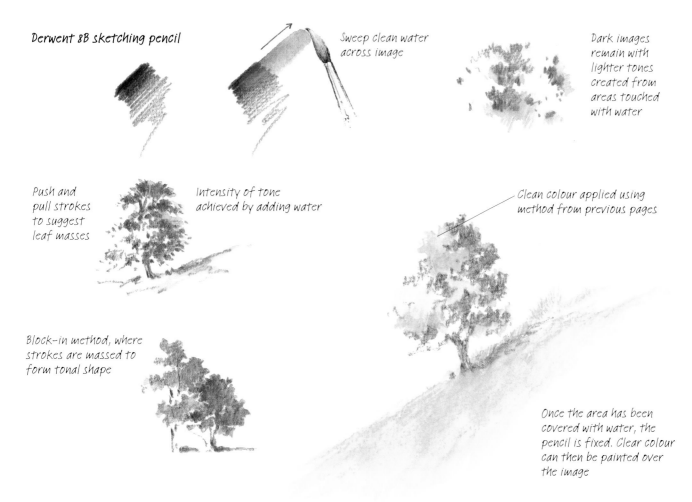

Derwent 8B sketching pencil

Sweep clean water across image

Dark images remain with lighter tones created from areas touched with water

Push and pull strokes to suggest leaf masses

Intensity of tone achieved by adding water

Clean colour applied using method from previous pages

Block-in method, where strokes are massed to form tonal shape

Once the area has been covered with water, the pencil is fixed. Clear colour can then be painted over the image

Locations and Views: **Typical Problems**

Low hills, found in gently undulating countryside, are often clad in a variety of trees, and the rounded forms of deciduous trees contrast with the pointed tips of conifers. Distant buildings, either dotted amongst the trees on the hillside or grouped at its base, can offer contrasting shapes to the expanses of fields and open spaces. The latter in their turn provide an interesting patchwork effect, and if all this is reflected in the surface of a winding stream or river, there is much for the eye to take in.

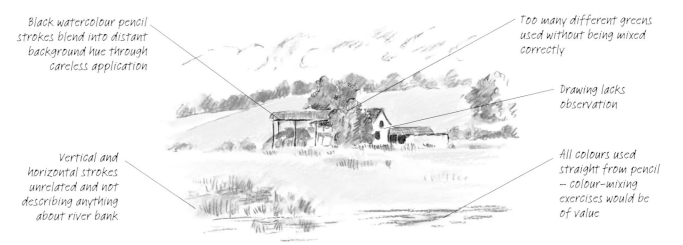

Black watercolour pencil strokes blend into distant background hue through careless application

Too many different greens used without being mixed correctly

Drawing lacks observation

Vertical and horizontal strokes unrelated and not describing anything about river bank

All colours used straight from pencil – colour-mixing exercises would be of value

View up river

On location it is possible to make a number of sketches from one position and then change the view entirely by turning to the right or left. This sketch shows tree-clad hills with an assortment of buildings grouped along their base, following the bank of a river.

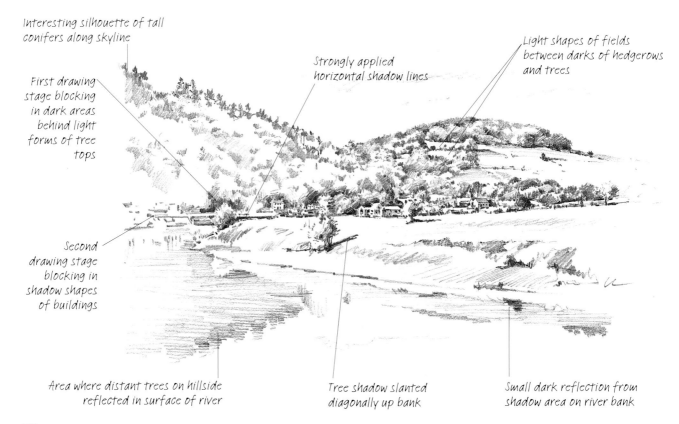

Interesting silhouette of tall conifers along skyline

First drawing stage blocking in dark areas behind light forms of tree tops

Strongly applied horizontal shadow lines

Light shapes of fields between darks of hedgerows and trees

Second drawing stage blocking in shadow shapes of buildings

Area where distant trees on hillside reflected in surface of river

Tree shadow slanted diagonally up bank

Small dark reflection from shadow area on river bank

Solutions

These two watercolour-pencil views across the river show a Dutch barn. This view, with wide expanses of water in the foreground, allows the inclusion of foliage on a tree on the near-side bank, depicted mainly by dark silhouettes. Watercolour pencils were used

delicately dry on dry before clean water was gently washed over the images to blend them. After the first layer had dried, subsequent layers were built.

Saunders Waterford Rough paper was used for both these demonstrations.

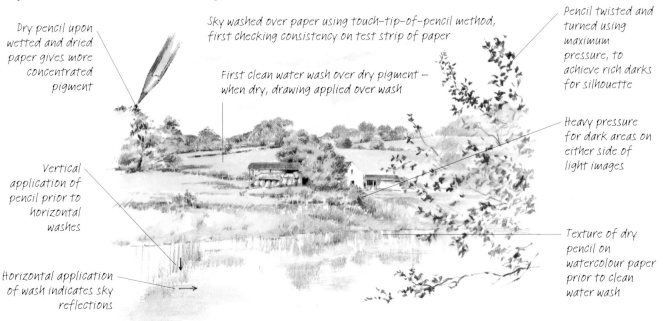

Dry pencil upon wetted and dried paper gives more concentrated pigment

Sky washed over paper using touch-tip-of-pencil method, first checking consistency on test strip of paper

Pencil twisted and turned using maximum pressure, to achieve rich darks for silhouette

First clean water wash over dry pigment – when dry, drawing applied over wash

Heavy pressure for dark areas on either side of light images

Vertical application of pencil prior to horizontal washes

Horizontal application of wash indicates sky reflections

Texture of dry pencil on watercolour paper prior to clean water wash

Low hills as backdrop

Moving in closer to the focal point and using the hills as a backdrop, this drawing shows a looser approach to

the scene. All the underdrawing was executed in watersoluble graphite pencil prior to freely applying watercolour pencil washes using the palette method.

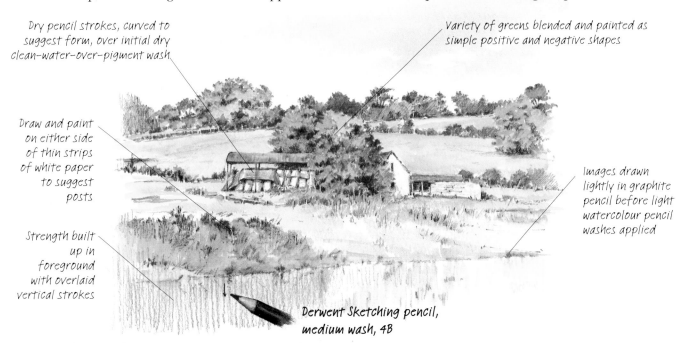

Dry pencil strokes, curved to suggest form, over initial dry clean-water-over-pigment wash

Variety of greens blended and painted as simple positive and negative shapes

Draw and paint on either side of thin strips of white paper to suggest posts

Images drawn lightly in graphite pencil before light watercolour pencil washes applied

Strength built up in foreground with overlaid vertical strokes

Derwent Sketching pencil, medium wash, 4B

Larger Hills: **Typical Problems**

From the gently undulating hills on the previous pages, we now look at higher structures whose scale is emphasized by the presence of small islands in the area of water. From this distance the water seems undisturbed, and it can be suggested by a simple, flat wash reflecting a blue sky. Working with tinted washes over a drawing executed in either permanent or watersoluble media encourages a looser approach.

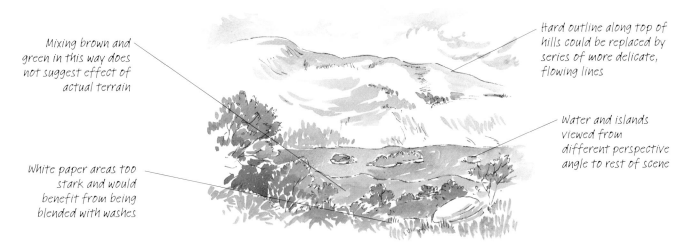

Mixing brown and green in this way does not suggest effect of actual terrain

Hard outline along top of hills could be replaced by series of more delicate, flowing lines

White paper areas too stark and would benefit from being blended with washes

Water and islands viewed from different perspective angle to rest of scene

Working in pen and ink
A few images that may be found in this type of setting have been arranged here with method suggestions for you to practise and put into effect in your own studies.

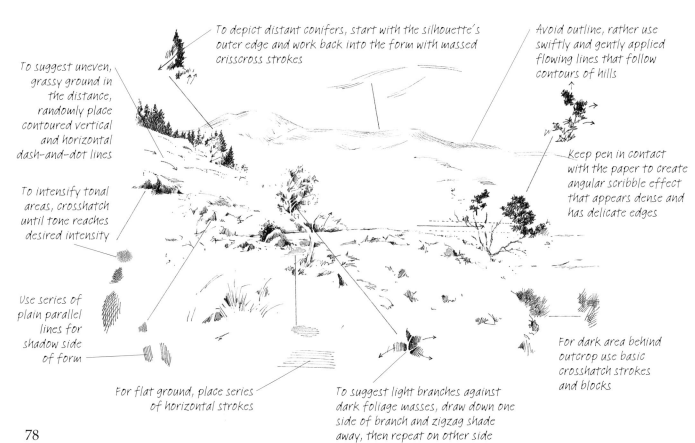

To suggest uneven, grassy ground in the distance, randomly place contoured vertical and horizontal dash-and-dot lines

To depict distant conifers, start with the silhouette's outer edge and work back into the form with massed crisscross strokes

Avoid outline, rather use swiftly and gently applied flowing lines that follow contours of hills

To intensify tonal areas, crosshatch until tone reaches desired intensity

Keep pen in contact with the paper to create angular scribble effect that appears dense and has delicate edges

Use series of plain parallel lines for shadow side of form

For flat ground, place series of horizontal strokes

To suggest light branches against dark foliage masses, draw down one side of branch and zigzag shade away, then repeat on other side

For dark area behind outcrop use basic crosshatch strokes and blocks

Solutions

I used an old sheet of paper for this painting, to encourage freedom of thought, as it prevents one from feeling the work is too precious, releases inhibitions and increases confidence; and I treated this scene as a learning exercise in which the methods shown on the opposite page could be put into practice.

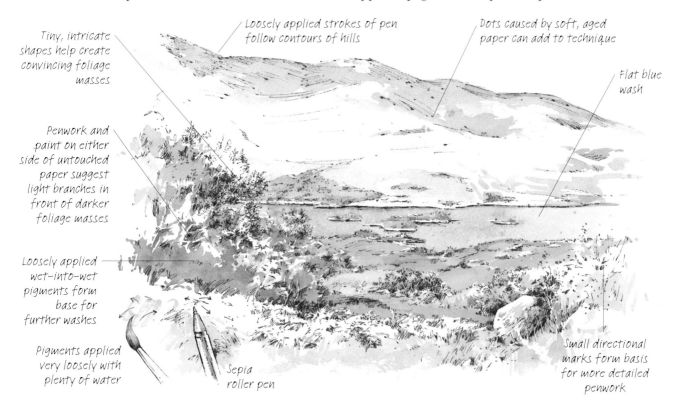

Tiny, intricate shapes help create convincing foliage masses

Loosely applied strokes of pen follow contours of hills

Dots caused by soft, aged paper can add to technique

Flat blue wash

Penwork and paint on either side of untouched paper suggest light branches in front of darker foliage masses

Loosely applied wet-into-wet pigments form base for further washes

Pigments applied very loosely with plenty of water

Sepia roller pen

Small directional marks form basis for more detailed penwork

Trial and error

Observing rocks close up helps you to understand the subject and how it relates to other components within the view. Using charcoal pencil marks as the underdrawing encourages a looser approach – in addition, I suggest you sometimes use old watercolour paper offcuts for a trial-and-error exercise – a learning experience rather than a careful study, as in the drawing above. The first stage is to draw shadow lines on rocks and then gently apply clean water over these directionally to fix them.

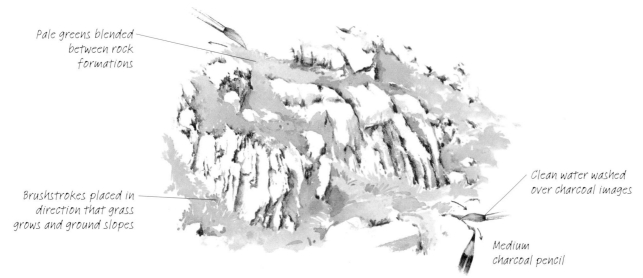

Pale greens blended between rock formations

Clean water washed over charcoal images

Brushstrokes placed in direction that grass grows and ground slopes

Medium charcoal pencil

Mountains: **Typical Problems**

Snow-capped mountains often have grassy areas against the sheer rock face, lower down, where the air is warmer. The cool blue greys of upper slopes in shadow are replaced in lower regions by warmer hues in the rocks and bright, soft greens – where fresh young grasses spring to life among the crevices as well as over larger expanses. The stark contrasts of lights against darks bring this type of scenery to life.

Too-even placing of certain images produces unsatisfactory composition

Wrong choice of green in watercolour pencils

Not clear if this is shadow shape or area of rock

Worm-like lines do not suggest craggy shadow lines along cracks in rocks

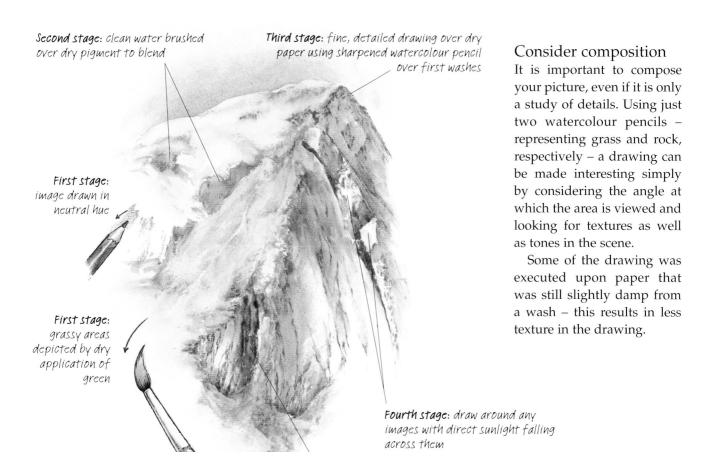

Second stage: clean water brushed over dry pigment to blend

Third stage: fine, detailed drawing over dry paper using sharpened watercolour pencil over first washes

First stage: image drawn in neutral hue

First stage: grassy areas depicted by dry application of green

Fourth stage: draw around any images with direct sunlight falling across them

Fifth stage: enrich dark (shadow) areas by increasing pressure on pencil

Consider composition

It is important to compose your picture, even if it is only a study of details. Using just two watercolour pencils – representing grass and rock, respectively – a drawing can be made interesting simply by considering the angle at which the area is viewed and looking for textures as well as tones in the scene.

Some of the drawing was executed upon paper that was still slightly damp from a wash – this results in less texture in the drawing.

Solutions

Although this exercise was executed in watercolour, you can easily follow exactly the same methods using watercolour pencils. Either touch the tip of the pencils with clean water to lift pigment prior to application, or, in order to mix colours, use the palette method mentioned on page 74.

Remember to let your brushstrokes follow directions suggested to you by the form of the subject, for instance sweep strokes down and swirl them around to suggest the open area of grass.

Method

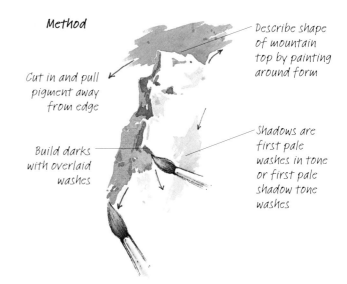

Cut in and pull pigment away from edge

Build darks with overlaid washes

Describe shape of mountain top by painting around form

Shadows are first pale washes in tone or first pale shadow tone washes

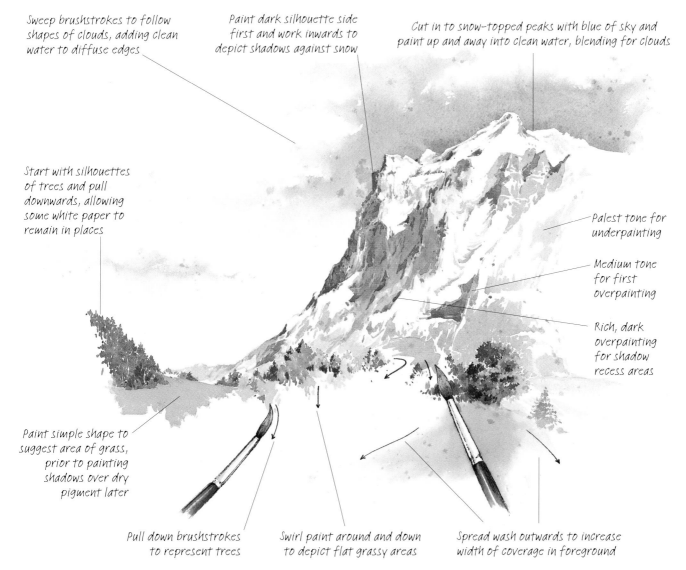

Sweep brushstrokes to follow shapes of clouds, adding clean water to diffuse edges

Paint dark silhouette side first and work inwards to depict shadows against snow

Cut in to snow-topped peaks with blue of sky and paint up and away into clean water, blending for clouds

Start with silhouettes of trees and pull downwards, allowing some white paper to remain in places

Palest tone for underpainting

Medium tone for first overpainting

Rich, dark overpainting for shadow recess areas

Paint simple shape to suggest area of grass, prior to painting shadows over dry pigment later

Pull down brushstrokes to represent trees

Swirl paint around and down to depict flat grassy areas

Spread wash outwards to increase width of coverage in foreground

Demonstration: Distant Mountain

Distant mountains shrouded in mist or muted in tone and colour sometimes present the problem of how to subdue colours and tones without adding too much white to the paint.

After time spent giving some thought to this problem, I chose to use mixed media on a tinted paper to unify the tones. The underpainting was approached in a free style of relatively loosely applied, directional brushstrokes using a very limited palette. It was my decision to subdue the colours with an overlaid wash that allowed the image to recede and sit comfortably in the distance.

Planning the composition

A rough sketch establishes the scene as a whole before deciding upon an aspect that will be chosen after consideration for the position of a focal point.

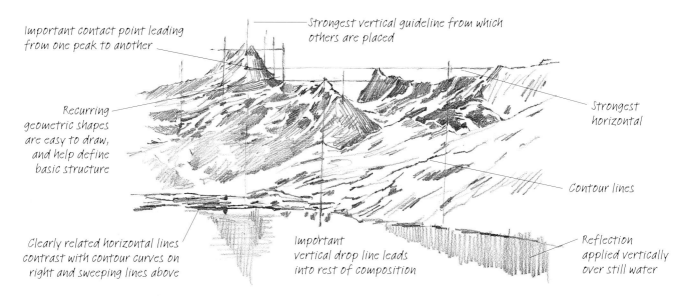

Important contact point leading from one peak to another

Strongest vertical guideline from which others are placed

Recurring geometric shapes are easy to draw, and help define basic structure

Strongest horizontal

Contour lines

Clearly related horizontal lines contrast with contour curves on right and sweeping lines above

Important vertical drop line leads into rest of composition

Reflection applied vertically over still water

Choice of aspect

Moving in closer to the focal point in a working sketch, the main areas of tone were drawn freely with a soft pencil on cartridge paper.

With tracing paper placed over this drawing, upon which only the essential lines were depicted, the image could then be easily transferred to a suitable tinted surface, shown opposite.

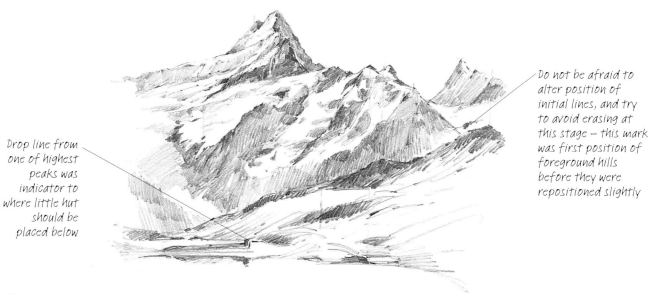

Drop line from one of highest peaks was indicator to where little hut should be placed below

Do not be afraid to alter position of initial lines, and try to avoid erasing at this stage – this mark was first position of foreground hills before they were repositioned slightly

Mixed-media painting

The use of an acrylic type of paint that is permanent once dry enables a wash of diluted white to be drawn across the whole of the underpainting using a flat brush. This gives a subdued effect without lifting or blending any of the colour beneath. When this surface is dry it forms a suitable base for fine, detailed drawing.

The softness of watercolour pencils led me to choose them as the second media.

I used Somerset Velvet, Newsprint Grey, as this paper has an appealing softness that encourages the use of watercolour pencil drawing – for completing the work over dry paint – and the tint of the paper was part of the final effect.

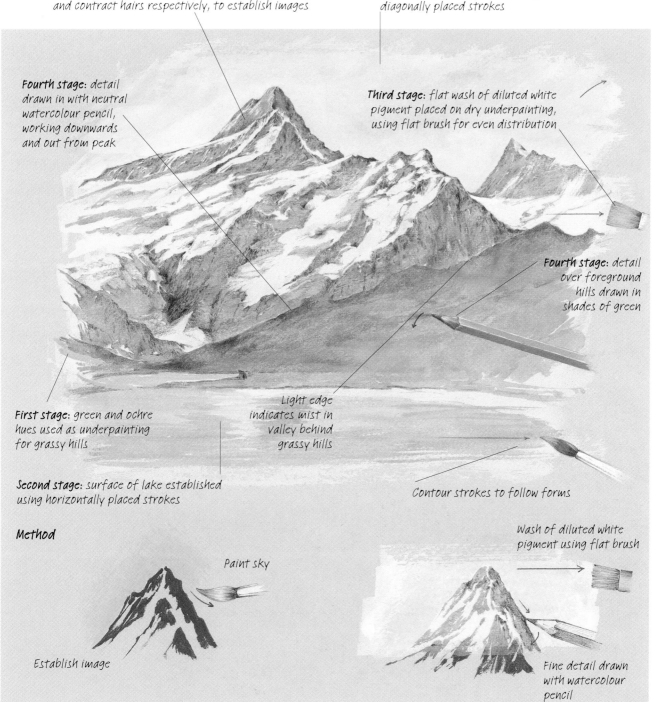

First stage: draw with brush, using varied pressure to spread and contract hairs respectively, to establish images

Second stage: sky painted freely with diagonally placed strokes

Fourth stage: detail drawn in with neutral watercolour pencil, working downwards and out from peak

Third stage: flat wash of diluted white pigment placed on dry underpainting, using flat brush for even distribution

Fourth stage: detail over foreground hills drawn in shades of green

First stage: green and ochre hues used as underpainting for grassy hills

Light edge indicates mist in valley behind grassy hills

Second stage: surface of lake established using horizontally placed strokes

Contour strokes to follow forms

Method

Paint sky

Establish image

Wash of diluted white pigment using flat brush

Fine detail drawn with watercolour pencil

Bridges and Buildings

Drawing exercises

These pencil strokes demonstrate how thick and thin lines can be achieved by turning the pencil after you have established a chisel shape when making an initial tonal block with a soft pencil.

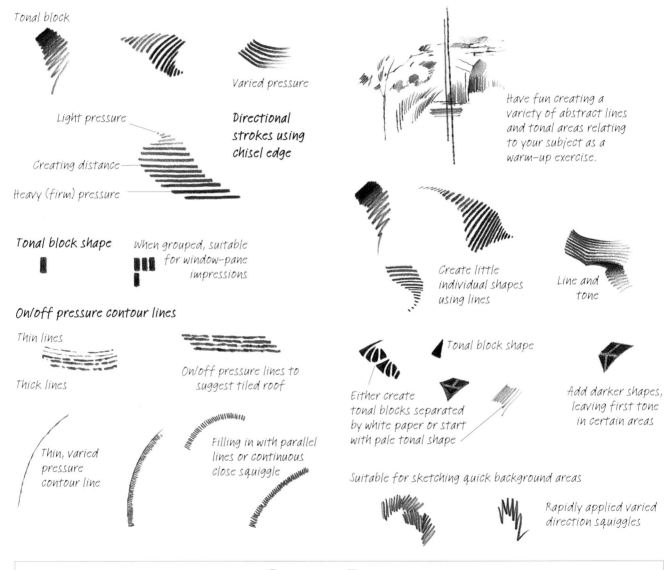

Tonal block

Varied pressure

Light pressure

Directional strokes using chisel edge

Creating distance

Heavy (firm) pressure

Tonal block shape

When grouped, suitable for window-pane impressions

On/off pressure contour lines

Thin lines

Thick lines

On/off pressure lines to suggest tiled roof

Thin, varied pressure contour line

Filling in with parallel lines or continuous close squiggle

Have fun creating a variety of abstract lines and tonal areas relating to your subject as a warm-up exercise.

Create little individual shapes using lines

Line and tone

Tonal block shape

Either create tonal blocks separated by white paper or start with pale tonal shape

Add darker shapes, leaving first tone in certain areas

Suitable for sketching quick background areas

Rapidly applied varied direction squiggles

CHOOSING PENCILS

Hard and soft grades of pencil react differently on various paper surfaces. You may find you prefer to use a harder HB or 2B on a softer, textured surface, and a softer 4B or 9B upon a smoother, white paper for richer contrasts.

2H

HB

2B

4B

6B

9B

'Studio' coloured pencils

This medium is useful for creating flat tonal areas and interesting lines.

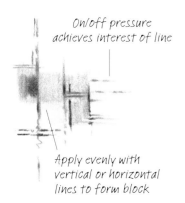

On/off pressure achieves interest of line

Apply evenly with vertical or horizontal lines to form block

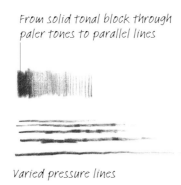

From solid tonal block through paler tones to parallel lines

Varied pressure lines

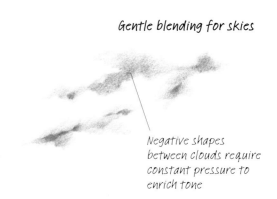

Gentle blending for skies

Negative shapes between clouds require constant pressure to enrich tone

Charcoal pencil

Charcoal pencils are light, medium or dark. They break easily, need to be handled with care and require the use of fixative, but are well worth these considerations, as they encourage loose, exciting application and produce an interesting range of contrasts and textures.

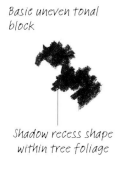

Basic uneven tonal block

Shadow recess shape within tree foliage

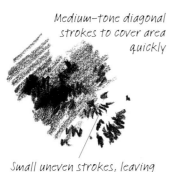

Medium-tone diagonal strokes to cover area quickly

Small uneven strokes, leaving area of white paper to suggest highlights

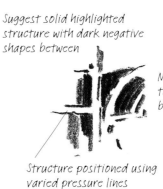

Suggest solid highlighted structure with dark negative shapes between

Negative tonal block

Structure positioned using varied pressure lines

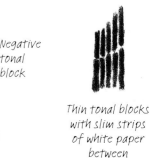

Thin tonal blocks with slim strips of white paper between

Ink and wash

A monochrome wash used with ink drawing is very effective for drawing both man-made and natural structures. For this exercise, the ink drawing was made first and the wash was freely applied over the linear work when it had dried completely.

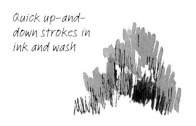

Quick up-and-down strokes in ink and wash

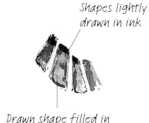

Shapes lightly drawn in ink

Drawn shape filled in with tonal washes

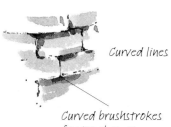

Curved lines

Curved brushstrokes for tonal areas

Watercolour exercises

These watercolour exercise strokes relate to images within this theme and, like the pencil exercises on the previous pages, benefit from being applied with on/off pressure and angled movements of the brush. Working wet into wet – adding water for blending and dropping dark pigment onto damp paper, thus enabling the effect of bleeding to appear – contrasts with working wet on dry, overlaying a wash onto paint that has already dried.

Overlays

Ensure the first wash has thoroughly dried before you gently apply a second wash either fully or partially over the underpainting. Try this exercise in monochrome first so that you can become fully aware of the tonal variations as you build the layers.

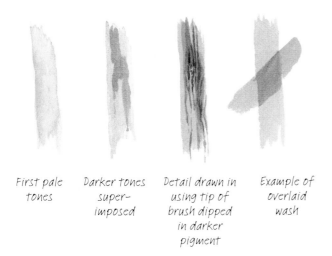

First pale tones

Darker tones super-imposed

Detail drawn in using tip of brush dipped in darker pigment

Example of overlaid wash

Tonal variations

When tones are not built up using overlaid washes, they can be swiftly achieved by adding clean water to certain areas of the existing damp pigment. This incorporates the wet-into-wet method, and there will also be clean water strokes that come in to touch edges of pigmented areas and encourage bleeding, giving you more control within this method.

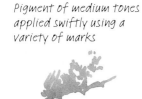

Pigment of medium tones applied swiftly using a variety of marks

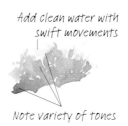

Add clean water with swift movements

Note variety of tones

On/off pressure lines

These on/off lines are very similar to those used in the combination exercises on page 60; here, however, they are not combined, but used in a repetitious manner.

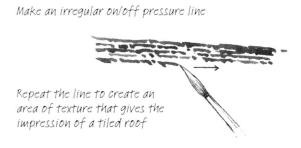

Make an irregular on/off pressure line

Repeat the line to create an area of texture that gives the impression of a tiled roof

Touch and blend

When depicting stones, bricks and the like, look to create the desired effect with as few marks as possible on the paper. Be selective, not only with the amount of darks you draw or place with your brush, but also with how much (or little) clean water you introduce to cause blending – and be aware of the importance of retaining white paper as part of the image.

Stones and bricks

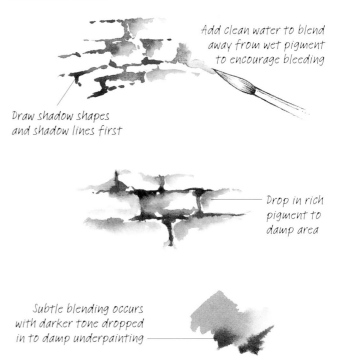

Add clean water to blend away from wet pigment to encourage bleeding

Draw shadow shapes and shadow lines first

Drop in rich pigment to damp area

Subtle blending occurs with darker tone dropped in to damp underpainting

Dark behind

The best way to make your light images stand forward is to introduce a darker tone directly behind the form. It is easy to inadvertently allow brushstrokes that indicate a background area to overlap the light image in front, but doing so fails to create the desired effect. This exercise illustrates how you can avoid losing clarity by cutting in.

Dark within

Quite often it is necessary to depict shadow recess areas within the forms. Here, it is important to understand exactly what you are trying to say with your areas of tone, so make sure the recess shape is convincing.

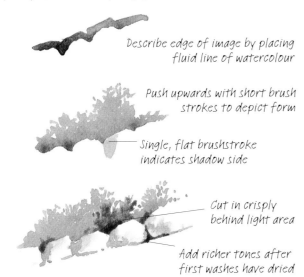

Mix plenty of water with your pigment to retain a reservoir

Describe edge of image by placing fluid line of watercolour

Push upwards with short brush strokes to depict form

Single, flat brushstroke indicates shadow side

Cut in crisply behind light area

Add richer tones after first washes have dried

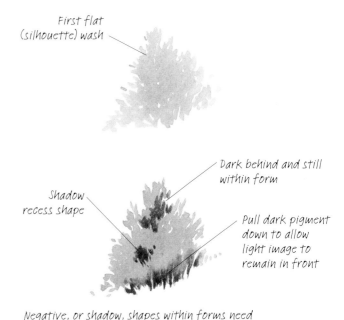

First flat (silhouette) wash

Dark behind and still within form

Shadow recess shape

Pull dark pigment down to allow light image to remain in front

Negative, or shadow, shapes within forms need careful consideration if they are to be successful.

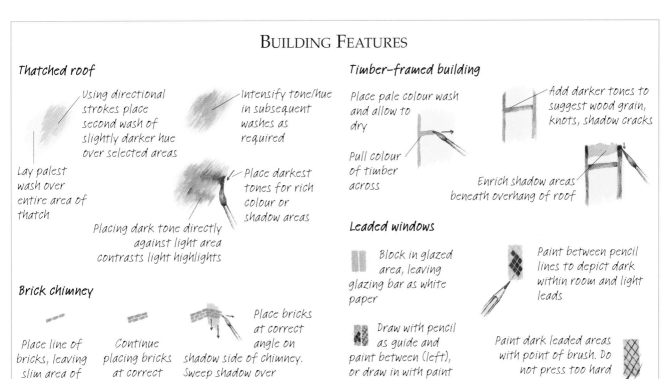

BUILDING FEATURES

Thatched roof

Using directional strokes place second wash of slightly darker hue over selected areas

Intensify tone/hue in subsequent washes as required

Lay palest wash over entire area of thatch

Place darkest tones for rich colour or shadow areas

Placing dark tone directly against light area contrasts light highlights

Brick chimney

Place line of bricks, leaving slim area of paper between each one

Continue placing bricks at correct perspective angle

Place bricks at correct angle on shadow side of chimney. Sweep shadow over painting of bricks using swift downward strokes

Timber-framed building

Place pale colour wash and allow to dry

Pull colour of timber across

Add darker tones to suggest wood grain, knots, shadow cracks

Enrich shadow areas beneath overhang of roof

Leaded windows

Block in glazed area, leaving glazing bar as white paper

Paint between pencil lines to depict dark within room and light leads

Draw with pencil as guide and paint between (left), or draw in with paint and brush for dark leads (right)

Paint dark leaded areas with point of brush. Do not press too hard

Small Structures: **Typical Problems**

Small structures may not have the grandeur of their larger counterparts, as shown overleaf, but they do possess their own particular charm. A small stone bridge and a compact country cottage are depicted here in watercolour and show both methods of laying washes:

wet-on-dry, used for the cottage, and a controlled wet-into-wet approach, used for the bridge. You can also see problems relating to the inclusion (or, should I say, intrusion) of white paper and the overuse of outlines, as well as with the choice of colours.

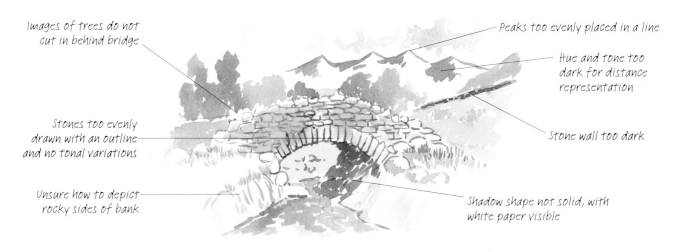

Images of trees do not cut in behind bridge

Peaks too evenly placed in a line

Hue and tone too dark for distance representation

Stones too evenly drawn with an outline and no tonal variations

Stone wall too dark

Unsure how to depict rocky sides of bank

Shadow shape not solid, with white paper visible

Solution

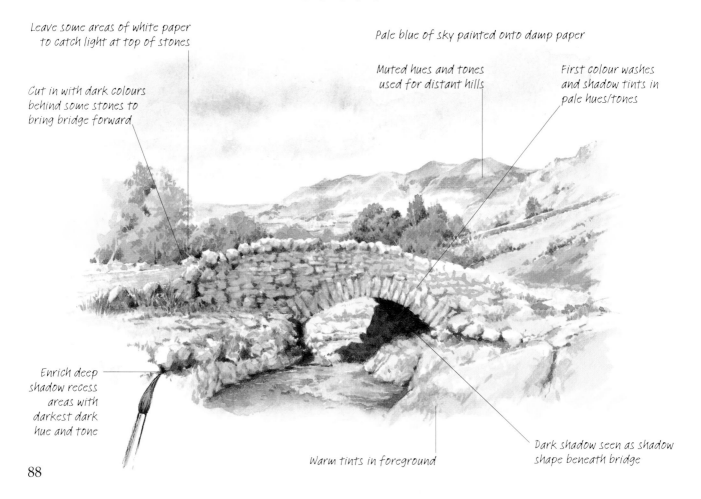

Leave some areas of white paper to catch light at top of stones

Pale blue of sky painted onto damp paper

Muted hues and tones used for distant hills

First colour washes and shadow tints in pale hues/tones

Cut in with dark colours behind some stones to bring bridge forward

Enrich deep shadow recess areas with darkest dark hue and tone

Warm tints in foreground

Dark shadow seen as shadow shape beneath bridge

Small Structures: **Typical Problems**

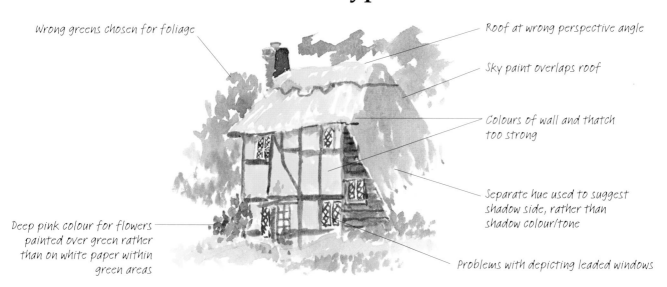

Wrong greens chosen for foliage

Roof at wrong perspective angle

Sky paint overlaps roof

Colours of wall and thatch too strong

Separate hue used to suggest shadow side, rather than shadow colour/tone

Deep pink colour for flowers painted over green rather than on white paper within green areas

Problems with depicting leaded windows

Solution

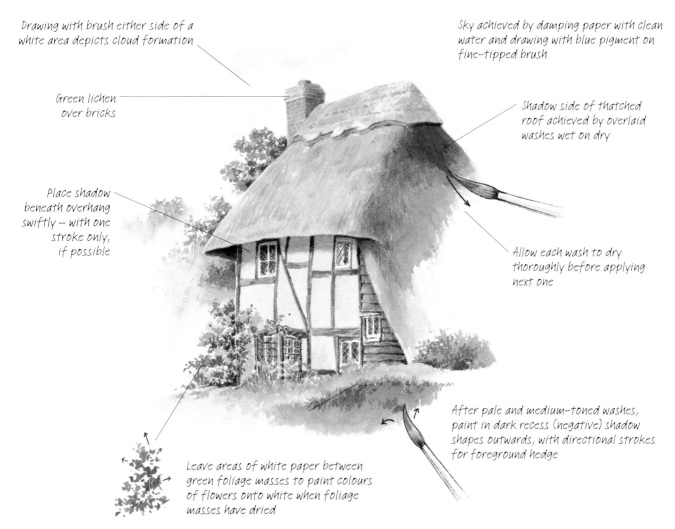

Drawing with brush either side of a white area depicts cloud formation

Sky achieved by damping paper with clean water and drawing with blue pigment on fine-tipped brush

Green lichen over bricks

Shadow side of thatched roof achieved by overlaid washes wet on dry

Place shadow beneath overhang swiftly – with one stroke only, if possible

Allow each wash to dry thoroughly before applying next one

After pale and medium-toned washes, paint in dark recess (negative) shadow shapes outwards, with directional strokes for foreground hedge

Leave areas of white paper between green foliage masses to paint colours of flowers onto white when foliage masses have dried

Buildings on Bridges: **Typical Problems**

Towers on suspension bridges present a structure that offers height as well as width and length. This view depicts an angle from which the graceful lines of massive girders can be drawn to lead the observer's eye towards the focal point of the main tower block. This is enhanced by the contrasting, sharp-edged shape of a strong area of shadow.

Coloured pencils encourage a delicacy of interpretation in the form of detailed drawing, enhancing the subject. Problems may arise, however, if the chosen pencils are not the sort that are ideal for detailed work, as in the sketch below, where the width of the pencil's coloured strip combined with heavy-handed use prevents the delicacy required for this scale and interpretation from being achieved.

Pen and ink sketch

The sketch below was executed using the dot/dash approach combined with vertical- (parallel-) lined shading. I used a finer nib for the shadow areas.

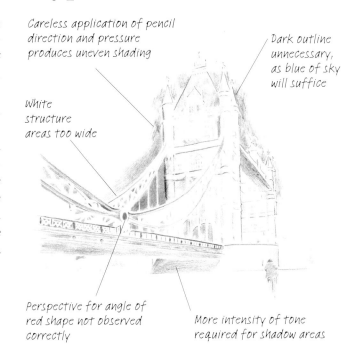

Careless application of pencil direction and pressure produces uneven shading

Dark outline unnecessary, as blue of sky will suffice

White structure areas too wide

Perspective for angle of red shape not observed correctly

More intensity of tone required for shadow areas

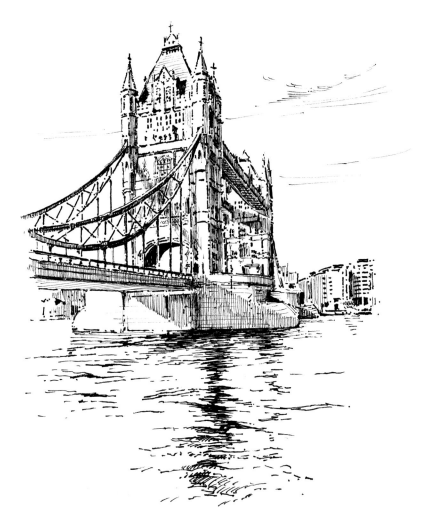

Solutions

In this drawing a change to 'studio' pencils, with their slim colour strips, has enabled a delicacy of detail to emerge as a result of careful handling and interpretation.

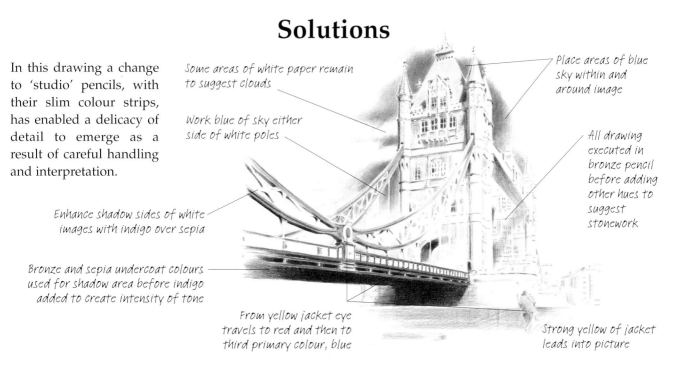

Some areas of white paper remain to suggest clouds

Work blue of sky either side of white poles

Place areas of blue sky within and around image

All drawing executed in bronze pencil before adding other hues to suggest stonework

Enhance shadow sides of white images with indigo over sepia

Bronze and sepia undercoat colours used for shadow area before indigo added to create intensity of tone

From yellow jacket eye travels to red and then to third primary colour, blue

Strong yellow of jacket leads into picture

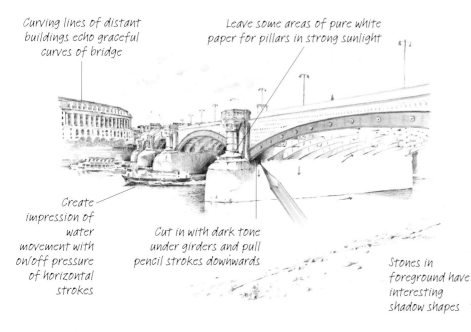

Curving lines of distant buildings echo graceful curves of bridge

Leave some areas of pure white paper for pillars in strong sunlight

Create impression of water movement with on/off pressure of horizontal strokes

Cut in with dark tone under girders and pull pencil strokes downwards

Stones in foreground have interesting shadow shapes

Low arched bridge

Before progressing into full colour, you may wish to try a combination of graphite drawing with limited colour. Here, I shaded a dark flesh watercolour pencil direct onto Bristol board, and then gently added water to blend the pigment and enable me to include more drawing over the (dried) colour.

Exploratory sketch

At whichever angle you choose to depict your image, it is helpful to view and sketch it from different angles.

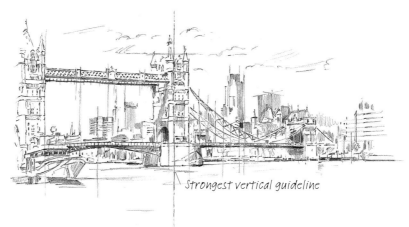

Strongest vertical guideline

Iron Bridges: **Typical Problems**

Whether in a high arched bridge spanning a narrow waterway or a series of arches supported upon stone pillars crossing a wider expanse of water, the patterns created by positive and negative shapes can sometimes cause problems for novice artists. The numerous shapes, curves, contours and contrasts incorporated within the structure provide a maze that can mystify and confuse, but by concentrating on negative shapes and shadow shapes, as well as the more obvious positives, many problems can be solved.

Open ironwork structures are an excellent example of pattern, where consideration of the shapes between the ironwork, and their relationship with each other, will solve perspective problems.

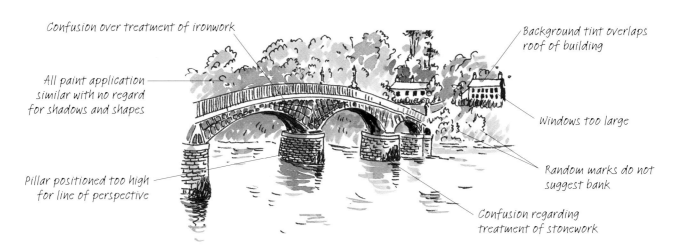

Confusion over treatment of ironwork

All paint application similar with no regard for shadows and shapes

Pillar positioned too high for line of perspective

Background tint overlaps roof of building

Windows too large

Random marks do not suggest bank

Confusion regarding treatment of stonework

Quick tonal sketch

Pen and ink with a monochrome tinted wash allows a gradual build-up of tones that results in exciting contrasts when the wider span pillars are viewed one in front of the other. In this study, the inclusion of buildings gives some idea of the scale of the bridge.

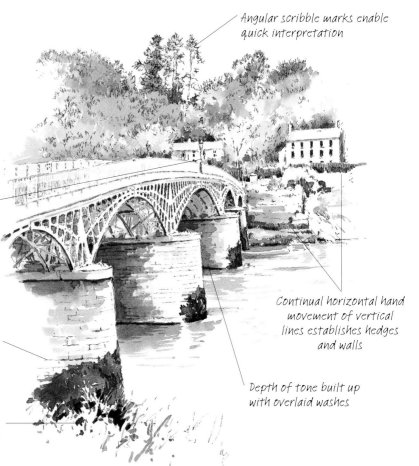

Angular scribble marks enable quick interpretation

Simple squiggle establishes form of lamppost quickly

Shadow lines within blockwork indicated with tonal brush marks

Dark negative shapes within weeds and grass masses

Continual horizontal hand movement of vertical lines establishes hedges and walls

Depth of tone built up with overlaid washes

Solutions

Although the bridge may be a complex structure, a pencil sketch can simplify it. The tree-clad hills rising up behind the buildings are depicted in simply applied directional tonal blocks, and the bridge can be positioned accurately in relation to this backdrop using lightly drawn guidelines and observing the negative shapes. Bristol board is an ideal surface for this technique, as it is possible to add detail over the initial tonal blocks.

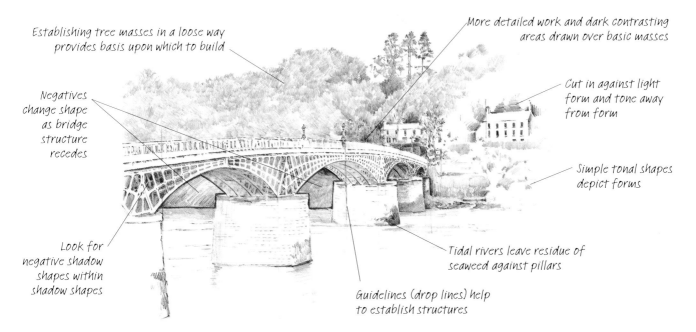

Establishing tree masses in a loose way provides basis upon which to build

More detailed work and dark contrasting areas drawn over basic masses

Cut in against light form and tone away from form

Negatives change shape as bridge structure recedes

Simple tonal shapes depict forms

Look for negative shadow shapes within shadow shapes

Tidal rivers leave residue of seaweed against pillars

Guidelines (drop lines) help to establish structures

Noticing the negatives

This drawing of a short-span iron bridge demonstrates the use of charcoal to create strong shadow shapes (the positive iron structure) and, by toning in the dark negatives, how the light positive shapes may be brought forward. I used soft charcoal pencil to enhance the darks to their full potential. Charcoal is also ideal when creating subtle areas of light and medium tones, such as over stonework in shadow, encouraging light shapes to stand forward on both sides of the bridge.

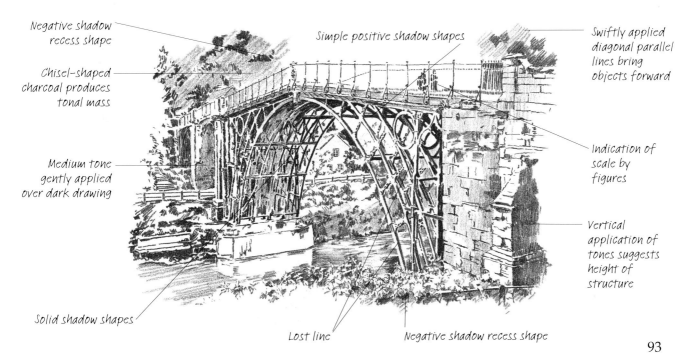

Negative shadow recess shape

Simple positive shadow shapes

Swiftly applied diagonal parallel lines bring objects forward

Chisel-shaped charcoal produces tonal mass

Medium tone gently applied over dark drawing

Indication of scale by figures

Vertical application of tones suggests height of structure

Solid shadow shapes

Lost line

Negative shadow recess shape

Demonstration: Windmill

Having analysed the structure of iron bridges, where the sky is visible through girders, it is interesting to compare a similar effect using the image of a windmill. The medium chosen for this demonstration is gouache, which enables the use of white paint on the sails in front of the sky and the main body of the building.

Working sketch

The initial sketch needs to be carefully executed using guidelines (drop lines) and horizontal lines that help to position other buildings in relation to the windmill. Strong shadows enhance the composition, and the shadow shapes made upon the ground help to contain the focal point lead-in, up to the top of the structure.

First stages

The image was then traced on to tinted Somerset Velvet paper in pencil. There are ten main stages of development to get the image established, which have been numbered in the order I worked, showing the initial pen drawing prior to all the areas of brushwork.

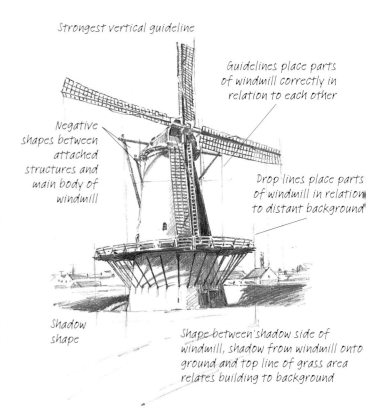

Strongest vertical guideline

Guidelines place parts of windmill correctly in relation to each other

Negative shapes between attached structures and main body of windmill

Drop lines place parts of windmill in relation to distant background

Shadow shape

Shape between shadow side of windmill, shadow from windmill onto ground and top line of grass area relates building to background

1 Use 0.1 Profipen to draw over pencilled image and erase pencil marks

2 Paint lightly with diluted pigment over sky area, allowing ink drawing to show through

3 Indicate shadow areas of clouds with directional strokes

4 Paint light edges of clouds up to greys and blues to describe forms

5 Paint shadow undercoat on side of building

6 Increase depth of shadow here and in other shadow areas

7 Cover side in direct sunlight with lighter hue

8 Paint lower part of structure with first light coat

9 Introduce dark side at base

10 Place first light colour over ground area

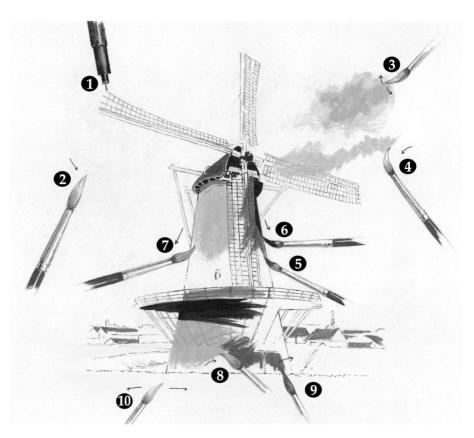

Final stages

Once the initial stages are complete, layers of gouache can be built up, one upon the other, and texture introduced where necessary using the drybrush technique.

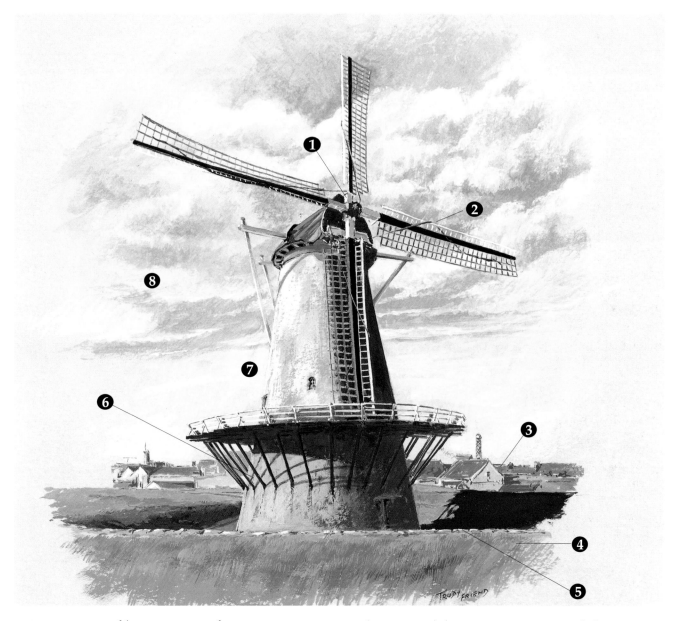

1 Note intricacies of busy area at top of structure
2 Use very fine brush for delicate lines
3 Avoid making warm hues of roofs too strong, to keep them in distance
4 Directional strokes indicate long grasses
5 Contrast very light areas against strongest darks
6 Include important shadows that enhance form
7 Pull almost dry paint across surface to create texture
8 Cloud formations become elongated as they recede into distance

Test your colour mixes on an offcut from your paper while you are working.

Country, Urban and City Landscapes

Drawing exercises

These tonal and linear pencil exercises demonstrate two extremes of use, and can be used alone or combined within a drawing. In this theme I refer to a method that tones up to, and away from, light edges, as well as the use of tonal blocks on either side of a light strip. Wandering lines help to describe form when creating loose sketches.

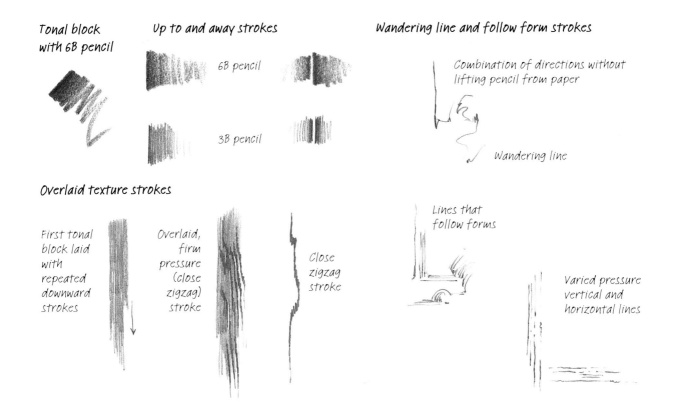

Tonal block with 6B pencil

Up to and away strokes

6B pencil

3B pencil

Wandering line and follow form strokes

Combination of directions without lifting pencil from paper

Wandering line

Overlaid texture strokes

First tonal block laid with repeated downward strokes

Overlaid, firm pressure (close zigzag) stroke

Close zigzag stroke

Lines that follow forms

Varied pressure vertical and horizontal lines

CHOOSING STROKES

You need to carefully consider strokes, their direction and application, for each subject you depict until their use becomes a natural habit. The more you can practise and experiment with angles, pressures, contours etc, the easier they become.

Vertical varied pressure

Normal writing position

Vertical outward gradation

Angle of hand achieved by keeping your elbow out and away from body

Fanning out With elbow closing in on body

Cut in and tone away

Pencil held above image with elbow on same line as pencil tip

Tip of pencil in cut-in position – elbow at side for push up, out and away strokes

Watercolour pencils

This versatile medium can be used both dry and wet to create interesting textures.

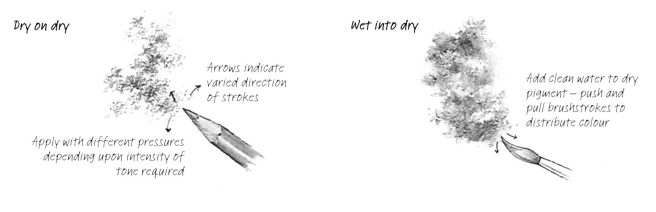

Dry on dry

Arrows indicate varied direction of strokes

Apply with different pressures depending upon intensity of tone required

Wet into dry

Add clean water to dry pigment – push and pull brushstrokes to distribute colour

Dry on dry

Sweep areas of pigment across surface of paper

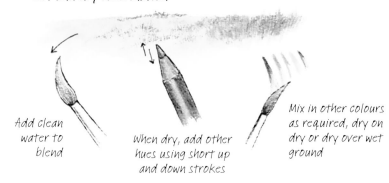

Wet and dry combination

Add clean water to blend

When dry, add other hues using short up and down strokes

Mix in other colours as required, dry on dry or dry over wet ground

The palette method

This is an ideal method for tinting pen-and-ink work where pale-tinted washes are required.

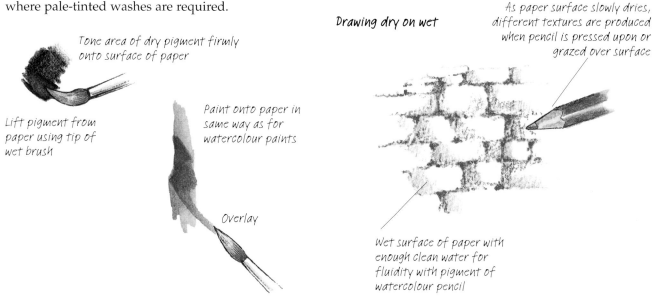

Tone area of dry pigment firmly onto surface of paper

Lift pigment from paper using tip of wet brush

Paint onto paper in same way as for watercolour paints

Overlay

Drawing dry on wet

As paper surface slowly dries, different textures are produced when pencil is pressed upon or grazed over surface

Wet surface of paper with enough clean water for fluidity with pigment of watercolour pencil

Watercolour pencil exercises

Watercolour pencil colour strips can be sharpened into a palette and mixed with water to create different hues. You can work in monochrome by applying the tip of a brush dipped in clean water to the colour strip of the pencil. Lift the pigment with the wet brush and paint it on the paper. Dry-on-dry images can be enhanced by adding water in sweeping strokes, blending the pigment to produce tinted washes over a softened image.

Clear water strokes

First draw the image dry on dry, then sweep clean water swiftly and lightly across your drawing. Experiment with the amount of water required so as not to erase the image by applying too much, or to smudge it by applying too little. Also practise leaving areas of white paper untouched where you wish to feature contrasting highlights.

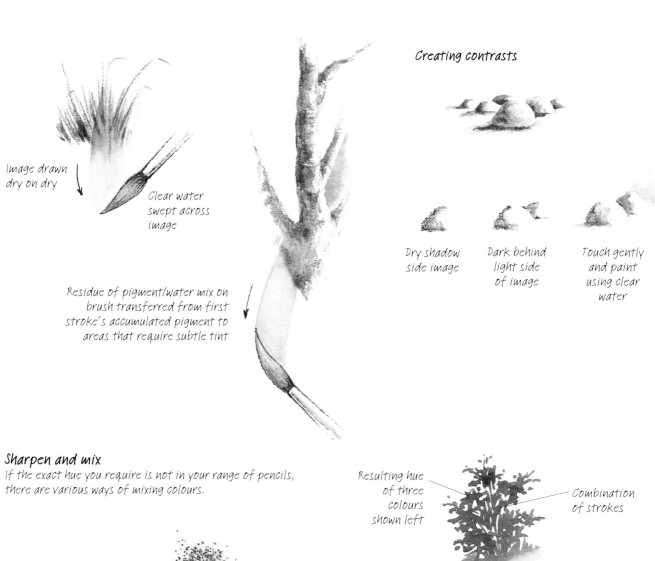

Image drawn dry on dry

Clear water swept across image

Residue of pigment/water mix on brush transferred from first stroke's accumulated pigment to areas that require subtle tint

Creating contrasts

Dry shadow side image

Dark behind light side of image

Touch gently and paint using clear water

Sharpen and mix
If the exact hue you require is not in your range of pencils, there are various ways of mixing colours.

Sharpen colours to be mixed into palette well

Add water and mix together with brush

Resulting hue of three colours shown left

Combination of strokes

Sweep stroke suggests ground

Touch tip and paint

Describe edge

Transfer the resulting pigment to paper and create images using a variety of strokes

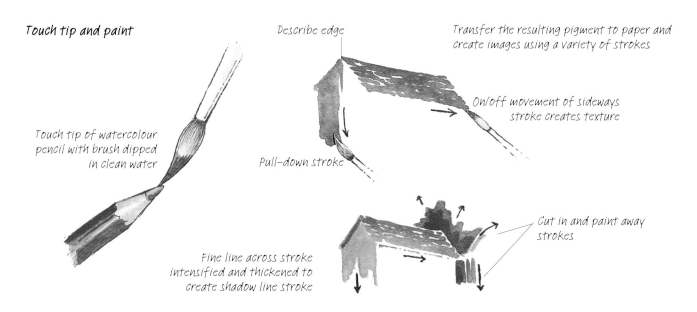

Touch tip of watercolour pencil with brush dipped in clean water

On/off movement of sideways stroke creates texture

Pull-down stroke

Cut in and paint away strokes

Fine line across stroke intensified and thickened to create shadow line stroke

Varied width strokes

Different widths of stroke can be achieved easily if you shape your brush prior to making a stroke. Press a medium-size brush (No. 8 or 9) into a pigment mix in the palette well, flattening the hairs to form a chisel shape, then use the narrow side you have created to produce very fine lines.

Normal (round shape) sweep-down stroke

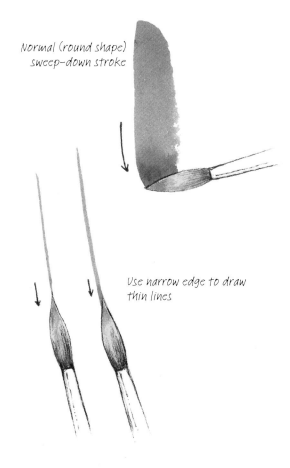

To create thin strokes

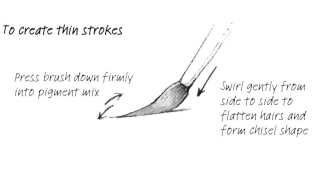

Press brush down firmly into pigment mix

Swirl gently from side to side to flatten hairs and form chisel shape

Use narrow edge to draw thin lines

Versatility of medium-size brush

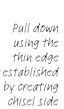

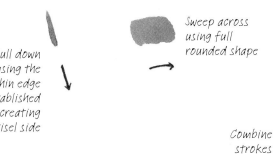

Pull down using the thin edge established by creating chisel side

Sweep across using full rounded shape

Combine strokes

Historic Building: **Typical Problems**

Half-timbered buildings tend to be associated with the countryside, but they may also be found within urban landscapes and historic towns. Sometimes the pattern of the woodwork may be superficial and only a façade, but whether they are an integral part of the structure or for cosmetic purposes only, the attractive patterns make interesting subjects for drawings and paintings.

Watercolour pencils are ideal for depicting this subject, as they can be used alone – wet or dry – or with another medium. They enable underdrawing and overpainting to work well together without the use of a second medium, such as graphite pencil.

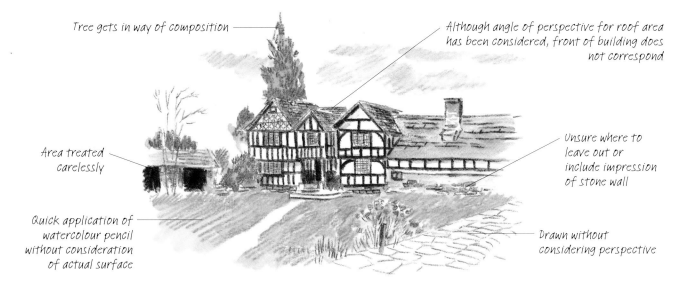

Tree gets in way of composition

Although angle of perspective for roof area has been considered, front of building does not correspond

Area treated carelessly

Unsure where to leave out or include impression of stone wall

Quick application of watercolour pencil without consideration of actual surface

Drawn without considering perspective

Mixed-media study

Making a monochrome study in mixed media – here, ivory black watercolour pencil and ink – enables you to pay attention to the drawing, which encourages close observation and helps with the correct placing of the dark timbers.

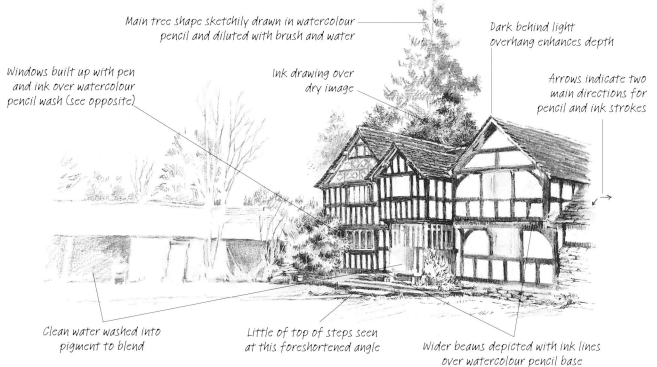

Main tree shape sketchily drawn in watercolour pencil and diluted with brush and water

Dark behind light overhang enhances depth

Windows built up with pen and ink over watercolour pencil wash (see opposite)

Ink drawing over dry image

Arrows indicate two main directions for pencil and ink strokes

Clean water washed into pigment to blend

Little of top of steps seen at this foreshortened angle

Wider beams depicted with ink lines over watercolour pencil base

Solutions

First application dry to tree moved within composition

Water added to blend

First drawing and simple colour washes position components

Depth of tone and colour enriched by adding damp pigment

Overlaid washes

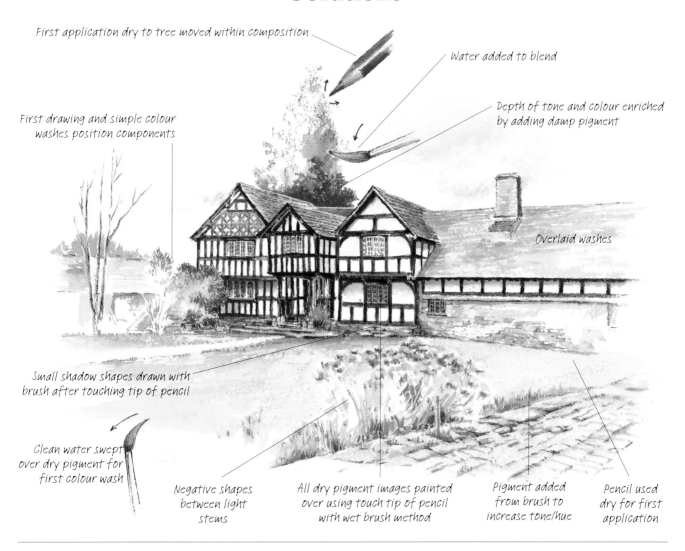

Small shadow shapes drawn with brush after touching tip of pencil

Clean water swept over dry pigment for first colour wash

Negative shapes between light stems

All dry pigment images painted over using touch tip of pencil with wet brush method

Pigment added from brush to increase tone/hue

Pencil used dry for first application

Building window image

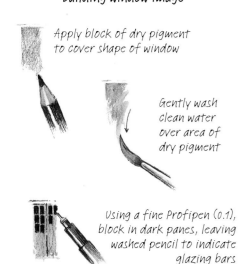

Apply block of dry pigment to cover shape of window

Gently wash clean water over area of dry pigment

Using a fine Profipen (0.1), block in dark panes, leaving washed pencil to indicate glazing bars

Wet and dry methods

Touching pencil tip

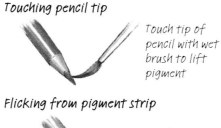

Touch tip of pencil with wet brush to lift pigment

Flicking from pigment strip

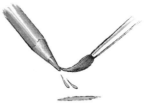

Flick downwards (towards palette or piece of practice paper) to drop diluted pigment for use from reservoir

Wetting dry pigment on paper

Draw image dry directly onto paper

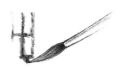

Dilute pigment with clean water on brush

Scale and Movement: **Typical Problems**

Viewing city buildings from a distance, without the movement suggested by the inclusion of people and traffic, can present an uninteresting, static landscape. If you are looking to create a feeling of movement, this can be achieved by choosing an angle that relates to disturbed water or a busy sky. When depicting the scale of tower blocks, it is useful to consider how this may be indicated, both at a distance and within the complex itself. You may also suggest a feeling of movement if you position your observation point in relation to water.

Watercolour study

Moving the observer's eye into your composition is important, and this sketch indicates how this can be achieved by the use of strongly angled forms – pathways and walls, etc. The same group of buildings as above right, viewed from a slightly different position, here introduces strong perspective angles that guide the eye into the picture.

No thought given to negative shape between buildings

Problems with perspective

Line dividing land and water should be horizontal

Structure incorrectly represented

Structures do not relate convincingly

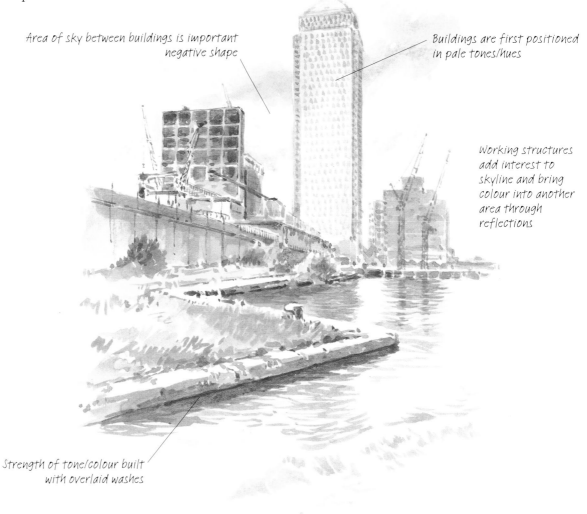

Area of sky between buildings is important negative shape

Buildings are first positioned in pale tones/hues

Working structures add interest to skyline and bring colour into another area through reflections

Strength of tone/colour built with overlaid washes

Solutions

We not only see movement in water but also in cloud formations in the sky. Either or both can help soften the image of tall, solid tower-block structures, creating movement within the picture.

Getting to know your subject

Wherever possible, familiarize yourself with buildings from different aspects, at a distance and close up. Standing within a complex of this nature, you move your eyes from the base of the structures up towards the sky. Small detailed pencil studies depicting patterns in glass-fronted buildings will help you understand how to select and simplify from the complexity of shapes you are confronted with. What you choose to leave out of your interpretation is just as important as what you choose to include.

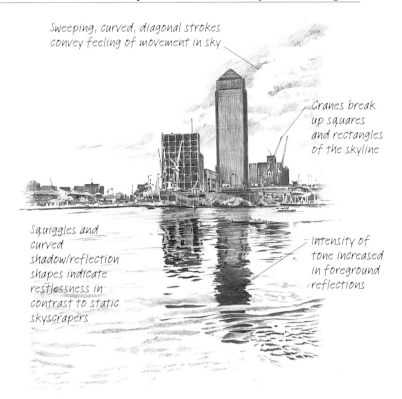

Sweeping, curved, diagonal strokes convey feeling of movement in sky

Cranes break up squares and rectangles of the skyline

Squiggles and curved shadow/reflection shapes indicate restlessness in contrast to static skyscrapers

Intensity of tone increased in foreground reflections

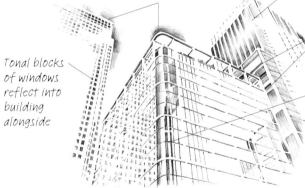

To enhance light forms against darker sky, apply pencil to outer edge of form and tone away

Tonal blocks of windows reflect into building alongside

Blending dark tone into light suggests light falling on subject

Simple abstract shapes indicate extreme perspective angles

Reflections of surrounding buildings

Curve of structure provides contrasting shape against verticals and angled horizontals of main building

The balance of busy areas

To comprehend the scale of buildings, freely interpreted sketches made while standing at the base of the structures enable you to introduce other relevant structures and the activity of figures. Both movement and scale should play a large part in your interpretation.

Glazing bars of main building drawn first

Reflection between bars (from separate buildings to the side) shows different perspective angle

Busy area at base of tower block introduces structures, trees, hedges and figures

Townscapes: **Typical Problems**

An effective way to create an impression of town or city streets is to observe and depict the view from a window that is above people, cars and buildings. As there is so much movement to cope with, it is advisable to take a photograph of the scene then use it as a reference to look for simple shapes, which should be your starting point.

If you wish to achieve a pure watercolour, you can still draw lightly on your watercolour paper and use the faint pencil lines as a guide, erasing as many as possible after your first pale watercolour washes have dried. Before doing this, however, it is wise to get to know your subject by sketching the positions of buildings and other urban features with the use of vertical and horizontal guidelines.

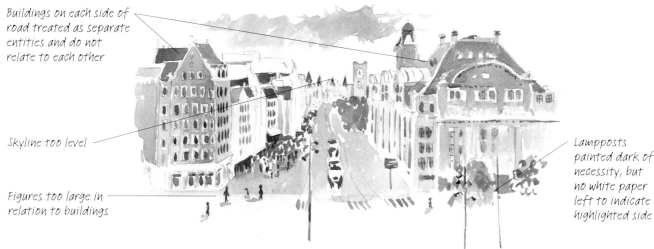

Buildings on each side of road treated as separate entities and do not relate to each other

Skyline too level

Figures too large in relation to buildings

Lampposts painted dark of necessity, but no white paper left to indicate highlighted side

Quick pen and ink sketch

Using a photograph as your guide, familiarize yourself with the juxtapositions of all of the components and introduce figures at random, complete with shadows.

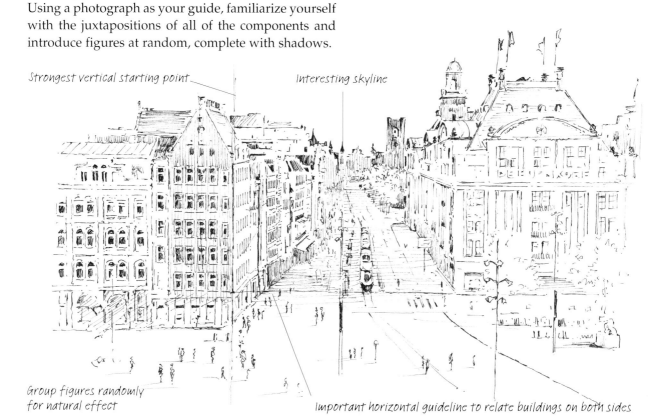

Strongest vertical starting point

Interesting skyline

Group figures randomly for natural effect

Important horizontal guideline to relate buildings on both sides

Solutions

In order to simplify, look for shapes – tonal blocks and colour blocks. In this illustration, I have painted over and within the first simple shapes directionally, to create an impression. You can see the various stages involved in building a composition that involves vast, busy areas, incorporating large, static buildings and smaller moving objects.

Because you are building a painting with overlaid washes – wet over dry – it is important to start with a drawing with which you are pleased, otherwise the tone/colour shapes you will be painting will not look convincing when the picture is complete. Remember to allow all the washes to dry completely before erasing any pencil marks.

Practise using more water with your pigment than you think you will need, as this will help you paint around the areas that are to remain white/light without creating watermarks. Should you go over one of these areas, you can correct the mistake by quickly blotting off, allowing the paper to dry and re-applying paint.

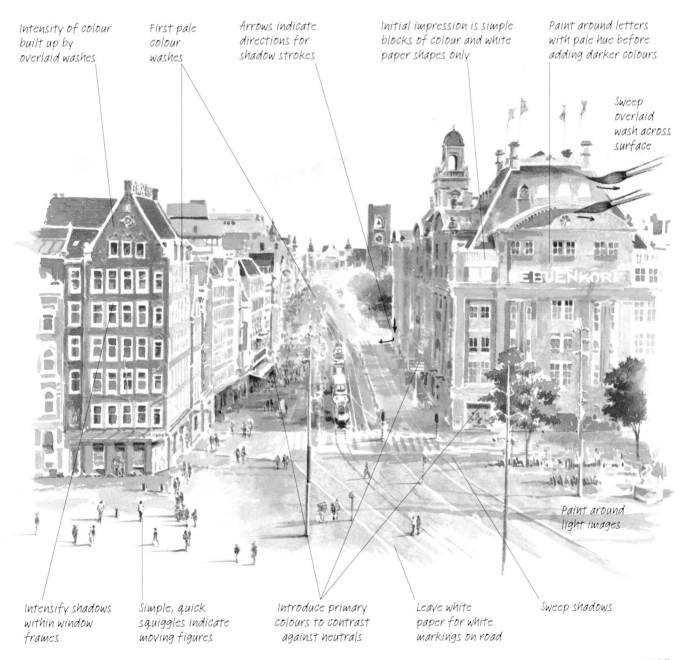

Intensity of colour built up by overlaid washes

First pale colour washes

Arrows indicate directions for shadow strokes

Initial impression is simple blocks of colour and white paper shapes only

Paint around letters with pale hue before adding darker colours

Sweep overlaid wash across surface

Paint around light images

Intensify shadows within window frames

Simple, quick squiggles indicate moving figures

Introduce primary colours to contrast against neutrals

Leave white paper for white markings on road

Sweep shadows

Demonstration: Old Buildings

Many urban landscapes contain pockets of character buildings – tree-lined streets with wide cobbled or slabbed pathways and spreads of grass, offer us tranquillity and a glimpse of the past that is very enticing. A variety of façades that may include hanging tiles, weatherboarding, plain rendered walls or rendering within timbers, often painted in strong pastel hues, provides the artist with tantalizing textures to depict. In the autumn, when leaves change to bright coppers and yellows before falling to add their gems of colour to wet pathways, the combination of ink and wash as a medium to enhance this clarity of tone and colour, seems an ideal choice.

Mixing the mediums of ink and wash can be approached in various ways. Three options are: placing tinted washes over an ink drawing, drawing over a wash painting, and working the two together right from the beginning as a planned progression. The first two – where ink drawing and first colour washes are minimal, to block in areas and establish the composition, before more pen-work and colour washes alternate in order to enhance tone and colour – are shown on this page, and the third method is described in the final demonstration opposite.

Wash over ink
I worked on Saunders Waterford 180gsm (90lb) Rough paper for the small study at right, using a 0.1 Profipen. As the pen grazes the surface a soft-textured effect is created, over which fluid washes may be placed. My pressure is always light upon the paper for this technique, and the darks are enriched by overworking in the same area rather than by applying firmer pressure.

As images recede, apply less pressure on the pen for minimum contact and to achieve faint impression

Vertical strokes used to enhance shadow areas

Vertical application of ink to suggest textured surfaces

First washes painted loosely

First rough indication of positions of glazing bars, clarified later by ink drawing

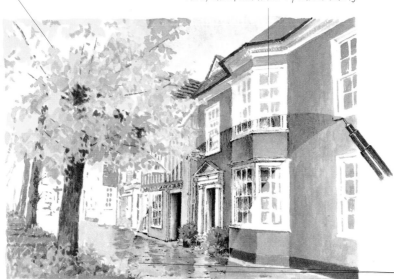

Ink over wash
In the study at left, washes have been painted freely over images that were lightly placed in pencil. As much of the pencil as possible is removed after the paint is dry before a fine pen is used to draw in the details and textures, as well as to enrich the dark tonal contrasts.

Bright yellow of individual leaves in different areas unifies painting

Pencil sketch (*right*)

The composition was planned in pencil, with the use of guidelines to establish the correct relationships between the different types of building.

Ink and wash combination (*below*)

I chose another angle, showing the same row of buildings, in order to look closer at the textures on timbers. The surface of Rough paper works with the pen to create textures instantly. Because there was a different variety of tree in this area that possessed no leaves, I omitted its form and faded the edges of the painted inked images, rather than restricting the composition to a definite format.

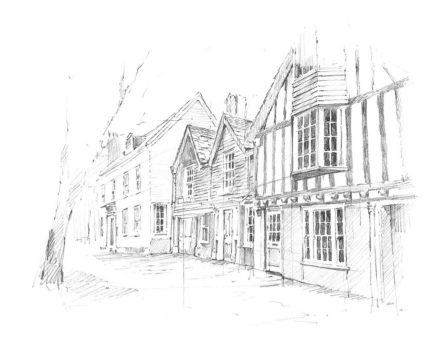

Main images lightly drawn in ink over faint pencil guide before erasing pencil

Avoid too much detail when depicting distant forms

Enhance areas of dark against light for full contrast

First pale colour washes swiftly placed to block in areas

Cut in to white/light forms and sweep strokes away to cover paper smoothly

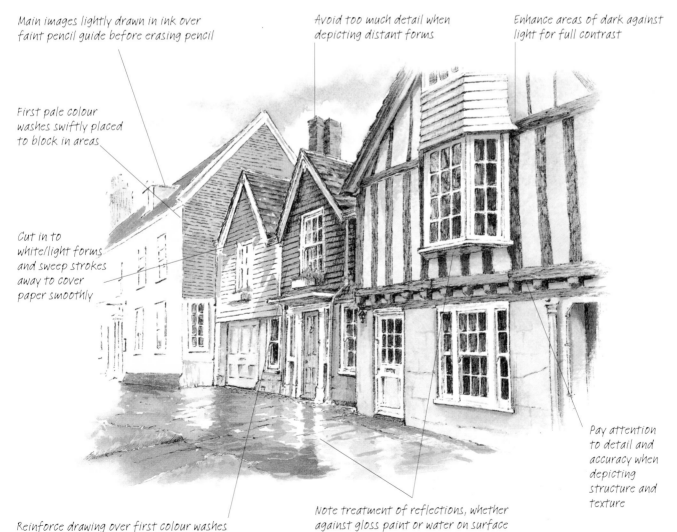

Pay attention to detail and accuracy when depicting structure and texture

Reinforce drawing over first colour washes

Note treatment of reflections, whether against gloss paint or water on surface

Trees and Woodland

Drawing exercises

The strokes here can be applied smoothly or erratically, to create interest of line. Practise twisting the pencil between your fingers as you push the pencil along, initially with firm pressure, before reducing your hand pressure prior to lifting the pencil from the paper. This type of stroke encourages a loose approach for more natural images. Try to create angles when practising these lines.

*Tonal block
5B pencil*

*Erratic upward
pressure*

*Lift
pressure*

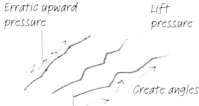

Smooth upward pressure

Create angles

*Keep pressure of pencil on
paper and twist it as the
stroke is drawn*

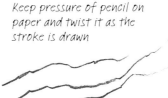

*Sharpen pencil to create
very fine lines*

*Single upward
push stroke*

*Massed upward push
strokes applied with
firm pressure*

Basic cross

*Mass of crosses
created by firm
pressure on paper*

*Central area of massed crosses, disguised to
lose initial image*

*Other tones and pressures with single
upward push strokes around edges*

CHOOSING SHAPES

Positive and negative shapes are important considerations for any subject, and their relationships with each other can help you create interesting compositions. Some shapes may be more geometric and possess crisp edges, whereas others may be uneven, lack definition and be broken. The juxtaposition of all these should provide interest and contrasts.

Try to observe your surroundings with an artist's eye in the form of positive and negative shapes – then practise drawing and painting them.

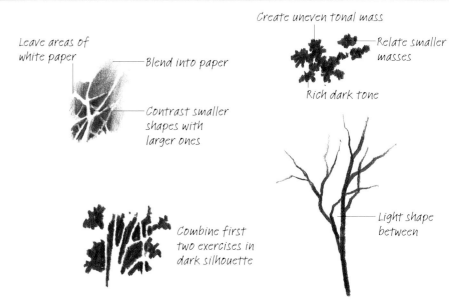

*Leave areas of
white paper*

Blend into paper

*Contrast smaller
shapes with
larger ones*

*Combine first
two exercises in
dark silhouette*

Create uneven tonal mass

*Relate smaller
masses*

Rich dark tone

*Light shape
between*

Soft pencil drawing

Although they may appear to be very varied, all these studies are exercises in downward directional strokes. In each, the continuous up-and-down application of tone creates interesting masses.

Textured mass

Vertically applied, varied-pressure strokes may result in your pencils having blunt ends when the strokes are executed with continuous movements to form a textured mass (below right).

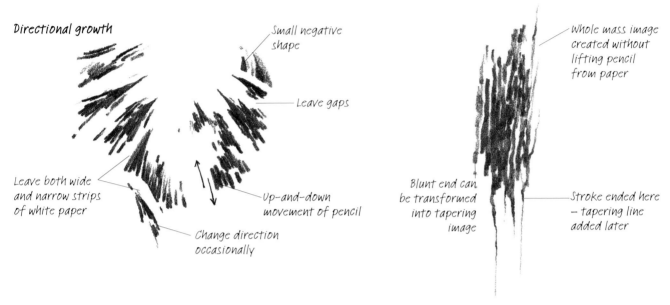

Directional growth

Small negative shape

Leave gaps

Leave both wide and narrow strips of white paper

Up-and-down movement of pencil

Change direction occasionally

Whole mass image created without lifting pencil from paper

Blunt end can be transformed into tapering image

Stroke ended here – tapering line added later

Recognizable image

A variety of strokes follows one after the other, with continuous application in order to create a recognizable image.

Recognizable mass

When depicting a mass area, you can travel from one shape to another without lifting pencil from paper by reducing the pressure to the extent that only fine wandering lines are visible before you reassert the pressure to make tonal shapes.

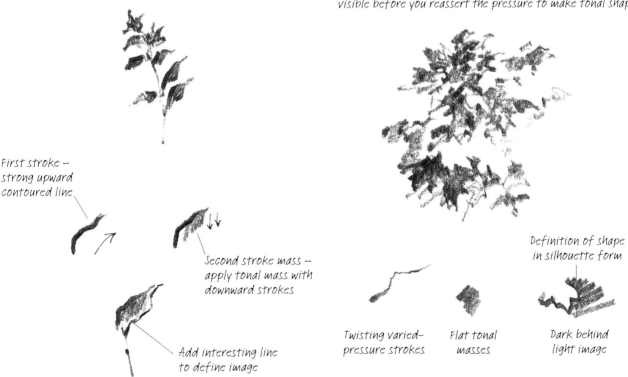

First stroke – strong upward contoured line

Second stroke mass – apply tonal mass with downward strokes

Add interesting line to define image

Definition of shape in silhouette form

Twisting varied-pressure strokes

Flat tonal masses

Dark behind light image

Coloured pencil exercises

The pencil exercises shown on the previous pages can also be effectively executed using coloured pencils. By gently increasing pressure in your stroke application for lines and masses, you will be able to enrich colours as well as tones.

It is by the depiction of contrasting areas that your work will most benefit. On these pages are some practice exercises to gain knowledge in the creation of contrasts by using white paper and light, bright colours against rich darks.

Cutting in

Olive green

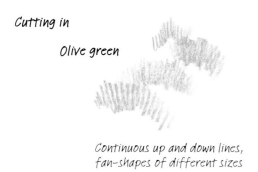

Continuous up and down lines, fan-shapes of different sizes

Cedar green added

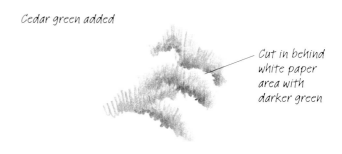

Cut in behind white paper area with darker green

Shadow recesses

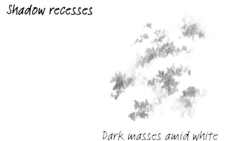

Dark masses amid white

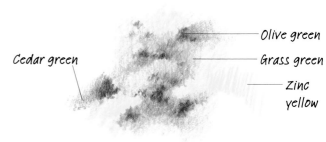

Cedar green

Olive green

Grass green

Zinc yellow

Variety of hues overlaid

Shadow lines

Vandyke brown

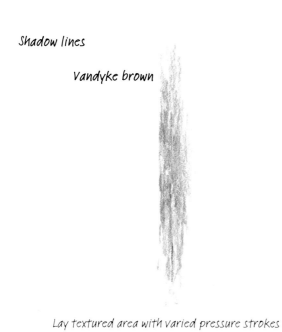

Lay textured area with varied pressure strokes

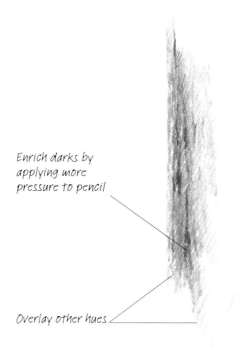

Enrich darks by applying more pressure to pencil

Overlay other hues

Watercolour exercises

The movements for the strokes in these exercises are similar to those used with pencils. By using a medium-sized brush – I used a No. 9 – their shapes will, however, appear different upon a watercolour paper surface.

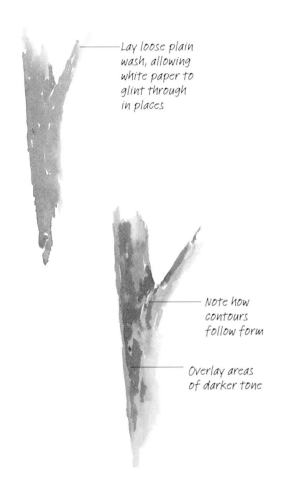

Lay loose plain wash, allowing white paper to glint through in places

Note how contours follow form

Overlay areas of darker tone

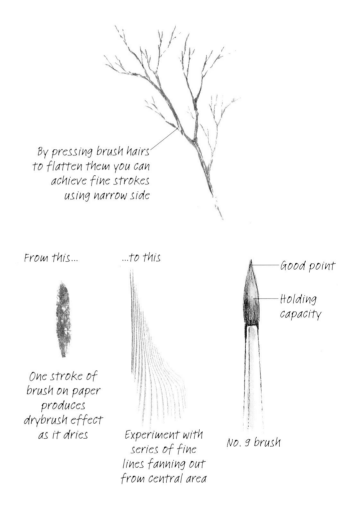

By pressing brush hairs to flatten them you can achieve fine strokes using narrow side

From this... ...to this Good point

Holding capacity

One stroke of brush on paper produces drybrush effect as it dries

Experiment with series of fine lines fanning out from central area

No. 9 brush

Foliage mass

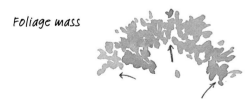

Push strokes upwards and outwards for interesting silhouette

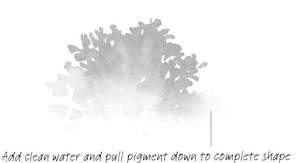

Add clean water and pull pigment down to complete shape

Drop in dark pigment to blend with damp surface, remaining crisp against white negative shape

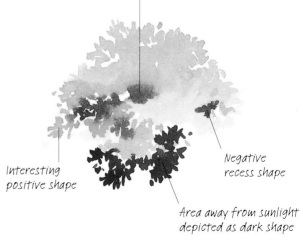

Interesting positive shape

Negative recess shape

Area away from sunlight depicted as dark shape

Single Trees: **Typical Problems**

With so many varieties of tree to choose from, whether viewed in gardens, parks, clinging to steep hillsides or in open countryside, their depiction can prove problematic. In addition to the basic structure, you need also to be aware of leaf mass shapes and direction of growth to correctly represent the species. This can be achieved in a loose, free style or with a tighter, more botanical approach – whichever method you choose, a good starting point is to observe a few individual specimens in isolation.

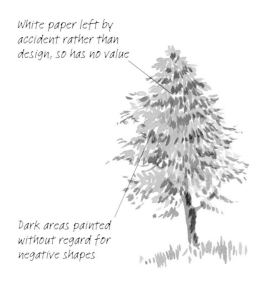

White paper left by accident rather than design, so has no value

Dark areas painted without regard for negative shapes

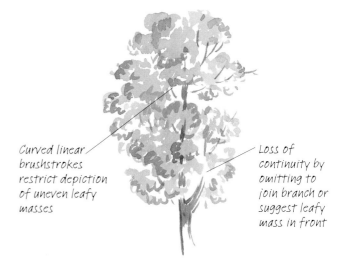

Curved linear brushstrokes restrict depiction of uneven leafy masses

Loss of continuity by omitting to join branch or suggest leafy mass in front

Small tree in garden

A slender garden specimen in its autumn splendour gives you an opportunity to consider colours other than green, as well as shapes (whether positive or negative) that can be abstracted and simplified.

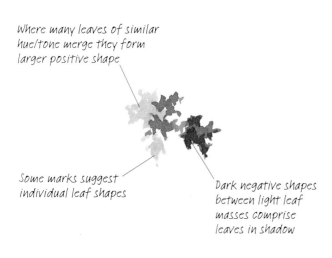

Where many leaves of similar hue/tone merge they form larger positive shape

Some marks suggest individual leaf shapes

Dark negative shapes between light leaf masses comprise leaves in shadow

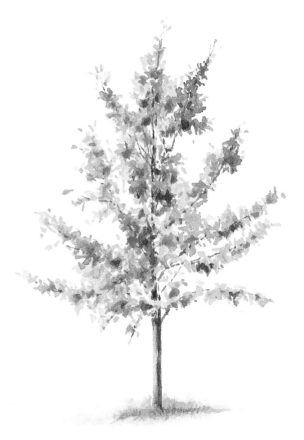

Solutions

In contrast to broadleaf varieties, we can observe more elongated negative shapes between the lighter masses in coniferous varieties.

Interesting and accurate small directional brushstrokes suggest tree species

Image of tree first painted as silhouette using pale, subtle, muted greens, then allowed to dry

Uneven silhouette shape carefully considered to achieve natural effect

Glazing

Shadow shapes (negatives) placed with consideration for light foliage at the fore

Dilute yellow mix gently passed over dry surface to glaze and introduce bright warmth

Silhouette pattern of tiny leaves against light sky

First pale tone/hue wash depicts entire tree

Negative shapes of completed tree before sky added

Adding a sky

When depicting an individual tree, you can add the sky colour after the tree image has been completed and allowed to dry thoroughly. Mix a suitable blue using plenty of water and gently apply it with the tip of your brush to the areas between foliage masses and branches. Then work out to the perimeter and blend it into the paper, adding water as required.

Sky painted between branches, twigs and leaves with delicate brushstrokes

Second overlaid wet-on-dry wash cuts in behind leaf mass shapes, retaining areas of first wash to suggest pale leaf masses

Negative (recess) shape enhances strong contrast of foliage mass in front

Light falling across main branch helps to define form

Variety of tones/hues, shadow shapes and negative shapes suggested by directional application of brushstrokes

Main branch in shadow provides strong contrast against light sky

Relationships: **Typical Problems**

A mass of trees and their foliage in a woodland setting can appear confusing. The situation is made easier when another structure is present. A derelict cottage offers the perfect solution where, over the years, nature has encroached upon the man-made form. This relationship provides the artist with a wealth of textures that require a variety of directional strokes to represent the different components convincingly.

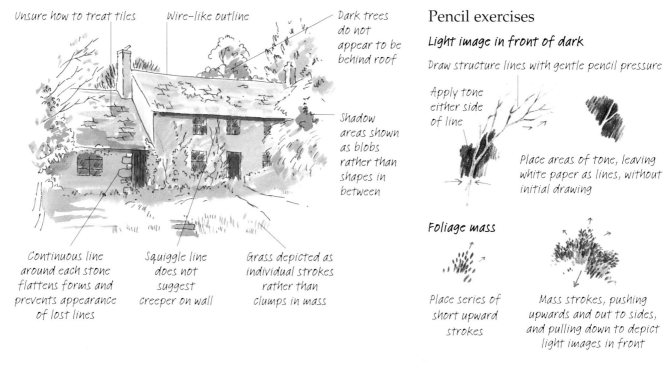

Unsure how to treat tiles

Wire-like outline

Dark trees do not appear to be behind roof

Shadow areas shown as blobs rather than shapes in between

Continuous line around each stone flattens forms and prevents appearance of lost lines

Squiggle line does not suggest creeper on wall

Grass depicted as individual strokes rather than clumps in mass

Pencil exercises

Light image in front of dark

Draw structure lines with gentle pencil pressure

Apply tone either side of line

Place areas of tone, leaving white paper as lines, without initial drawing

Foliage mass

Place series of short upward strokes

Mass strokes, pushing upwards and out to sides, and pulling down to depict light images in front

Pen and ink exercises

Allow pen to travel lightly across paper to encourage texture

Directional push strokes create image of foliage mass

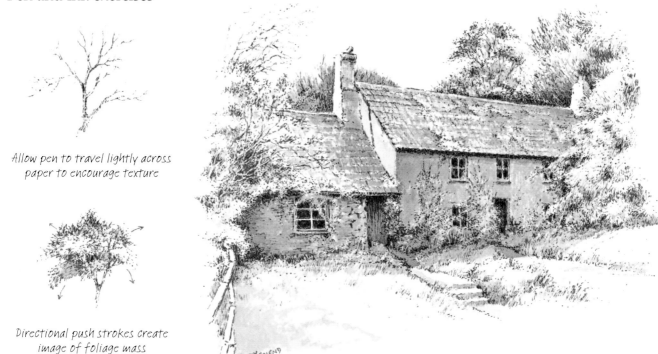

TRUDY FRIEND

Solutions

For this study the foreground has been simplified in order to make use of strong contrasting shadows falling across a wide expanse of lawn. This offers an area that rests the eye against the busy background.

The building is overshadowed by the woodland, but a strong shaft of light gives us something to focus on.

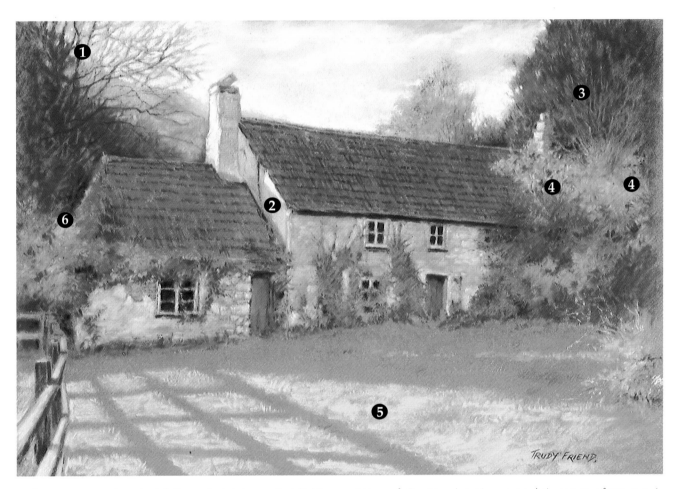

1 Where some trees have lost foliage, dark twigs against light sky offer contrast to other areas

2 Look for shadow shapes to add interest, and for highlighted areas among shadows

3 Strong contrast against rich darks of surrounding woodland

4 Mass of directional strokes uses subtle variety of tones and colour

5 Foreground treated loosely, allowing some background (support) colour to show through

6 Autumn tints among greens

Pastel exercises

Tree structure

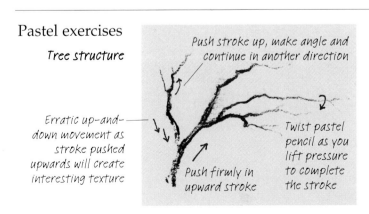

Push stroke up, make angle and continue in another direction

Erratic up-and-down movement as stroke pushed upwards will create interesting texture

Push firmly in upward stroke

Twist pastel pencil as you lift pressure to complete the stroke

Foliage mass

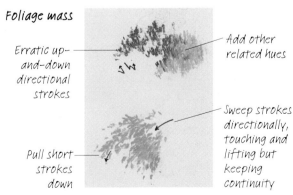

Erratic up-and-down directional strokes

Add other related hues

Pull short strokes down

Sweep strokes directionally, touching and lifting but keeping continuity

Summer and Winter Trees: **Typical Problems**

Drawings of trees are most effective and naturalistic when the growth direction of branches, twig placement, and a realistic interpretation of leaf masses have been observed, considered and depicted. If the tree is in full leaf you will need to pay particular attention to the position of the main trunk and the leafless branch and twig structures. When the tree skeleton is exposed in the winter months, we can gain the most benefit for practice exercises, and can understand how the structure of the tree works.

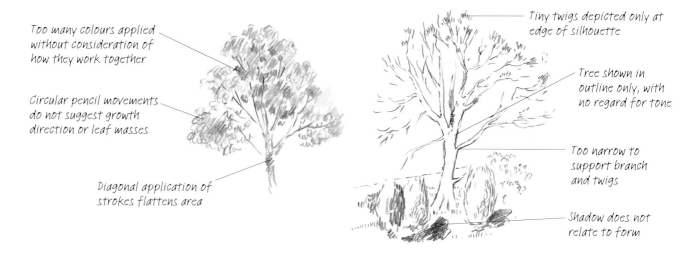

Too many colours applied without consideration of how they work together

Circular pencil movements do not suggest growth direction or leaf masses

Diagonal application of strokes flattens area

Tiny twigs depicted only at edge of silhouette

Tree shown in outline only, with no regard for tone

Too narrow to support branch and twigs

Shadow does not relate to form

Tree in summer

Coloured pencils give an opportunity to build up layers of pigment, which may combine to produce a variety of tone and colour, depending upon variations in pencil pressure. This study, using just three greens and sepia, shows how this can be achieved.

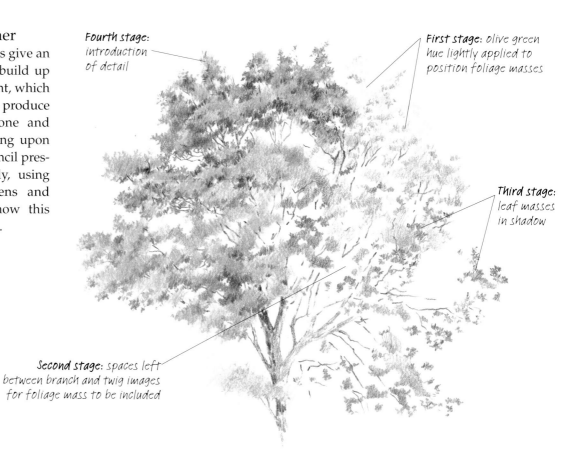

Fourth stage: introduction of detail

First stage: olive green hue lightly applied to position foliage masses

Third stage: leaf masses in shadow

Second stage: spaces left between branch and twig images for foliage mass to be included

Solutions

Tree in winter

The thought of depicting masses of twigs on twisting branches can be daunting. All that is required is a sense of logic and patience. Logic: make it believable – depict the widest part of a twig nearest the branch and the widest part of the branch nearest the trunk. Patience: time taken does not matter.

Don't worry over how long an exercise like this may take – and if you are tired of it after a while, just put it on hold and return to it later.

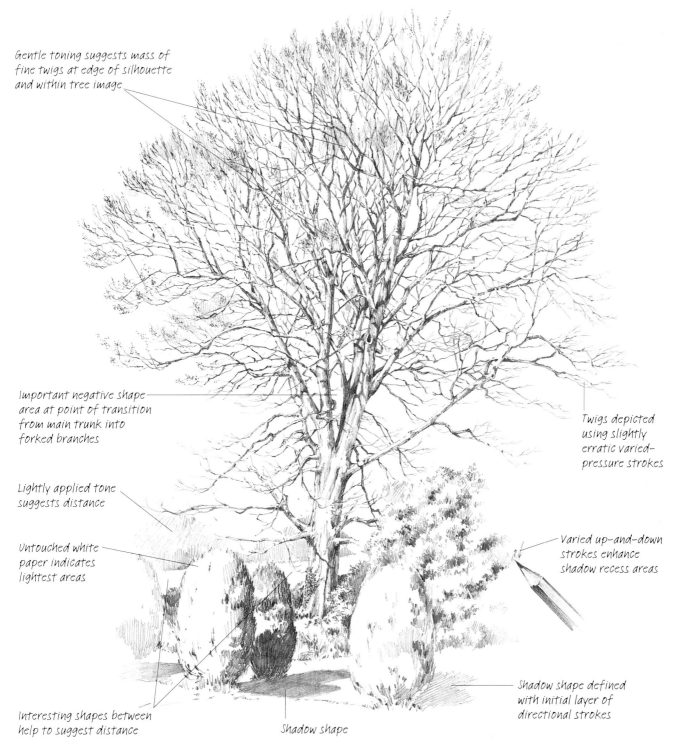

Gentle toning suggests mass of fine twigs at edge of silhouette and within tree image

Important negative shape area at point of transition from main trunk into forked branches

Lightly applied tone suggests distance

Untouched white paper indicates lightest areas

Interesting shapes between help to suggest distance

Shadow shape

Twigs depicted using slightly erratic varied-pressure strokes

Varied up-and-down strokes enhance shadow recess areas

Shadow shape defined with initial layer of directional strokes

117

Demonstration: Coniferous Woodland

Tall coniferous trees, with their strong vertical trunks and horizontal foliage masses, produce an infinite variety of negative shapes. Areas of dense shadow, contrasting with brilliant light foliage plateaus of feathery fronds amidst a maze of criss-crossed twigs, provide an irresistible combination.

In order to concentrate fully upon the negative shapes that guide us towards establishing the correct relationships between these majestic trees, I have chosen to take a close-up view of this subject, rather than a distant interpretation.

DIAGRAMMATIC SKETCH

This sketch concentrates upon awareness of negative shapes to help you understand the relationships between vertical and horizontal forms. You can also discover more shapes within the shadow recesses and arrangements of fine twigs. Some of the main negative shapes have been outlined in red.

Twigs and background

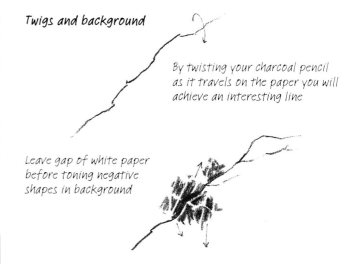

By twisting your charcoal pencil as it travels on the paper you will achieve an interesting line

Leave gap of white paper before toning negative shapes in background

Conifer foliage masses

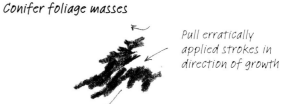

Pull erratically applied strokes in direction of growth

Push short strokes upwards to cut in to light areas

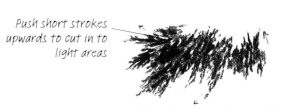

Pull strokes down directionally

Trunks

Place strong, unevenly applied, thick line to suggest shadow side of trunk

Up-and-down strokes applied lightly to indicate distant background

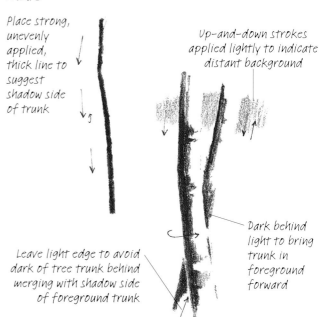

Leave light edge to avoid dark of tree trunk behind merging with shadow side of foreground trunk

Dark behind light to bring trunk in foreground forward

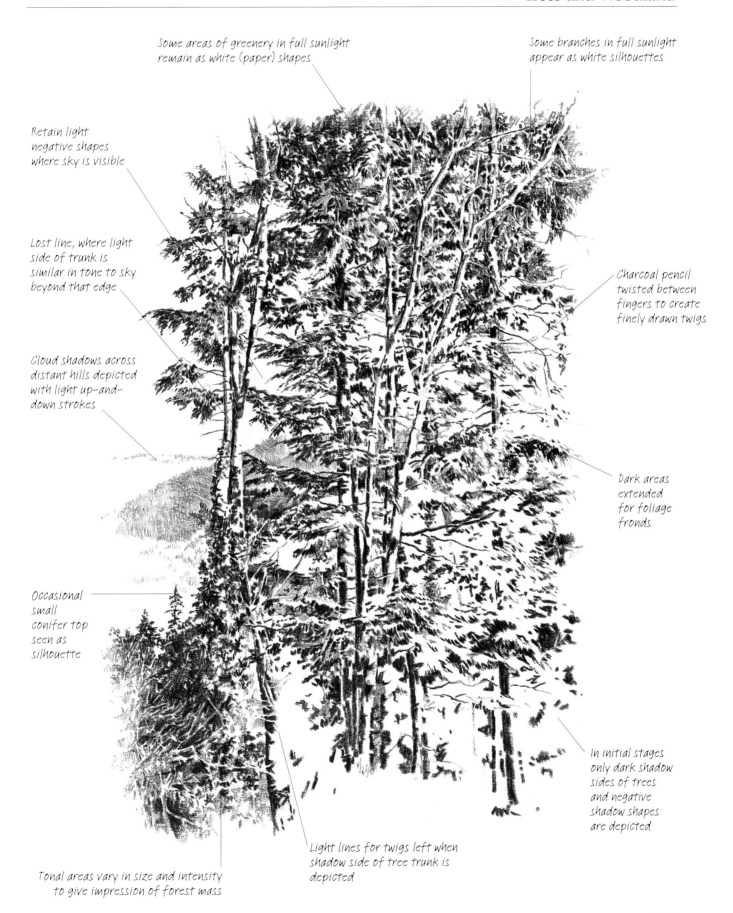

Some areas of greenery in full sunlight remain as white (paper) shapes

Some branches in full sunlight appear as white silhouettes

Retain light negative shapes where sky is visible

Lost line, where light side of trunk is similar in tone to sky beyond that edge

Charcoal pencil twisted between fingers to create finely drawn twigs

Cloud shadows across distant hills depicted with light up-and-down strokes

Dark areas extended for foliage fronds

Occasional small conifer top seen as silhouette

In initial stages only dark shadow sides of trees and negative shadow shapes are depicted

Tonal areas vary in size and intensity to give impression of forest mass

Light lines for twigs left when shadow side of tree trunk is depicted

119

Index

Mississippi riverboat

I used Saunders Waterford Rough paper 320gsm (140lb). With sharpened watercolour pencils and firm pressure, certain areas become embossed and the rough surface enhances the pencil texture for the dry overworking. The initial drawing was made in brown ochre.

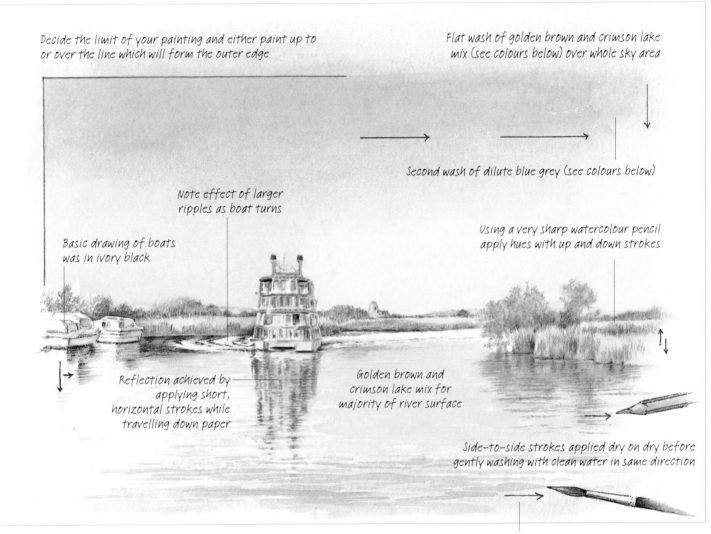

Decide the limit of your painting and either paint up to or over the line which will form the outer edge

Flat wash of golden brown and crimson lake mix (see colours below) over whole sky area

Second wash of dilute blue grey (see colours below)

Note effect of larger ripples as boat turns

Using a very sharp watercolour pencil apply hues with up and down strokes

Basic drawing of boats was in ivory black

Reflection achieved by applying short, horizontal strokes while travelling down paper

Golden brown and crimson lake mix for majority of river surface

Side-to-side strokes applied dry on dry before gently washing with clean water in same direction

Side-to-side on/off strokes to suggest light touching surface of water

Brown ochre for initial drawing

Olive green and raw sienna for banks and rivers

Ivory black for rich shadows and reflections

Terracotta and Vandyke brown for boat

Blue grey for shadow areas. Sharpenings diluted with plenty of water for second sky and river surface wash

Golden brown and crimson lake. Sharpenings diluted in a palette with plenty of water for the first sky and river surface washes